17

THE BLACK PANTHERS

THE BLACK PANTHERS

Portraits from an Unfinished Revolution

Edited by

Bryan Shih
and
Yohuru Williams

**Cuyahoga Falls
Library**
Cuyahoga Falls, Ohio

NATION
BOOKS
New York

Published by Nation Books,
An imprint of Perseus Books, a division of PBG Publishing, LLC, a subsidiary of Hachette Book Group, Inc.
116 East 16th Street, 8th Floor
New York, NY 10003

Nation Books is a co-publishing venture of the Nation Institute and Perseus Books.

Books published by Nation Books are available at special discounts for bulk purchases in the United States by corporations, institutions, and other organizations. For more information, please contact the Special Markets Department at the Perseus Books Group, 2300 Chestnut Street, Suite 200, Philadelphia, PA 19103, or call (800) 810-4145, ext. 5000, or e-mail special.markets@perseusbooks.com.

Designed by Jack Lenzo

Library of Congress Cataloging-in-Publication Data
Names: Shih, Bryan, editor. | Williams, Yohuru R., editor.
Title: The Black Panthers : portraits from an unfinished revolution / edited by Bryan Shih and Yohuru Williams.
Description: First edition. | New York : Nation Books, [2016] | Includes bibliographical references and index.
Identifiers: LCCN 2016012694 (print) | LCCN 2016012882 (ebook) | ISBN 9781568585550 (pbk.) | ISBN 9781568585567 (e-book)
Subjects: LCSH: Black Panther Party—History. | Black Panther Party—Pictorial works. | Black Panther Party—Interviews. | African American political activists—Interviews. | African American social reformers—Interviews. | African American radicals—Interviews. | Black Panther Party—History—Sources. | Black power—United States—History—20th century—Sources. | African Americans—Politics and government—20th century—Sources.
Classification: LCC E185.615 .B54645 2016 (print) | LCC E185.615 (ebook) | DDC 322.4/20973—dc23
LC record available at http://lccn.loc.gov/2016012694

10 9 8 7 6 5 4 3 2

To my mother, for teaching me fairness. To my father, for teaching me the power of a good letter.

—BRYAN SHIH

For my parents, Ralph and Elizabeth Williams

—YOHURU WILLIAMS

CONTENTS

Chapter 4 Block by Block, Door-to-Door: Building Community Support by Serving the People 111

Chapter 5 The Single Greatest Threat: The Covert War Against the BPP 179

PREFACE

"The easiest way to say it is just to imagine worker bees. You've got one queen; everybody else works. Rank and file—those were the worker bees. We did it all."

—Claudia Chesson-Williams

"We worked a lot, but it was good work, it was great work. Honestly, it was the best job I ever had."

—Madalynn "Carol" Rucker

"THERE ARE ALWAYS TWO PEOPLE IN EVERY PICTURE," THE CELEBRATED photographer Ansel Adams once observed, "the photographer and the viewer." But what of the subject of both the photographer and the viewer's gaze? The year 2016 marked the fiftieth anniversary of the Black Panther Party for Self-Defense (BPP), an organization that remains largely frozen in the popular narrative portrait of the 1960s as the most fearsome and violent of extremist organizations. These labels have stuck despite an explosion of books, articles, movies, and several documentaries meant to shine a brighter light on its activities. Notwithstanding these efforts, the BPP remains one of the most misunderstood organizations of the twentieth century.

Founded by Merritt Junior College students Huey Newton and Bobby Seale in Oakland in 1966, at its height the party boasted some 5,000 members nationally and even an international wing. Heavily influenced by the speeches and writings of Black Power luminaries such as Malcolm X and Stokely Carmichael (Kwame Ture), the party took its symbol from the Alabama Lowndes County Freedom Organization but fashioned a program that pledged revolutionary change, celebrated third world revolutionary struggles, and

made armed self-defense one of its cornerstones. Despite dropping self-defense from its title in 1968, the party was maligned in the national press for its rhetoric and targeted by the FBI for neutralization, forever shaping how we understand it.

In the popular retelling of the Panthers' history, the party's founders and national spokesperson Eldridge Cleaver, as well as its numerous run-ins with police, take center stage. But the history of the Black Panther Party is about more than iconic leaders such as Huey Newton and Eldridge Cleaver. Here, instead of taking the typical top-down view of Panther history, we offer the reader a view of the party from the bottom up by focusing on the rank-and-file members responsible for its day-to-day operations. These women and men transformed the BPP from a small, Oakland-based organization into an influential national party with chapters in nearly every major city across the country. It is in this sense a very different portrait of the party, one in which the subjects and not merely their photographers and viewers speak.

The book was the brainchild of former print and radio journalist and photographer Bryan Shih, who started taking portraits of the Panthers at reunions and gatherings to demystify the group and present its former members as they are today: a collection of individuals from a wide variety of professions linked by a commitment to social justice that remains even fifty years after the BPP's creation. His stunning photography is matched by the poignant stories shared by the women and men whose powerful images reveal the dignity, love, grit, and battle scars of the foot soldiers of the party.

From the outset, Bryan and I sought to shift the conventional history of the party away from its leaders to the grassroots by conducting oral histories with ordinary members, many of whom were teenagers when they joined and thus still alive to give their testimonies. They spoke of why they joined, what appealed to them about the BPP, the sacrifices they made, and how they understood their work. Above all, they recalled the long-lasting transformations they went through during their time in the party. Richard Brown says he "joined for the gun" and the chance to finally stand toe-to-toe with the police but along the way found an unexpected talent for community organizing. Norma Mtume was a college student in Los Angeles with a flair for

numbers when she joined the Panthers. She eventually rose to become the minister of finance for the entire party. Like so many of the subjects included in this book, both Brown and Mtume have dedicated much of their post-Panther lives to community and professional work whose roots stretch back to the original principles of the party.

The interviews are divided loosely based on the content Bryan covered in his conversations with the Panthers, which took place sometime after their photo sessions. Although we have elected to separate them based on subject headings to provide organization and structure, the content is generally more extensive than the chapter titles alone indicate.

To provide the reader additional perspective we solicited essays from leading scholars on the party, whose contributions we have woven into the fabric of the text. By no means exhaustive, the essays here are meant to highlight some of the more exciting avenues of research that complement the oral histories in this volume.

In the Introduction, for example, award-winning historian and Black Power studies founder Peniel E. Joseph offers a brief sketch of the origins of the party and its connection to the Black Power Movement. In my own essay, I expand on the history of the party, seeking to shift our gaze away from the dominant, Oakland-centered narrative of the party to one that appreciates the contributions and stories of local Panthers such as the individuals featured in this book.

Although often perceived as an all-black organization, the Panthers did include diverse members such as Christine Choy and Mike Tagawa, both of whom are interviewed in this book and explain how they found their way to the BPP. The party also developed strong alliances with other civil rights, antiwar, and Black Power organizations, not to mention third-world liberation struggles. In the second and third essays, historians Jeffrey Ogbar and Nico Slate, respectively, explore the cross-cultural alliances and global impact of the party.

The iconic male leaders of the Black Panther Party still dominate the popular imagination, but as award-winning historian Rhonda Williams shows, women played a crucial and leading role in the organization. Women, of course, exerted tremendous influence and direction over the party at both the local and national level, and although often absent from the narrative, were a major part of the party's success.

The rank-and-file Panthers whose names have too often been forgotten were important conduits for change. In Panther chapters across the nation, local leaders organized political education classes, staffed community service initiatives, and spearheaded the day-to-day activities of the party. As professor and Panther scholar Jama Lazerow shows, ordinary people such as Boston Panther Frank Parky Grace were the shock troops of the Panther cause.

Although the image we tend to have of the BPP is of Newton and other leaders, armed and facing down police, we forget that the BPP's social programs were at the forefront of many of its efforts after 1968. The Panthers out of the spotlight worked tirelessly to address poverty and inequality at the local level. In her essay, Columbia University professor Alondra Nelson explores the little-known health activism of the BPP. She illustrates the ways in which the party's activism went beyond self-defense and the more popularly known Panther programs such as the Breakfast for Schoolchildren Program.

The interviews, essays, and photographs herein offer readers a chance to reflect on the history of a radical organization whose name continues to elicit bitter rancor and strike fear in the hearts of its detractors; any mention or use of Panther imagery is quickly condemned in an ongoing effort to narrow the focus on the party to the most sensational and unsavory events in its history. Doing so allows the Panthers to be dismissed simply as "thugs" and—what's worse—their demands for a more just society to be ignored.

But as the men and women whose fascinating stories constitute this book make clear, they were truly inspired to act out of a sincere love for the people. They are not uncritical of the party itself, but they also believe that history has shortchanged them. For many of these individuals and the communities it served, the BPP was a lifesaver that opened their eyes to both social injustice and their own political potential. This moment—on the fiftieth anniversary of the party and amidst the ongoing politicization of young Black Americans in the wake of clear and disturbing patterns of police repression throughout America—is the perfect moment to revisit this history and to reexamine the Panther legacy.

Yohuru Williams and Bryan Shih, 2016

INTRODUCTION

THE BLACK PANTHERS AND BLACK POWER
PENIEL E. JOSEPH

The Black Panther Party (BPP) remains, fifty years after the group's founding, perhaps the most celebrated, demonized, controversial, and debated radical political organization in American history. Young, brash, angry, and eloquent, the Black Panthers set the world on revolutionary fire in the late 1960s. The BPP grew out of a postwar black freedom struggle most popularly identified with civil rights struggles but one that cultivated equal ferment in black radicalism. If Martin Luther King Jr. endeavored to use nonviolent civil disobedience as a shield against institutional racism and white supremacy, Malcolm X brought forth a gospel of self-defense and revolutionary violence that took hold, like Promethean fire, in small but significant pockets of black America.

Stokely Carmichael, the Student Nonviolent Coordinating Committee (SNCC) chair, who counted Malcolm and Martin as political mentors, became the nation's foremost spokesperson for black radicalism after Malcolm's February 21, 1965, assassination at the Audubon Ballroom in Washington Heights, New York. Carmichael's call for "Black Power!" in Greenwood, Mississippi, popularized a movement that paralleled, intersected, and overlapped national civil rights struggles.

The Black Panthers emerged out of the oppressive racial conditions that Malcolm denounced, Martin sought to ameliorate,

and the SNCC vowed to transform. Voting rights demonstrations in Alabama during the winter and spring of 1965 set the stage for state-sanctioned violence against innocent demonstrators that would come to be known as "Bloody Sunday." The bloodshed triggered a crisis of race and democracy that drew thirty thousand demonstrators to Selma, inspired President Lyndon Johnson to publicly embrace the civil rights movement before a joint session of Congress on March 15, and culminated in the August 6 passage of the Voting Rights Act.

Against the backdrop of the Selma-to-Montgomery demonstration, SNCC activists led by Carmichael, Judy Richardson, Bob Mants, and local leaders such as John Hulett entered Lowndes County, Alabama, a black-belt county in the grips of racial and economic oppression. The Lowndes County Freedom Organization (LCFO) organized rural sharecroppers for political and economic self-determination and racial dignity. Racial terror practices by white authorities and plantation owners forced activists to build tent cities, raise money in urban cities (most notably Detroit), and organize self-defense patrols to protect civil rights workers. By the spring of 1966 LCFO adopted the black panther as a symbol of its newly formed independent political party and its fierce determination to break ancient bonds of oppression.

The black panther served as a symbol of defiance and political engagement as LCFO candidates vied for several local offices including sheriff, coroner, tax assessor, and school board member, positions that remained exclusively white in a county that was 80 percent black. The LCFO held a successful primary in May 1966 that allowed the Black Panther candidates to compete in a November election marred by fraud and threats of violence.

By the summer of 1966 the black panther symbol reverberated across the country with Panther chapters being set up by various local militants. In October of that year two Oakland activists, Huey P. Newton and Bobby Seale, formed their own group, the Black Panther Party for Self-Defense (BPP).

The twenty-four-year-old Newton and thirty-year-old Seale were both southern migrants whose families had moved, respectively,

from Louisiana and Texas in hopes of participating in Oakland's postwar economic boom. They found a city steeped in racial and economic segregation. Stubborn race and class hierarchies persisted in a postwar industrial Oakland where the police innovated new forms of racial profiling that snared virtually all young black men in a citywide police dragnet that made them subject to harassment, brutality, arrest, and sometimes death.

Newton and Seale cut their political teeth in local black nationalist study groups and political organizations during the early 1960s. Newton also spent time in prison for petty theft and fighting. Their lives also reflected the stark reality of urban life. Like many young black men of their generation (and those older, such as Malcolm X), Newton and Seale chafed against institutional racism, inadequate education, and police brutality.

This original Black Panther Party chapter, founded by Newton and Seale, drew from extensive reading of Malcolm X and black history, the political example of the Nation of Islam, and the anticolonial struggles in Africa, Latin America, and the Caribbean.

On October 15, 1966, at the North Oakland antipoverty center (a product of Lyndon Johnson's "Great Society") the BPP was born, with Seale writing and serving as the practical sounding board for Newton's ideas about political revolution and self-determination. The resulting Ten-Point Platform and Program (included in this book's Appendix) divided the black community's goals along dual tracks of political goals ("What We Want") and beliefs ("What We Believe"). The Panthers called for an end to police brutality, exemption from military service, quality education, decent housing, land, peace, bread, and justice. The Panthers both derided American democracy as the pipe dream Malcolm X had ridiculed and, following Martin Luther King Jr., extolled the founding documents as expansive enough to allow the nation to march forward into an undiscovered country of racial equality and economic justice.

The Black Panthers announced a bracing brand of revolutionary nationalism, a political philosophy influenced by Malcolm X, *Negroes with Guns* author Robert F. Williams, and black political theorist and former Marxist Harold W. Cruse. Revolutionary nationalism

connected domestic antiracist struggles to anticolonial wars being waged around the world, all the while maintaining a fierce allegiance to the struggles, hopes, and dreams of indigenous people.

Within two years the Black Panthers would emerge as the most visible revolutionary group in the world, having successfully absorbed (through alliance or intimidation) rival Panther groups and drafted a coterie of the era's most iconic Black Power revolutionaries into the group, most notably Stokely Carmichael as prime minister in 1968.

Like the #BlackLivesMatter movement of today, the Black Panthers identified the American criminal justice system as a gateway to a wider, yet interconnected, system of racial and class oppression, global in its scope. Newton's arrest on charges of murdering an Oakland police officer (he was convicted of manslaughter in 1968, released in 1970) inspired the "Free Huey" movement, which, with the expert public relations work of Minister of Information Eldridge Cleaver and Communications Secretary Kathleen Neal Cleaver, turned a local group of militants into international icons.

During the BPP's first five years of existence the group deployed multiple and provocative organizing techniques ranging from early Panther patrols that pitted armed Panthers in showdowns with local police officers and teetered on the edge of violence to community programs that offered free breakfast, lunch, health care, and legal assistance to poor black folk. Dozens of chapters sprung up throughout the nation, with Chicago, New York, and Los Angeles emerging as key Panther sites outside of Oakland.

The group's open advocacy of revolutionary socialism by 1968 pushed it to adopt a historical materialist (Marxist) critique of racial injustice and economic inequality. The BPP was the only major Black Power organization to openly align itself with whites, a position that put its members at odds with former allies. The Panthers adopted an anti-imperialist framework that identified them as a revolutionary "vanguard" daring to fight American empire from inside the belly of the beast.

Like surrealist painters the Panthers sought to will the new world they imagined into being. They did so through practical politics in

the form of a well-received newspaper, founding dozens of chapters nationally and later National Committees to Combat Fascism, innovating social programs, and aligning themselves with a host of indigenous Black Power–era groups, including the Brown Berets, Young Lords Party, Red Guard, Students for a Democratic Society (SDS), Peace and Freedom Party, and American Indian Movement (AIM).

Globally, the BPP inspired similar groups in London, India, the Middle East, Scandinavia, and elsewhere. For international radicals buoyed by the revolutionary conflagrations of 1968 the BPP came to symbolize the hopes for revolution at home and abroad. The Panthers became by the late 1960s, perhaps more than any other group in America, the symbol of anti-imperialist, antiwar, and anticapitalist organizing. Before Richard Nixon went to China, Newton traveled there and was accorded the treatment and meetings of a foreign dignitary.

The group's politics and activism attracted local, state, national, and international surveillance. The FBI's Counterintelligence Program (COINTELPRO) unleashed hundreds of highly coordinated attacks on the group that left it reeling, with some members imprisoned or dead, and undermined its social programs. Local authorities, less publicly but no less effectively, undermined the group through harassment, confrontations, arrests, and incarceration. The Panthers unveiled the depths of racial inequality in the American justice system and paid the price. Former Panthers, having served longer sentences than nonpolitical prisoners have, attest to the harsh reality of the nation's criminal justice system, with supporters characterizing them, decades later, as political prisoners. Indeed, some remain in prison, including Herman A. Bell and Jalil Muntaqim (formerly Anthony Bottom), who are included in this book.

Some wounds were self-inflicted. The Panthers suffered from a centralized, hierarchical leadership structure, deep misogyny and sexism within the rank and file and leadership, and too casual use of violence and intimidation to settle disputes within and outside of the organization.

By the early 1970s the group changed course, with former confidantes Newton and Cleaver engaging in a very public feud over

strategy and tactics that erupted in virtual civil war between East and West Coast representatives, which left at least two Panthers dead and more injured. Newton's decision to disband chapters and consolidate the party's strength in Oakland left many Panthers disillusioned. Some traveled to Oakland to continue the party building through a successful charter school and political campaigns. Seale lost a close runoff election for mayor of Oakland, and Elaine Brown ran a strong campaign for city council.

Ultimately, the Black Panthers represented one of the most bracing challenges to institutional racism in the postwar era. The Panthers, following Malcolm X, Stokely Carmichael, and the revolutionary activists of the Black Power Movement, called out the structural and policy roots of racism, poverty, state violence, and inequality. They blasted America, as did Martin Luther King Jr., as a nation sick with the diseases of materialism, militarism, and racism. Their rhetorical brio was matched by a dazzling aesthetic. Black men and women, telegenic and articulate, in black leather jackets, tilted berets, powder-blue shirts, and armed with rifles, guns, and bandoliers marched in unison calling on America to end its long history of racial and class oppression.

Black lives mattered for the Panthers both rhetorically and programmatically. Rhetorically, the BPP innovated a new language to designate a political structure it identified as being antiblack. Its members called police "pigs" not to denigrate officers who upheld the law and protected lives but to call out the large numbers who in the context of America in the 1960s and 1970s did not. Panthers decried America as racist, greedy, repressive, complete with law enforcement who relished in the use of "Gestapo" tactics in the black community. Malcolm X leveled similar charges.

A half-century later the Panthers' critique of the American criminal justice system resonates even more powerfully. The rise of mass incarceration has placed 2.3 million Americans in federal, state, and local prisons and more than five million more on probation and parole. The Black Panthers, who innovated a busing-to-prison program in the 1970s and recruited prisoners and ex-offenders into the group's leadership, anticipated the rise of the prison state. Prisoner

rights, which have become central to contemporary reform movements (with an able assist from Michelle Alexander's best-selling *The New Jim Crow*), include defending not only the innocent but the guilty from a system more comfortable with punishing black bodies than rehabilitating them.

The Black Panthers' greatest legacy for contemporary activists remains their ability to speak truth to power and act, at their best, with courage, determination, and grace, which allowed them to stand out as perhaps the boldest and most cohesive example of black self-determination in American history. The Panthers illustrated how radical black struggles for freedom enabled a wide range of groups to engage in envelope-pushing activism capable of expanding liberal democracy into the still-undiscovered terrain of radical humanism.

Peniel E. Joseph is professor of history and the Barbara Jordan Chair in Political Values and Ethics at the Lyndon Baines Johnson School of Public Policy, where he serves as founding director of the Center for the Study of Race and Democracy at the University of Texas at Austin. He is the author of the award-winning *Waiting 'til the Midnight Hour: A Narrative History of Black Power in America*; *Dark Days, Bright Nights: From Black Power to Barack Obama*; and *Stokely: A Life*, which received the Benjamin Hooks Institute for Social Change National Book Award and was named a *New York Times* editor's pick. He is also the editor of *The Black Power Movement* and *Neighborhood Rebels*. A frequent national commentator on issues of race, democracy, and civil rights, he is a contributing editor at TheRoot .com whose writing has appeared in the *New York Times*, *Washington Post*, Reuters.com, and Newsweek.com. A Harvard alumnus Caperton fellow at that university's Hutchins Center, he lives in Austin, Texas.

CHAPTER ONE

IN DEFENSE OF SELF-DEFENSE
PATHWAYS TO THE BPP

People joined the BPP for many different reasons. The moment of politicization was different for everybody, but a few were commonly shared, including the 1963 bombing of the Sixteenth Street Baptist Church in Birmingham, Alabama, and the 1965 Watts urban rebellion. A more general sense of frustration and alienation compelled others to join the Panthers' ranks. The party exerted enormous pull on the imaginations of the members, especially those who experienced police brutality. In the rebellious spirit of the times, the party's bold stance on self-defense resonated with those seeking fresh alternatives for achieving social justice and Black Liberation. Party members expressed a deep appreciation for other aspects of the Panthers' program, including its community service programs, which grew out of a genuine love for the people.

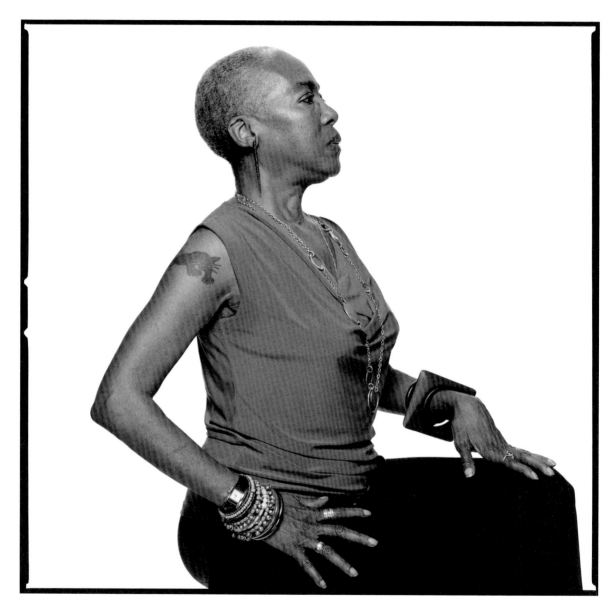

"When you're young, fear is really not in your vocabulary."

Claudia Chesson-Williams (b. April 23, 1951) was a member of the Corona, Queens, Branch of the Black Panther Party. She later worked in the Information Technology Department of Columbia University for twenty-three years, and then for Greenhope Services for Women, an alternative-to-incarceration program. She is part of the Black Panther Commemoration Committee New York, which hosts an annual film festival to raise money for political prisoners.

MY NEIGHBORHOOD FRIEND, A SISTER THAT I'VE KNOWN SINCE I WAS about eleven years old, said, "Claudia, I want you to go with me. We're going to go and hear these Panthers speak at PS 92," which was an elementary school in our community. I said, "Okay, I'll go. I'm down."

I listened to these brothers speak, and I heard the pitch. I saw the determination, and I saw the compassion. I thought, "Wow, this is the feeling that I used to get when I went into clubs and popped my fingers and got on the dance floor." It was the same feeling, except it was bigger than me now. It was bigger than I. It was full of love of the people.

No longer did we have to argue and fight about, "What are you looking at me like that for?" and "Don't step on my sneaker," and "This is my block." Now, we really had something to fight for. We had a people to fight for. That was bigger than any gang or any club. We had a goal. We had something to look forward to, which was the betterment of black people.

It was most definitely something that I was searching for, but I didn't yet know that I was searching. I didn't find it. It fell on me. That was the first meeting. That's what actually started the wheels of my mind for me to become political.

I was rank and file. I did a lot of things. The easiest way to say it is just to imagine worker bees. You've got one queen; everybody else works. Rank and file—those were the worker bees. We did it all. The one thing I enjoyed the most was teaching the political education (PE) classes on Seventh Avenue in front of the Harlem office. That was the most fruitful, but anything I did, it was for the love of the people. Wherever I was, wherever I was sent, or whatever I had to do, it didn't matter anymore because it was for the love of

the people. We were trying to get the word out. If I had to sell 125 papers in a day, and I got close to that goal, then I did a good job.

I was originally from Queens and came out of the Corona Branch of the Black Panther Party. When the Panther Twenty-One were arrested and went to jail,* in order to keep those offices open and functioning, Panthers were sent from all over the city to Harlem. I was one of the Panthers that ended up in the Harlem Branch. That's how I got to be there on Wednesday nights to give the PE classes. I was extremely nervous the first time, but once I found my voice, then it went like clockwork. A lot of the people in the community who were just walking by were like, "Well, let me stop and see what this little girl is talking about," because I was indeed a little girl at that time.

We started off every PE class with the Ten-Point Program, and we ended every PE class with, "Okay, let me hear from you guys. What do you want to see different in your community? How are you living?" Then we would get the feedback, and then we would know how to concentrate our efforts. Rent strikes were crazy because if you had to live like that, why should you pay rent? We did clothing drives. We did food drives. We did, of course, the breakfast program.

There were a lot of other things that happened, and they might have been more meaningful, but those PE classes stayed with me. We were outside on the street in front of the office. When you were giving a class or you were having a talk inside the office, and there were only Panthers around you, the feeling was just different than outside on the street. The Panthers knew what you were doing because they were Panthers and they were doing the same thing. Outside, there were constant questions and answers with the people. You had to give yourself up when you were outside in that crowd. You never knew who was going to say, "We don't care about that, and we don't care about you. You need to go away." There were a lot

* In April 1969, prominent New York Panthers were arrested and charged with a plot to carry out a series of bombings throughout the city. The charges against all twenty-one were eventually dropped, but high bail amounts leading to extended jail time crippled the once vibrant chapter.

Black Panther Party
BOOK LIST

MALCOLM X	The Autobiography of Malcolm X
FANON, FRANTZ	Wretched of the Earth
NKRUMAH, KWAME	I Speak of Freedom
DAVIDSON, BASIL	The Lost Cities of Africa
APTHEKER, HERBERT	The Nat Turner Slave Revolt
Aptheker, Herbert	American Negro Slave Revolts
	A Documentary History of the Negro People in the U.S.
Bennett, Lerone Jr.	Before the Mayflower
Bontemps, Arna W.	American Negro Poetry--Story of the Negro
Cronin, E.D.	Black Moses (The story of Garvey and the UNIA)
DuBois, W.E.B.	Black Reconstruction in America--Souls of Black Folk
	The World and Africa
Davidson, Basil	Black Mother, the Years of the African Slave Trade
Fanon, Frantz	Studies in a Dying Colonialism
Franklin, John Hope	From Slavery to Freedom--Negro in the United States
Frazier, C.F.	Black Bourgeoisie
Harrington, Michael	The Other America
Garvey, Marcus	Garvey & Garveyism--The Philosophy & Opinions of Garveyism
Herskovitts, Melville J.	The Myth of the Negro Past
James, C.L.R.	A History of Negro Revolts
Janheinz, John	MUNTU: The New African Culture
Jones, LeRoi	Blues People
Lincoln, C.E.	Black Muslims in America
Malcolm X	Malcolm X Speaks
Mwmmi, Albert	The Colonizer and the Colonized
Nkrumah, Kwame	Ghana
Patterson, William L.	We Charge Genocide
Rogers, J.A.	Africa's Gift to America
	World's Great Men of Color; 3,000 B.C. to 1946 A.D.
Wesley, Charles H. & Woodson, Carter G	The Negro in Our History
Woodward, C. Van	The Strange Career of Jim Crow
Wright, Richard	Native Son

of people that just did not know where we were coming from and were afraid that if they were seen at the office or they were seen asking questions that they'd get the reprisals; that they would end up getting hurt. They were afraid.

Things went so fast. Time seems to accelerate when you're always looking over your shoulder. At this time, it was all-out war against the Panthers, and brothers were being shot down in the street or set up or going to jail for years. We have brothers in jail since that time, forty, forty-one years. We've had brothers that we've lost on the inside that we can't let the world forget. The government said, "Okay, we're going to lock them up and throw away the key and nobody will ever care." That's not true. We want them out. We want freedom for all political prisoners. We don't want any more of them to die on the inside. That's the biggest injustice.

There were times that our cadre consisted of almost nothing but women, and that was when the brothers were locked up or had to go underground. I remember being on a front line against a policeman on horseback and being six months pregnant. What we wanted was a simple streetlight, and we got the community out there, and we blocked traffic. I didn't know whether I was going to be trampled and my baby killed, but I knew that I had to be there. I was an active member of the party from 1968 to 1971, and in those few years, I aged ten, fifteen years. We didn't have much time to be little girls. We went straight to womanhood.

Talking about these things is bringing up all of these feelings, things that I haven't thought about or touched on for a long time. It seems that as you get older, and you look back on the things that you've done in your life, you say, "Oh my God, I could have gotten killed then." When you're young, fear is really not in your vocabulary, and once you look back, you wonder, "Why wasn't I afraid?" We didn't have time to be afraid. It was all about survival. That's pretty much what it was. You worked hard, and you grew up fast.

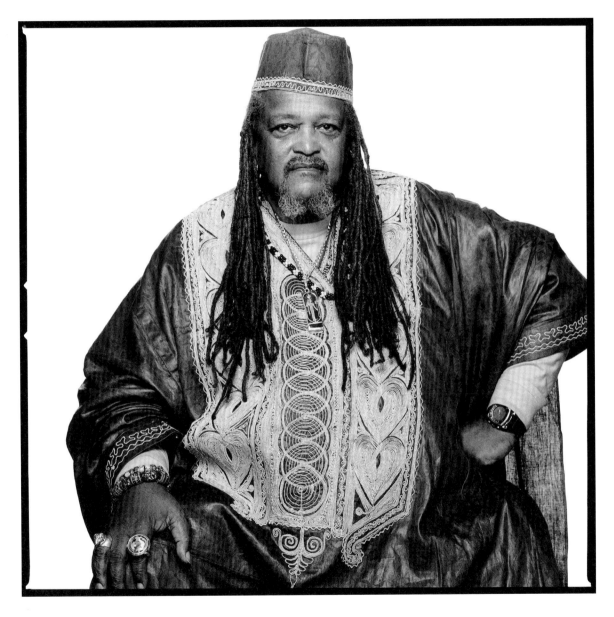

*"I knew I was fighting for my rights. I was fighting
for something that I truly believed in my heart."*

Cyril "Bullwhip" Innis Jr. (b. February 12, 1945) grew up in Queens, New York, where he joined the Corona Branch of the party. He held several leadership positions, especially following the arrest of the Panther Twenty-One. He retired from the New York City Board of Education. He is part of the Black Panther Commemoration Committee New York, which hosts an annual film festival to raise money for political prisoners.

Everybody had stopped "jitterbugging" (fighting)—there were no more gangs. The people that I knew who were in gangs, the majority of them were at this cultural center, the Malcolm X Cultural Center. And I said, "Oh!" I came in, and some of my old friends were there. I met Mr. Bill Brownville,* and I asked, "Can I become part of this?" With the expanding knowledge of myself that I got through books such as *From "Superman" to Man* by J. A. Rogers, I figured this culture center would help me to learn even more about myself.

I was more into the progressiveness of the Malcolm X Cultural Center. We were doing things in the community, which I liked to do. Now, in 1968 the Black Panther Party had started. I heard about them. We all heard about them. They were already in New York, and the Jamaica Branch of the Panther Party in Queens was functioning. The brothers and sisters from there came to our office in Corona, Queens, and we sat down and met. They asked, "Would you guys like to become part of the Black Panther Party?"

I was attracted to the Black Panther Party. I was a reader and had read a lot about what they were doing in California. I embraced that military look. They had their little guns, and they were stepping to the man. And to me, I enjoy stepping to the man. I never had a fear of the police at all.

But let me go back. There was a piece in my life that really hurt me at one point, and to this day I always think about that because I never could understand it. It was back when they blew up the Sixteenth Street Baptist Church in Alabama and killed those four little girls. I never knew that people could be so vicious and so deranged

* A revered community elder in Corona, Queens.

and so racist that you could blow up a church. Now mind you that in the Corona, Queens–East Elmhurst area we come from, a lot of our families were very churchgoing people. So even if I was a little, bad knucklehead, I still had that church thing. I went to Sunday school. I believed in the church. So when this happened I said, "White people don't have any respect for our churches. They killed these four little girls." That stayed in me. And then, Emmett Till! I saw a picture, how they beat him and hung him. I said, "Wait a minute! This is crazy." All of that was festering in me, so for me to become a Panther? I was already ready. You created me to become the one who's going to be against you. You're my adversary now. I'm going to defend my community, and this is what the Panthers were doing. I felt that I would be a hell of a fine Panther.

After Malcolm was assassinated, the Corona Branch of the Black Panther Party became Sister Betty Shabazz's bodyguards for a while. It was an honor to make sure that we protected what we called the "first family" because of Malcolm. We were the seeds of Malcolm. I'm not talking just about the Corona Branch, I'm saying the Black Panther Party as a whole. We did what Malcolm said needed to be done, and we weren't afraid to do it. One concept that I would tell people that they have to understand is that we were young, but you know what? We weren't afraid of death because we knew that was the epitome of being a true revolutionary. Che Guevara said it. Patrice Lumumba said it. A lot of people said that power cedes to nothing but power, so it was an honor to be a Panther, and if I were to die, to die as a Panther. I knew I was fighting for my rights. I was fighting for something that I truly believed in my heart.

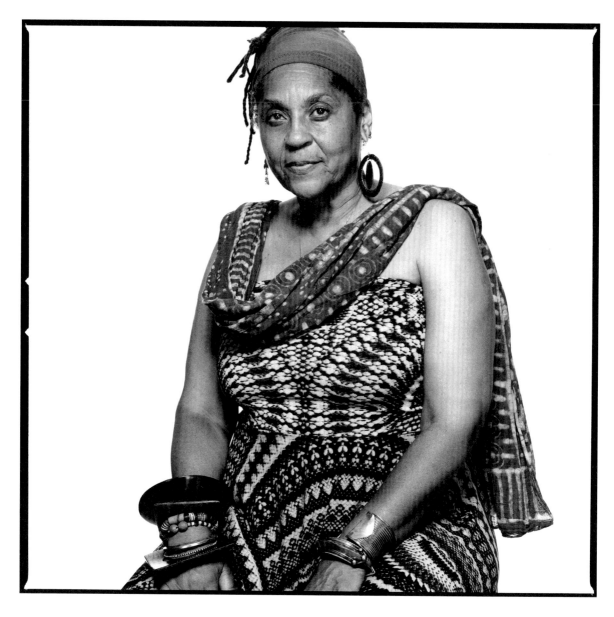

"We were blinded by our love and devotion.
I think that's what revolution is."

J. Yasmeen Sutton (b. March 10, 1950) was on the Finance Committee of the Corona Branch of the Black Panther Party in Queens, New York. Currently, she is senior accountant at the Center for Rapid Recovery, a mental health nonprofit organization in Hempstead, New York. Previously she was the vice president of finance and operations at Greenhope Services for Women in East Harlem, a criminal justice program offering alternatives to incarceration. She volunteers as the treasurer for the Finance Committee of New York state assemblyman Jeffrion Aubry and is active on the Black Panther Commemoration Committee New York, which hosts an annual film festival to raise money for political prisoners, as well as the National Alumni Association of the Black Panther Party.

UNLIKE COMRADES THAT LEFT HOME AND LIVED IN "PANTHER PADS," I never left my house and still did Panther work. I was in college at the time, and I stayed in college. Actually, I sold my papers on campus. Before classes I had a little part-time job working in a cafeteria out at Kennedy Airport. I would take the leftover bread and milk— kind of liberating it—for the breakfast program. Then after I came home from school, I went to the Panther office in Corona, Queens.

The uniqueness of the Corona Branch was that you had all different types of people. I was nineteen. Claudia (Chesson-Williams) was eighteen, but we had people who were fourteen, fifteen. There were people who followed Malcolm and others that followed Paul Robeson. Others were part of the Communist Party. There were older people and people that were part of street gangs. Then you had drug users that were cleaning themselves up down in the basement of the office who then came up as Panthers. I was a good kid who went to school. I was square. I was quiet. But there I was, because it was about the party, the injustices, and the revolution. We were all part of something.

Another unique thing about Corona was that we were involved in starting the Langston Hughes Library, not just as a library but as a cultural center as well. Members of the party were part of the committee. That was one of the things we fought for. Another thing we're proud of is getting a traffic light installed in our neighborhood, where there were a lot of accidents and hit-and-runs. People were getting killed out in the street. We ended up writing letters to

the mayor, to the traffic people. Finally, one day, we just disrupted traffic in order to get the light.

To illustrate how young we were, Omar (Barbour) and I had to open up a party bank account. We went to a bank on Jamaica Avenue, and they said to us, "Well, who's your president? Who's in charge?" We told them Huey Newton and Bobby Seale. We had no inkling. We were that young. I just knew that I was studying accounting at community college at the time and that they trusted me. So I would count the money when newspaper sales came in, write it up, and record it. That's how I really became involved in the finances for the Black Panther Party.

My first experience with a gun was going to the arcade on Forty-second Street, where you could just aim and shoot. Eventually we went out into the woods to practice. You had to learn how to shoot a gun, how to respect it. They actually blindfolded us, and we had to break a gun down and put it back together within a certain time. We were preparing ourselves for the revolution, even if it meant dying, because we knew that it was going to make a difference, that people were going to be better off.

It's interesting now when I think about how much we thought about death and dying. That's not natural with young people. But we were blinded by our love and devotion. I think that's what revolution is.

Anatomy of a Setup No. 1

As told separately by
Cyril "Bullwhip" Innis Jr., J. Yasmeen Sutton, and Claudia Chesson-Williams

Cyril "Bullwhip" Innis Jr.: Here's a story for you, and only Corona Panthers know it. As soon as we became Panthers we had an incident. It was 11:30, 12 o'clock at night, and we just came from a party at the office, brothers and sisters. We were walking down 102nd Street. Now mind you, we had just become members of the Panther Party, so we were celebrating.

J. Yasmeen Sutton: We used to be together all the time. After doing party work during the day we would sit up and drink "bitter dog" (red wine and lemon juice) and then go home. Well, one night, we're on our way home, singing "off the pig" and "no more pigs in the community."

Claudia Chesson-Williams: I was in awe of some of these people I had known all my life. They were fierce, and they were determined, and they had on their fatigues and berets. It was just wonderful to be a part of something. They were singing their songs, and I was just walking and looking and listening when all of a sudden this man pulls up, jumps out of his car, and says that he was robbed.

CI: The guy jumps out of his car with a gun, black dude. "Where y'all going?! Stop! I want y'all to stop now! Wait right here!" So we're like, "Oh shit!" He's got this gun, and I'm looking at the dude. He's got it pointed at Claudia's face.

YS: He says somebody stole his TV, record player, and all this other stuff from him.

CW: The gun was pointing right at my face, and the brothers surrounded me to protect me while they were trying to talk to him.

YS: One of the brothers named Daoud said, "Brother, we're Panthers. We don't steal from the people. If you tell us what was stolen, we'll try to help find it for you."

CI: So we're trying to negotiate with this guy, because he's got this gun out, but you could smell the liquor on him.

YS: This guy was drunk.

CW: While the other brothers were trying to talk to him to make him put the gun down, he fell. He was drunk.

CI: So, we're looking at each other, and we're looking at this guy, and I don't know how it happened—we closed in on him and hit him at the same time. We held his hand up so we could force the gun from him. We're hitting him, and as he goes to the ground, handcuffs come out.

YS: They pushed him over and took the gun, but while they were doing it, his handcuffs fell out of his pocket along with his shield. That night it was . . . they beat him up.

CW: We came to find out it was a policeman. I guess he figured if he locked up that many teenagers at one time, it would be a big feather in his cap.

CI: I see these cuffs, and I scream, "This motherfucker's a pig!" because it blew my mind. And he's there on the ground, "No, don't hit me. Don't hit me no more." Well, I wanted to do things that my comrades stopped me from doing. I was no joke. I didn't care.

YS: They took his gun and his badge and the handcuffs. They took everything from him.

CW: That's why we always said, "A pig is a pig is a pig is a pig." It didn't matter what color they were. If someone's going to brutalize you and victimize you, they are still a pig.

YS: The next day, the newspaper said young thugs had robbed this guy, but it wasn't true.

CI: When we opened up the trunk of his car, everything that this sucker said we stole was in his car! It was the first set up of the Corona Branch of the Black Panther Party.

YS: A couple of days later, some of our guys were arrested, charged with robbing the cop.

CW: Protect and serve was really not what it was about.

CI: Ronnie got picked up. They came to us looking for the gun. We knew what to do. "You let Ronnie go no charges, you get the gun

back." That's all we said, because we had already given Bill (Brownville) the gun.

CW: Mr. Brownville had us go down to the Civilian Review Board and get signatures. He said, "Let's do it by the book. Let me show you how it is with the legal system and how to do things." We did that. We did that, and nothing ever happened. Two of the brothers that were with us were on probation and ended up going back to jail because of this arrest.

CI: That was the very first litmus test for us as Panthers, and we passed. After that, they knew we were not a group to play with. To this day, every group that has worked with us knows, "Those Corona Panthers? They don't play."

YS: The interesting thing about it was that twenty years later, this same cop was killed in an illegal after-hours spot, where he shouldn't have been anyway.

CW: He got a parade. He made it all the way to gold-shield detective. But we know.

YS: It was that particular night that always made me doubt and not trust the police.

CW: That was the turning point. That's what brought me into the Black Panther Party.

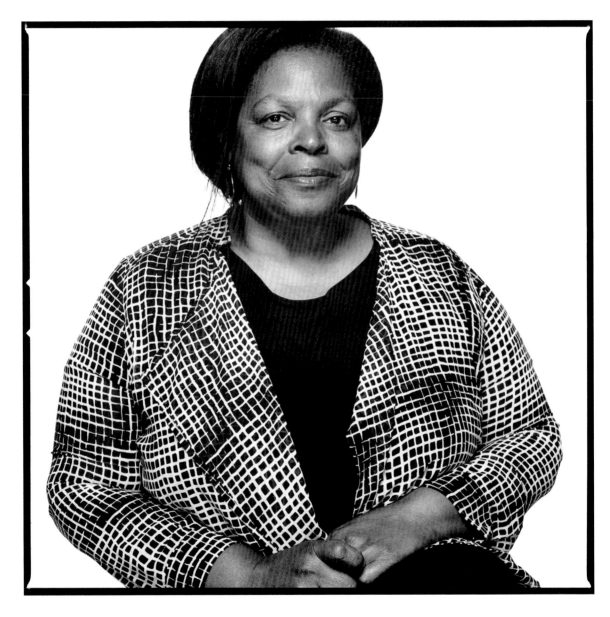

"We just had to mourn their deaths and keep going."

Katherine Campbell (b. October 8, 1951) was raised in San Francisco, where she also first encountered the party. In addition to working on the newspaper, she was a longtime worker at the Oakland Community School, where she was in charge of preparing special menus for people with allergies.

IN AN ENGLISH CLASS AT SAN FRANCISCO CITY COLLEGE, THE TEACHER asked us to write a paper on the most beautiful animal in the world. I thought, Everybody's going to write about a horse. I don't want to write about a horse. I want to write about something else. I came upon a book in the library, and on the cover was a panther, the cat. It looked fierce and scary. I read that it was very gentle and nice unless provoked, and I thought, Wow, what a good thing to write about.

So I wrote my paper on that and turned it in to my English class. When the teacher handed the papers back I didn't get mine, so I asked her, "What happened to my paper?"

She said, "Well, you have to go to the dean for your paper."

I was so excited! I thought, Oh gosh! I'm going to get credit for this. They really liked my paper.

So I go to the dean's office, and this man is sitting there furious. "What's the meaning of writing this paper? You must belong to the Black Panthers."

I didn't know anything about the Black Panthers at that time. My legs were wobbling. I said, "I just wrote it. The teacher asked us to write on an animal, and I just chose that." I got scared. I went home and told my mother, "I never want to go to college again, ever."

My sister lived across the street from Sacred Heart Church at that time. She had a couple of children. She said, "You know what? You can do some volunteer work. Why don't you go across the street to that church? They have a breakfast program. I send the kids there in the morning." I started volunteering there, and it turned out to be the Black Panthers' Breakfast for Schoolchildren Program. It was like I was destined for it, like I couldn't get away from it.

They gave me the newspaper, and I took it home and was reading it. I thought, Wow, this is what's really going on? Gosh, I guess I'm not black enough. What I mean by that was I really had all these

ideas and dreams of what I was going to be and how I was going to do it. I was going to go to university and get my degree. I was going to be really equal with people. My grandmother and grandfather had a church, and that's one thing that I did grow up in. They taught us there's no prejudice when you're Christian.

Still, I didn't know what I was getting myself into until I started working on the newspaper and I started reading some of the articles that we had to cut out and put together. They were calling the police "the pigs." Then there was the incident where the fire department came in, and they took their fire hoses and sprayed all the newspapers. We were just getting ready to take the newspapers to the airport to send them all over the world. They really destroyed them. They were really trying to break down our structure.

I was there during the time someone blew up the office in San Francisco on Fillmore Street. My husband at the time was doing security. I got a call in the middle of the night that the office had been blown up after someone had been calling just about every day for weeks threatening to blow it up. We had a big printer that wasn't being used that was blown ten feet from the wall. It blew the bathroom up right after my husband had just come out of there.

Some people thought the Panthers were nothing but a gang. I got all kinds of negative comments about it from my family. We used to get together for Sunday dinners at my grandmother's. I remember one of my cousins coming up to me. I didn't know that they had been talking about me. My cousin decided to put me on the hot seat. "Who do you think you are? You think you're real tough, don't you? You think you're a Panther. You don't know what you're doing." A lot of people didn't know that some of us in the party were catching hell from our own families for it.

The thing that I worried about a lot is that everybody hated me, but just because they didn't know what I was doing. The more I heard about us being a militant organization and a communist organization, the more I thought they were wrong. I thought, I'm in this, but I'm not a militant. My grandmother taught me to love people. People are hungry, feed them. People need clothes, if you've got any clothes to spare, give it to them. If they need help across

the street, help them across the street. All of that was implanted in me, so that kept my strength up because I felt like I wasn't doing anything wrong. At that time they didn't realize that we were really putting our lives on the line for the future.

I didn't think I was going to survive it, so I didn't have a plan for the future. I wish I had known that this was something that I was going to spend five years in and then remove myself. You couldn't do that in that type of organization or that type of movement, because you didn't know. I was there when some people died. That was scary, and we didn't have processing groups like today when traumatic things happen. We just had to mourn their deaths and keep going.

I tried to go back to school. I started going to college again. I tried to make it on my own. I sent my daughter to stay with her father for a while so I could try to get myself together. It just seemed like it wouldn't come together at all. I felt like I was too far behind in life to catch up with it. I'm homeless right now, and I thought, You know what? I did all that fighting and helping the party and fighting for rights, and I'm right back where I started.

It had a lot of meaning. I know that it did. Actually, it saved my life. I'm glad that I did it because I could see that we were laying the foundation for the future. I am grateful for it because I know at the Oakland Community School we really taught the children well. Some of those children were playing chess at five years old. A lot of them went on to universities and got their degrees. My daughter has her master's degree. I could have been a junkie out in the street and not cared about anything. I could have even been suicidal at one point. I just wanted to say that I give the party credit and Huey credit for instilling in me what it takes to be a community. I also learned a lot about history and what it means to be in a leadership position and what it means to be a good teacher.

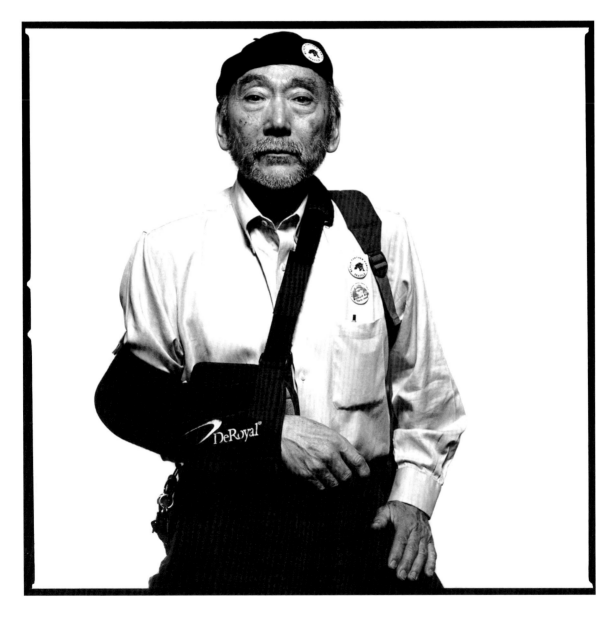

*"I never felt strange not being black in the party,
because growing up in the Central District of Seattle,
blacks, Asians, whites—we all got along just fine."*

Mike Tagawa (b. February 19, 1944) was born in Minidoka Relocation Camp in southern Idaho, one of several such camps in which Japanese citizens were interned during World War II by the US government. After being released, he and his family moved to the Central District of Seattle. He joined the US Air Force and later the Seattle Chapter of the Black Panther Party. He currently works as a bus driver for King County Metro in Seattle.

ONE DAY I WAS DRIVING WITH MY GIRLFRIEND THROUGH THE ARBO-retum, which is a park here in Seattle, and we noticed a bunch of black brothers marching around in black leather jackets, black pants, blue shirts, and berets, so we pulled into the lot immediately and watched them go through their marching practice. After it was over, one of the brothers came up to me and said, "Hey, Mike, how you doing?" It was a guy I went to school with since grade school named Bobby White.

I said, "Hey, Bobby, what the hell is going on here, man? What is all this stuff?"

He gave me a quick rundown of the Black Panther Party, a quick history and how they got started in Seattle. He ended by saying, "Hey, man, you've got to join the party with us."

I said, "You want me to join the Black Panther Party? But I ain't black."

He said, "You ain't white either."

He was right. We weren't any different in the way the larger society was treating us. Within a few days, I was up at the Black Panther headquarters in Seattle at Thirty-fourth and Union, signing up.

I never felt strange not being black in the party, because growing up in the Central District of Seattle, blacks, Asians, whites—we all got along just fine. I found this out later, but Garfield High School was the most integrated school in Seattle, and everybody from all economic classes and ethnic backgrounds lived in the Central District. We all knew each other. We all hung out with each other. We all knew about other races. We all assumed it was no big deal because that's the way we grew up.

On top of other things in the party, I taught military marching so that when we had rallies and went out into the community, we

SEATTLE CHAPTER OPENS THIRD FREE BREAKFAST PROGRAM

(Seattle, Washington) - The Washington State Chapter of the Black Panther Party recently announced the opening of its third Free Breakfast Program for Schoolchildren here. The new Breakfast Program, in the High Point community, is located at 3204 S.W. Holly Street.

Just prior to the opening of the new program, someone broke into the facilities which house the Chapter's two other Breakfast Programs. On the weekend of September 15, the Atlantic Street facility (2103 Atlantic St.) was broken into and the program's tables and furniture destroyed and the facility ransacked.

On the same weekend, the Breakfast Program facility in Holly Park (6809 32nd Ave. S.), located in a large housing project, was burglarized. Food was stolen, eggs thrown on the walls and partially cooked food left on the kitchen stove.

Despite these attempts at sabotage, all three Breakfast Programs opened at 7:30 a.m. as scheduled that Monday morning, serving hot, nutritious meals our children deserve. All three Survival Programs combined now feed 1,000 children each week.

showed discipline. It was important to look good for the community, so they could see that we had a purpose. We also wanted young brothers to know how to handle their firearms so the community wouldn't think, "Jesus Christ, these guys don't know what they're doing with

these guns. They're going to shoot somebody." That's why we used to go out into the countryside here and have weapons training, target practice, and how to carry them and handle them safely.

I joined up in 1968. We probably had several hundred people that claimed membership, though many of them were what Aaron Dixon called "Summertime Panthers," meaning they only came out when the weather was good. Even then, we easily had seventy-five people show up for marches and rallies. But by 1971, I was pretty unsure about what was going on with the party. It was on the edge. It was becoming obvious that there was a problem with dedication falling and questions as to whether or not some of the members were FBI informants. It was strange when brothers who didn't seem to know anything about the party would show up to organizational meetings or political education classes, check things out, and then leave, like they were keeping tabs on what was going on. Then there was a lot more police activity, and it was clear that it was not good, and things were falling apart. There were some things that party members were doing that were definitely not good for the party and were detrimental to relations with the community, but I don't want to talk about that. But people started drifting away, and the party fell to about a dozen members.

When I first heard that Richard (Aoki) was a snitch, I was shocked.* The more I thought about that, the more it occurred to me that Richard may have been talking to federal agents, COINTEL-PRO people. But if anything, I think he was playing them.

At first he was gung-ho US government, but as he became more politically aware, he saw that it was his friends, his neighborhood brothers and sisters who he grew up with, and even himself who were the ones being treated badly by the government.

I think he figured out early on that all he had to do was give them some bullshit information that anybody who went to community meetings and hung out in the community could pass on,

* A former soldier and prominent San Francisco Bay Area activist who provided the Panthers some of their earliest guns, Aoki was later revealed to be a longtime government informant.

and they would give him money. It was a mutually beneficial arrangement that meant nothing. And I say that confidently because Richard stayed with us. When people became informants and double agents, they gave information and then they got the hell out of there because they had given information that was going to get someone busted or killed.

But in close to half a century, while he was a member of the Black Panther Party and leading protests with the Asians at Berkeley, nobody ever got busted or hurt. He didn't do shit. I imagine he probably laughed every night after he went to sleep, for getting a few bucks from the government. Here he was, talking to the government. They give him a few bucks, and then he goes and buys a few more guns for the party.

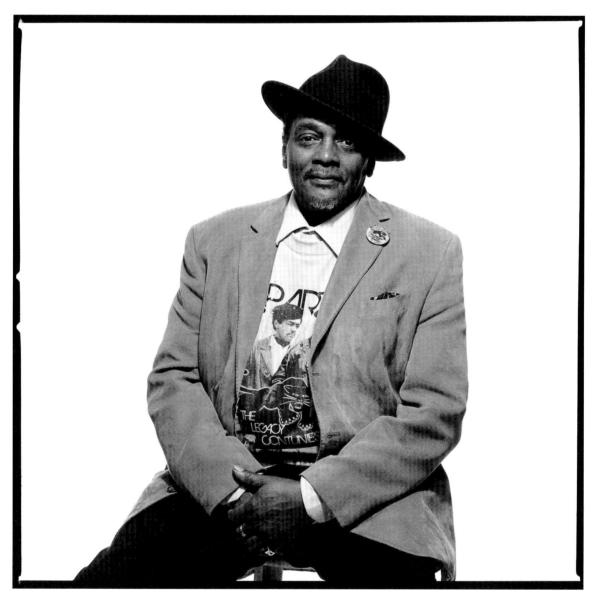

"My message was, 'Capitalism plus drugs equals genocide.'"

William "BJ" Johnson (b. March 4, 1949) grew up in Corona, Queens, where he also joined the party. Later he was the road manager for a singing group called the Variations that he says opened for James Brown, Sammy Davis Jr., and Aretha Franklin. He is part of the Black Panther Commemoration Committee New York, which hosts an annual film festival in New York City to raise money for political prisoners.

I joined the party about three different times. I was a drug dealer. I was slinging on the corner, selling heroin and shooting heroin. I was a big-time drug dealer. "Dollar Bill," that's what they called me back then, because if you were a dollar short I would let you go. They said, "Where's your Cadillac, with all these drugs you've been selling?" I rolled up my sleeves to show them my tracks. I said, "Right here in my arms." I was a drug dealer that was strung out.

So when the Malcolm X Cultural Center came around, there was this guy named Bill Brownville. He was going around talking to the young brothers strung out on heroin. He was helping them. He put them in the basement and gave them tea with lemon and helped them kick their habit. Bill Brownville came and talked to my mother. He said, "I'm going to keep him for a week right there in that basement."

While I'm kicking this habit, Eldridge Cleaver comes to town. He gave a big old speech at a school in Harlem, and everybody went. They said, "Come on! You too. You're going. All of us, the sisters, everybody." Afterward, I went back in the basement. About two days later, I came out of the basement, and the Malcolm X Cultural Center was now the Black Panther Party office, Subsection of Jamaica. I said, "What?!"

They said, "Yeah! You're a Panther now. You aren't going to shoot any more dope." So that's how I became a Panther, by osmosis.

My job was as a speaker. I spoke about the evils of drug addiction in Corona, in the same neighborhood where I used to sell. My message was, "Capitalism plus drugs equals genocide." I went to the Queensbridge (South Houses) projects, the South Jamaica 40 Houses, and I would speak about the ills of drugs. I said, "Join the Black Panther Party. They can help you kick. And a lot of you know me, man. A lot of you bought drugs from me. Look at me now."

A lot of our stuff was serious, but a lot of it was fun. My most memorable story was a benefit concert for the families of all the victims of the Attica riots. There were entertainers like Don Covay, Aretha Franklin, John Lennon, you name them, and they were there. So we get a call from Huey Newton. John Lennon was going to Harlem, so he wanted some Panthers to escort him, because he knew if he was going to Harlem with all those black people, if he had some Panthers with him, nothing was going to happen to him.

So I was assigned to him, along with Omar (Barbour), a brother named Billy King, Pete King, and Stu Albert. I think Stu was a journalist at the time, and he was the one that made the initial contact between Lennon, Huey, and the Panthers and us. John Lennon was living on Bank Street in the Village. We walked in, and he was in the basement playing his guitar, "Imagine all the people, imagine all the people in the world." Jerry Rubin* was standing next to him with the biggest joint I'd ever seen in my life. He said, "You want some, brother?"

"Hell, yeah!!" So I hit it a couple of times and turned to Lennon. I said, "John, play one of your Beatles' songs." In the middle of singing, he says, "I forgot that shit. Here, you want one of my new albums? It's coming out next week."

Here's the deal. John Lennon was told that the Panthers would escort him when he goes to meet Aretha Franklin to get her personal phone number for Huey P. Newton, because Huey wanted to call her to do a benefit concert. So that was the mission. We were all going to the Apollo!

We get to the Apollo, and we're walking backstage with John Lennon! Man, we were VIPs! Everybody was saying, "John Lennon's here!" They stuck their heads out of their dressing rooms. Don Covay stopped him on the floor, and they started playing "Eleanor Rigby," with John Lennon playing his guitar. It was an impromptu concert between these two guys on the stairs. Finally we

* A prominent social activist, Vietnam War protester, and later businessman; also one of the founders of the Youth International Party, or Yippies, which engaged in theatrical protests and pranks.

get to Aretha Franklin's room. She said, "Hey, John!" They were hugging and making small talk. John Lennon turned away, getting ready to leave. I grabbed John by the shoulder and said, "John, you forgot the phone number!"

"Oh, oh, oh, oh!"

He turns around, whispers in Aretha's ear, and I hear her say, "So let it be." She calls to her bodyguard, "Gimme a pen!" She writes down her number, gives it to John, John hands it to me, I hand it to Omar.

The concert was great, and later we all go to this restaurant with John Lennon. Before we get there, Omar whispers to us, "Don't get anything too extravagant. Just get coffee and donuts." We get in there, and the restaurant was like, "Oh! It's John Lennon!"

John says, "I need five tables." They fix the tables, and people were seeing John: "Hey, John! We're having a party over here. Come over here!"

"Alright. Ok. Ok."

The waiter gets to us. I say, "Give me a black coffee and a donut."

John looks up and looks at me, because I'm the one sitting closest to him. He said, "That's all you want?"

I said, "Yeah, man."

He said, "You sure?"

I said, "Yeah. That's all I want. Coffee and a donut."

So John Lennon turns to me, opens the menu, and said, "If there is anything on this menu that you'd really like to eat, well, what would it be?"

I said, "Well, I'd love some steak and eggs."

And he said, "Waiter! Bring him some steak and eggs."

I said, "Make my eggs over easy."

Pete King hollered, "Get me bacon and eggs."

Bill King says, "Get me steak and eggs too."

We were not looking at Omar. We just ordered.

Like I said, we had a lot of fun, but I look at the fiftieth anniversary with great sadness. I'm lucky to be alive, but at that time I was willing to die for the people. The NAACP is still an organization. (Marcus) Garvey's organization is still going, and they still

have members. So are the Black Muslims, and they were attacked by the FBI. But our organization, the greatest organization for black people, was actually destroyed by this government. There is no longer an organization called the Black Panther Party. People get mad at me when I say I'm a former member of the Black Panther Party. They ask, "Why do you say that?" Because the organization does not exist any longer. I look at this with sadness coming up on the fiftieth anniversary, that the government was allowed to destroy this great organization that I was part of.

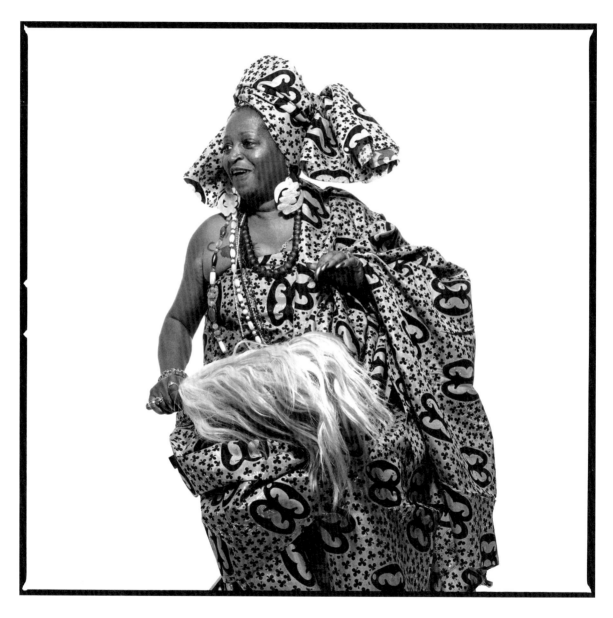

"I tell people that comradeship doesn't come any deeper than that with my comrades in the Black Panther Party."

Nana Ohema Akua Anum Njinga Onyame Nyamekye (formerly Patti Byrd, b. May 27, 1952) joined the Baltimore Chapter of the party, where she was a rank-and-file member. She later became an emergency medical technician (EMT) and worked in the emergency room and cardiac unit of the Johns Hopkins Hospital in Baltimore. She retired from the federal government, where she assisted mothers with drug-exposed newborns, and is a board member of the National Alumni Association of the Black Panther Party.

I'M FROM MCKEESPORT, PENNSYLVANIA. GROWING UP THERE WAS wonderful. My parents, Nora and Elmer Byrd, provided me with a strong foundation and political awareness. My father worked and was an activist in National Tube Works, where he developed the lung cancer and heart disease that killed him.

A girl I met in 1969 while attending Strayer College (now University) in Baltimore introduced me to some Baltimore Panthers, and I joined. I was rank and file. I sold the Black Panther Party newspapers, attended and taught political education classes, worked at the free health clinic in Baltimore, and worked for the breakfast program collecting donations and food. I was the East Coast food coordinator for the Philadelphia People's Constitutional Convention, along with sister Rosemari Mealy, and did any duties assigned to me, which included at the office and community service.

I remain in contact with many of my Panther comrades all around the United States and internationally. I work on behalf of the political prisoners that are still locked in the belly of the foul prisons in the United States and my exiled comrades. I tell people that comradeship doesn't come any deeper than that with my comrades in the Black Panther Party, and my life commitment is to my comrades.

The Black Panther Party did not change me; it greatly enhanced the foundation that my parents placed under my feet. Serving the people body and soul has been my honor. My love for the Black Panther Party has been filled with life lessons that have stayed with me. The Ten-Point Platform and Program and the Eight

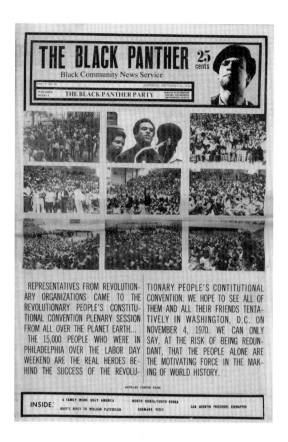

Points of Attention* are still as valuable today as they were then. I hold tight to my memories of our united struggle and continue to actively struggle even today. Until recently, I worked with women who have given birth to drug-exposed newborns. I help them get the help they need to reunite with their children and stay in a drug-free, safe environment. I am an Akan priest and the chief priest of Ohene Kra Konmude Shrine House, where I serve my community and mentor others in the ways of traditional spirituality.

This has been very hard to do because I find it hard to open up publicly. I have always been a humble person and always do what I do for the betterment of humanity. I see what I do as my purpose, the job required of me in this life.

* Mao Tse-tung, considered the founder of the People's Republic of China, issued the Three Rules of Discipline and Eight Points of Attention to the Chinese Red Army as guidelines and restrictions on their behavior, especially toward civilians, who were to be treated fairly and respectfully during wartime.

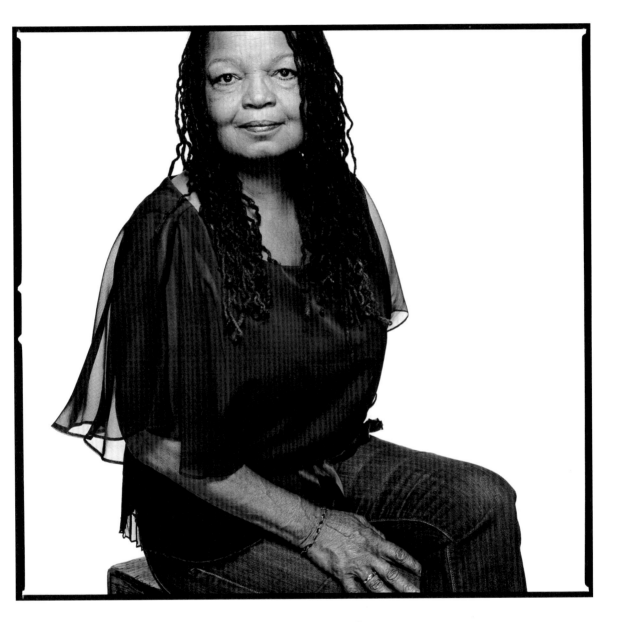

*"It wasn't hard to join. It took more courage
and more heart to leave."*

Madalynn "Carol" Rucker (b. May 5, 1950) was born in New York, grew up in Los Angeles, and joined the party in San Francisco. She later completed a master's of political science/public administration at Stanford University and worked for San Mateo County in employment and training services, followed by the Community Services Planning Council in Sacramento. She is the founder and executive director of ONTRACK Program Resources in Sacramento, which consults with community-based and local agencies on strengthening their services for disadvantaged populations.

It did not take a lot of courage to join the party. It felt very right. I just felt very fortunate that I was hearing something that spoke to me, and I had somewhere to put my passion and frustration and disillusionment with the way things were going. I couldn't understand how people couldn't get involved in what we were dealing with, watching our actual classmates coming home in body bags after Vietnam and the party leaders getting shot one by one by the police. I was in LA during the Watts riots too, so it was just a perfect storm of events. It wasn't hard to join. It took more courage and more heart to leave.

Central newspaper distribution was in San Francisco at the time on Fillmore Street. The printing press was there, and we did runs to the airport to distribute the paper all over the country. That was a lot of the income that supported the chapters because the majority of us did not have jobs. These were our jobs, and that's how we brought in money, along with selling Red Books, buttons and posters, and Emory's artwork.* Those were good times. Those were the best of times.

It was pretty magical in the early days because there was a lot of support and commitment and love and passion and admiration for the work that we were doing. We definitely had our share of run-ins with the police and got picked up for various stuff like disturbing the peace, or if we were selling papers in places and they tried to get us to move on. Always the police were patrolling.

* Emory Douglas was the party's minister of culture. His iconic artwork became a mainstay of the *Black Panther* newspaper.

We had a lot of scares here and there and had to pull extra security depending on what was going on, because you did have a sense that there was going to be a vamp (attack) on a house or an office. You might sleep for three hours and get tapped to do security for the next two to three hours, and you were lucky if you were able to lay back down again, but usually by then it was time to get up at 5:00 in the morning to get ready for the breakfast program. Then we went back to the office and did distribution work all day and cooked dinner for everyone. We also had physical education and we had political education classes and we had technical education, learning how to shoot and break down guns. We worked a lot but it was good work, it was great work. Honestly, it was the best job I ever had.

We were passionate about it, and we were very much aware of the importance of what we were doing. When you joined the party, and you were there for a while, you gave up everything for the most part, your family, the friends you had. The party became your family. We had to protect each other and our facilities and our families. If you were in those spaces for any length of time, you knew that you were putting your life at risk, so most took it very seriously.

Not that everyone loved each other, but we loved and respected that bond. We were brothers and sisters and lovers, and we were in that very vulnerable situation together, not unlike soldiers. You just trusted that people would have your back, and you had to be willing to have theirs because you never knew when you were going to get calls or something might happen.

It was truly the most liberating experience of my life. It was just such a transformation to give up everything that you thought was important, any material possessions, and just be totally committed to the party and to the experience. It was the closest thing to freedom I think I ever will experience.

I do remember after the "split"[†] it feeling somewhat surreal, particularly in San Francisco because we had such close relationships

† The "split" refers to the acrimonious and volatile rupture of the party in 1971 over its future direction, with Huey Newton emphasizing the party's "survival (programs) pending revolution" and Eldridge Cleaver demanding immediate and violent revolution.

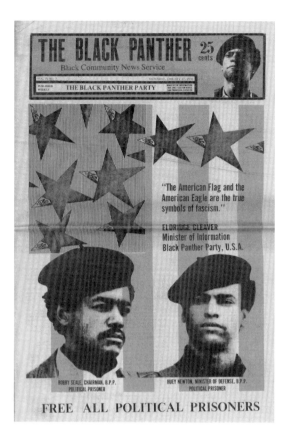

with the comrades there, and because Eldridge worked out of San Francisco. It was a moment of just pure agony that this was occurring, and what it meant was that basically you lost half your family.

We got bombed after the defection—that's what we called the split—and I believe it was part of the defection rather than the police, but who knows now because through the FBI Counterintelligence Program (COINTELPRO) they might have made us believe that. We had no idea. We had a big hole in the back of the Fillmore office for a while and had to pull security sitting in a big hole.

That was a very difficult time, and I remember someone saying to me—I believe it was Ellis White—that one of the most significant times for him that really showed him who I was and how strong I was, was when everyone was wringing their hands and going, "Oh, my God. What's going on here? How are we going to deal with this?" I got up and went and ripped Eldridge's poster off of the office wall. After that people started moving on. I did not remember that

happening as clearly as he did, but when he shared it with me, it reminded me that it got the office unstuck. It was a deciding moment where you either needed to move forward or you were gone.

There was a lot of paranoia after that. We know now that a lot of the initiating factors came from COINTELPRO. There's definitely evidence that that was exactly what was intended to happen—to turn us against each other—and it becomes clearer all the time as information comes out and people come forward. We were very unprepared for it, and the paranoia that it created really took away from the work we were doing because after a certain point I was almost as concerned about being harmed by ex-Panthers who defected as I was by the police, because they were dangerous and we were dangerous as a divided force. We not only had to deal with the police, we now had to deal with very strong-willed and in many cases much-loved people who thought they were doing it for the right reasons.

Though we had guns, and we continued to learn how to use them, they weren't essential after a certain point. I think they played an important part in the timing and history to show people they had a right to stand up and arm themselves, but after a while they put community folks in more danger than they were in before, and we wanted to shift into helping the community and at the same advocate for our right to self-defense. We didn't want it to be all about the militaristic side because the community had become occupied by police 24/7 because of the work we were doing. We needed to regain some of the trust. Even community folks who had poured into the streets to support us when there was some sort of showdown with the police started becoming afraid. They were in a community that was even less safe than it was before the party, and we didn't want that either. That was the basis of, at least we thought, the basis of the split—that Eldridge and those who defected thought that we were getting soft and moving away from the reasons that the party started. That was a challenge because it didn't mean they were bad folks and we didn't love them, we were just in different places. But again COINTELPRO did everything they could to create that divide, and they were successful, and we had no comeback for it. We weren't prepared. We couldn't survive that.

To Live for the People
The Rank and File and the "Histories" of the Black Panther Party
Yohuru Williams

I grew up in Bridgeport, Connecticut, about twenty minutes south of New Haven, where in 1970, the year before I was born, leaders of the Black Panther Party went on trial for murder. Various Panthers were accused of involvement in the killing of Alex Rackley, another Panther, on suspicion that he was a police informant. Several Panthers admitted to pulling the trigger. But on flimsy evidence, prosecutors accused Panther leaders Ericka Huggins and Bobby Seale of ordering the killing. Beneath all the legal wrangling and headlines, the New Haven trial was a trial of the party itself.

On May Day 1970, some 15,000 Black Panther Party supporters gathered in New Haven to protest the trial. Fearing violence, the White House dispatched 4,000 members of the National Guard, reinforced by state troopers. Yale president Kingman Brewster, who opened his campus to the protesters, said, "I am skeptical of the ability of black revolutionaries to achieve a fair trial anywhere in the United States." Eventually, a jury acquitted Huggins and Seale, and the judge said he would not retry them because it would be hard to find an impartial jury. In spite of the concerns expressed on both sides, the system worked, and New Haven remained safe. As much as a trial, the proceedings proved to be a clash between competing narratives of crime and punishment as well as democracy and justice. Although the Panthers won in court, their image as a violent and dangerous menace was fixed in the public imagination.

I didn't know any of that at the time. My father, an artist and musician, made collages from the newspaper clippings from the trial, and I first read about it in the yellowing scraps of his work. I was fascinated by one article in particular, featuring a photograph of Huggins, the leader of the New Haven Chapter of the Panthers, sporting a towering Afro, seated in court. She looked like some of

my neighbors or older cousins—not a threat. Of course, I had questions. My parents tried to answer them. Although my mother, a day-care teacher, proudly recalled watching my father play African drums for a benefit for the Panthers in Boston, there was also an element of fear in the way she talked about the party. She seemed to approve of the Panthers' activities, but still I got the impression that affiliation with the party was dangerous. Those fears were partly confirmed in 1986 when a former self-proclaimed Panther named Lawrence Townsend gunned down the head of an antipoverty program in the same building where my father worked. Although the killing took place more than a decade after Townsend's affiliation with the party, newspapers' accounts of the murder, complete with his scowling image, referenced his former association with the group as if it were an essential part of his crime.

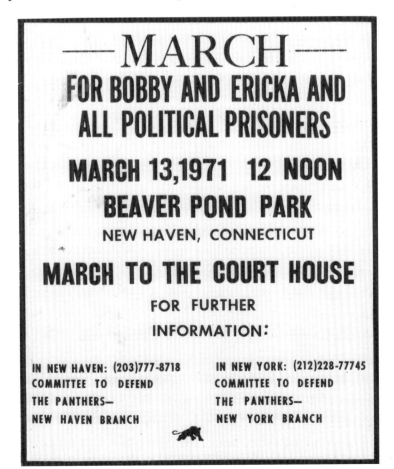

I thought back to the picture of Ericka Huggins. I had trouble reconciling her face with what I had read and been told. She didn't look dangerous. I also remembered a few former local Panthers I'd met, including a firefighter and civil rights activist Craig Kelly, who talked about the work of the party during meetings of the African Guides, a local rite-of-passage group for young men of color I attended. They didn't look dangerous either, but they alluded to the government's record of violence against them. They talked about themselves as community builders, but outsiders feared them or called them violent. I wanted to know why.

When I was in college, in 1993, I wrote my senior thesis on the Black Panther Party. I found most journalistic accounts focused on the national organization, and I finally began to understand the perception of fear that followed the party. Even sources friendly to the Panthers played up their angry rhetoric and violent encounters with police. Furthermore, accounts of crimes and abuses by leaders such as Huey Newton and Eldridge Cleaver "seemed" to justify government repression, including FBI director J. Edgar Hoover's wildly overstated designation of the Panthers as "the single greatest threat to the nation's internal security." When I returned to the Panthers as a topic for my dissertation for a doctorate in 1996, I decided to focus on the Panthers of New Haven as a new way to tell the story of the party. Over the course of my research, I developed a deep respect for the members the Panthers called the "rank and file," the dedicated activists who carried out the day-to-day functions of the party—the women and men unheralded in national accounts who formed the backbone of the party. It became important to understand their stories both as connected to and distinct from the top-down narrative of the history of the party.

That narrative tends to privilege the history of the founders, college students Huey Newton and Bobby Seale. They formed the Black Panther Party in Oakland, California, in 1966, viewing self-defense as a means to resist police violence. At the peak of their activism, mainstream authority figures such as the president of Yale and the judge at the New Haven trial might have appreciated aspects of their program as legitimate responses to deep-seated

racial inequality. The media, for their part, fixated on the Panthers' clashes with the police, which have shaped the popular understanding of the party ever since. Television cameras, for instance, were on hand to capture many of the dramatic moments in the party's history, but from the perspective of the journalists, not the Panthers. The day-to-day life of the party attracted fewer viewers—as members printed and disseminated newspapers; provided children breakfast; organized schools, ambulances, and buses for prison visits; and met with multiracial coalition partners. The media focus on the charismatic, erratic, and combustible Panther cofounder Huey Newton reinforced the image of the Black Panther Party as a violent, antiestablishment, extremist organization. Today, any mention of the party is shorthand for violence. When Hillary Clinton ran for the US Senate, for instance, her opponents tried to discredit her by spreading a false rumor that as a Yale law student, she volunteered for the defense at the Panthers' trial. Sympathizing with the Panthers, her detractors assumed, meant she was an apologist for their violent rhetoric.

While writing my dissertation, I encountered a very different history. I came to appreciate the importance of the muted voices of ordinary members of the party and how documenting their stories and experiences both complicated and deepened the party's history. I became convinced that the best way to understand the Black Panther Party was through the perspectives of these members, not the party's founders. For me, the question is how we might glean from the individual stories of the Panthers a more nuanced portrait of the party than the one featured in the dominant narrative. Such a portrait would balance the fear the Panthers inspired with the complex mix of trauma and love that drove their activism—a nonidealized or vilified history that would reflect conflicting portraits of the party that could incorporate the experiences of an Ericka Huggins, a Huey Newton, and a Lawrence Townsend. It is the question I first posed, hazily, as a child, and one that this book of portraits and interviews brings us closer to answering.

The work of the founders, to be sure, was essential. Huey Newton and Bobby Seale's fearless stance against police brutality

launched the party into existence. Soon after, Eldridge Cleaver, his mind "blown" at seeing Newton draw his gun in a confrontation with Oakland police, joined the party and became its chief scribe and public voice. Cleaver's fiery rhetoric along with the iconography of the party, including a widely circulated image of Newton seated majestically in a wicker chair with a shotgun and a spear, sparked awe, fear, and imagination. To most outsiders, this was the essence of the party.

Yet many Panthers active in local chapters projected their own vision of black liberation onto the canvas of the Black Panther Party. Others never wholly bought into the Panther program or were drawn in by the uniforms and guns but proved largely unprepared for the more quotidian work of the party. Still others recognized the party's limitations but saw it as the best option for revolutionary change. Few party members joined with the illusion that the party was perfect. Some remember the work fondly. Others note that the work was hard and unity, at times, elusive. At the end of the day, what truly drove people to give their lives to the cause was a profound sense that they were making a difference. As Panther Hazel Mack observes in these pages, many felt that at least they had taken an active stand against injustice.

The party achieved this not on a grand national stage but in local spaces beyond the scope or interest of the press. Panthers, for instance, helped install traffic lights in West Oakland; set up free transportation for the families of the incarcerated in Milwaukee; and established People's Free Medical Clinics in thirteen cities, including Baltimore and Los Angeles. These victories did not capture headlines, but they did transform lives and communities. The Free Breakfast for Schoolchildren Program enlisted Panthers every day in dozens of cities across the country and became a blueprint for the federal government's school breakfast and lunch program. Still, it can be difficult to assess the overall impact of the party without the clear national benchmarks for success of civil rights campaigns that sought to desegregate lunch counters or solidify voting rights. There was no single goal except for a hazily defined "revolution," and with the loose organizational structure of the party, we were

left with different people in different places enacting the Panthers' official Ten-Point Platform and Program in different ways. As these interviews show, there is no single, national Panther history but rather myriad Panther histories.

What these histories have in common is the manner in which local activists under the aegis of the BPP responded to poverty and racial inequality. The Black Panther Party emerged in the wake of post–World War II deindustrialization. A massive migration of African Americans from the South to the North and the flight of middle-class, white city dwellers to the suburbs left many cities with significant numbers of poor, black migrants without access to stable and gainful employment. The cities themselves felt like occupied territories, where contact with the government was limited to a slate of declining social services and encounters with the police. Compounding the indignities involved in applying for and maintaining eligibility for public assistance, social welfare programs seemed like a trap that mocked people's desire to live free of grinding poverty and governmental intrusion.

Ordinary people were attracted to the party because of their own disquieting experiences with American apartheid. No matter what their educational level or socioeconomic background, they encountered a stark, separate-and-unequal racism in military barracks, on college campuses, in hotels and restaurants, in their jobs, and on the streets. This reality belied the progress of the civil rights movement in winning the Civil Rights Act of 1964 and the Voting Rights Act of 1965. The Black Panther Party Program offered a clear response.

Often lost in the discussion of the violence between police and Panthers, of course, is the Panther Party's full Ten-Point Program. The implementation of the program evolved over time, including demands for self-determination for black communities, full employment, reparations for slavery, decent housing, education that reflects black history, an exemption for black people from military service, self-defense for black people from police and their brutality, freedom for incarcerated black people because of the racism of the criminal justice system, black juries for black defendants, and a

general declaration to address the anomaly of poverty in the midst of an affluent society: "We want land, bread, housing, education, justice, and peace." Beyond police brutality, this was an effort to confront all forms of inequality.

In the fall of 1968, the Panthers moderated their position on self-defense in favor of a new set of community "survival programs" designed to "serve the people" by addressing critical needs in poor, black communities. These survival programs, and later efforts to create parallel institutions such as the Oakland Free Community School, were ultimately attempts at "survival pending revolution," operations to meet the basic needs of people until the Panthers could achieve a moment of a deeper social and political transformation. Political education classes were a staple at local Panther offices, to help those living near the margins in the United States see themselves as part of a much larger struggle against colonialism and capitalism. But the emphasis on social programs also set off a rift within the party, between those who imagined the Panthers as the vanguard of a coming armed revolution and those who embraced the social programs as a productive way of building revolutionary consciousness and organizing people in struggle.

It is problematic to view the history of the party solely as a response to repression, for as the interviews in this volume attest, love was also a powerful motivating factor. A love of a people, a love of peace, and a deep desire for social justice compelled much of the Panthers' work, as evidenced by the community service programs that occupied much of the party's attention. As Panther Yasmeen Sutton recalls, "We were blinded by our love and devotion. I think that's what revolution is."

After the party shifted its focus away from self-defense, a significant Panther underground continued to engage in revolutionary activities, purportedly to support the party but bringing the organization under even more intense scrutiny from law enforcement agencies. The 1968 split between Huey Newton and Eldridge Cleaver exacerbated the problem, further dividing the party and serving as a convenient tool for mischief making by police and agents provocateurs. The organization came close to internal warfare, and many

Panthers defected. The story often told about this split hones in on the drives and foibles of the party's leaders but not on the experience of the vast majority who joined the party's ranks in search of an alternative future. In these pages many of these rank-and-file members seek to share their stories for the first time.

In spite of the explosion in scholarship since I first sought to understand the BPP nearly twenty years ago, the "true" Panther history remains untold for rank-and-file members, primarily because—with few exceptions—they are unable to see themselves or their stories in the top-down narratives of the party. These Panther members talk not about memory, or history, but about "telling the truth" about what happened to them. Truths, however, are intensely personal and highly individualized.

Many Panthers, for example, were attracted by the party's message of self-defense and joined after troubling encounters with the police. This was the case with Elbert "Big Man" Howard, who officially became a member after he was stopped for a parking infraction, challenged police for singling him out, and was charged with disorderly conduct and resisting arrest. These moments of "radicalization" appear in many accounts in these pages as flashes of inspiration when people elected to join a cause bigger than themselves and dedicated themselves to fighting for justice and equality. Military service had a radicalizing influence on others. The military brought not only discipline but also the conundrum of fighting for a nation whose black and white citizens were not entitled to the same rights. In his 1978 autobiography, *A Lonely Rage*, Bobby Seale reveals that a "bad conduct" discharge ended his time in the Air Force, leaving him with indelible memories of racism and discrimination at the hands of his fellow airmen and nagging questions about the ethics of serving as an agent of US imperialism. Others had experiences that translated more directly into their work with the party. Florida native Esutosin Omowale Osunkoya (born Charles Brunson) also served in the Air Force but after his discharge settled in Sacramento, where he emerged as the driving force behind the Sacramento Branch of the Black Panther Party and used his military experience in defense of its headquarters.

Some of the Panthers who tell their stories here were also deeply involved in activism for prisoners. The party, for instance, played an important part in mounting a defense for Joan Little, a twenty-year-old African American woman who stabbed and killed her sixty-two-year-old white jailer, Charles Aligood, after he sexually assaulted her. In a precedent-setting verdict a mixed-race jury found her not guilty by reason of self-defense. As Panther Larry Little notes in his interview, the Panthers were an integral part of her defense. They helped to raise money to provide legal assistance for her while she was incarcerated and during the trial.

Prison also had a radicalizing influence on some Panthers, exposing them to radical politics by highlighting the racial and economic disparities in the sentencing and treatment of prisoners. Although these experiences often fed activism, they also left the subjects deeply damaged. After being cleared of murder charges in the shooting of Officer John Frey in 1969, Huey Newton returned to the party a shadow of himself. As several of the interviewees explain in these pages, the person who emerged from the California penal system was not the same dedicated activist who had collaborated with Bobby Seale in the formation of the Black Panther Party in 1966. They were forced to grapple with the person he became and how his changes affected their work in the party.

Gender issues also complicated the party's work. Despite the highly masculine image of the party, women accounted for as much as 60 percent of the party's membership. Women joined the party in large numbers, finding an organization willing to acknowledge gender equality in the abstract and place several women in top positions—even if this did not always result in tangible changes in expectations for women in the rank and file. As historian Rhonda Williams has noted, women navigated the double bind of addressing racism and sexism, and they also were the driving force behind many of the party's social programs.

Fifty years after the party's founding and beyond, the Panthers live in a world that continues to draw inspiration from their struggles in addressing similar forms of inequality. During the 2016

Super Bowl half-time show popular recording artist Beyoncé paid homage to the Panthers in a provocative performance that connected the party's history to the more recent #BlackLivesMatter movement, which has again focused national attention on police brutality against people of color. But even this is not new. In 1989, the politically conscious rap group Public Enemy conjured shades of the Panthers in its song "Fight the Power," with the lyric "Power to the people no delay." The following year, hip-hop artists Brand Nubian, in the song "Concerto in X Minor," invoked the murder of Huey Newton along with the killing of New York teen Yusef Hawkins by a white mob in Brooklyn to condemn the "false compassion" of police officials at a memorial rally who "tried to bash in our brains." "Further adding to the bloodstains," the group's front man rhymed in earnest:

"I was mad at this news and so was my brothers
And I wanted to get violent but I'm a lover of black mothers
And black mothers need sons
Not children that's been killed by guns."

Many of the women and men profiled in this volume might see themselves and their work for the Panthers in this riff.

October 2016 marked the fiftieth anniversary of the founding of the Black Panther Party. Fifty years later, the revolution looked very different to many onetime members of the party. I look at their faces in the moving portraits by Bryan Shih, and I think of Ericka Huggins's face in the picture I saw in the newspaper so many years ago, the one that intrigued me with its familiarity and approachability even as it seemed surrounded by a sense of myth and danger. The portraits and interviews in this book represent a powerful form of testimony. Now long removed from the sense of danger, these former Panthers are climbing out from the myths to describe the realities of their ideals and their lives.

They might be distant from the revolution in the 1960s and 1970s, but many have brought a sense of that fight into the lives

they lead now as community organizers, teachers and professors, artists and social workers, and representatives in elected office. The Black Panther Party marked them and the course their lives would take, just as they and their lives shaped the Black Panther Party and the story we are only beginning to tell about it.

Yohuru Williams is professor of history and dean of the College of Arts and Sciences at Fairfield University. He is the author of *Black Politics/White Power: Civil Rights Black Power and Black Panthers in New Haven* (Blackwell, 2006), *Teaching U.S. History Beyond the Textbook* (Corwin, 2008) and *Rethinking the Black Freedom Movement* (Routledge, 2015). He is the editor of *A Constant Struggle: African-American History from 1865 to the Present—Documents and Essays* (Kendall Hunt, 2002) and the coeditor of *In Search of the Black Panther Party: New Perspectives on a Revolutionary Movement* (Duke University, 2006) and *Liberated Territory: Toward a Local History of the Black Panther Party* (Duke University, 2009).

CHAPTER TWO

THE PEOPLE ARE MY STRENGTH
COALITION BUILDING IN THE BPP

FAR FROM ITS IMAGE AS A BLACK NATIONALIST OR ANTIWHITE ORGANI-zation, the party fought oppression on many fronts and came to see itself as the "vanguard" of revolutionary struggle. As such, it appealed to, drew from, and allied with a multitude of racial groups, labor unions, prisoners, and even revolutionary movements outside America. BPP political education classes focused not only on problems in the United States but also on global social, economic, and political issues. Panthers sought to apply the lessons gleaned from third-world revolutionary struggles to the inequality they faced at home. Members often found sound, if unlikely, partners in church and civic organizations that supported the party's community service programs. Inspired by the Panthers, a number of foreign and domestic organizations, such as the Puerto Rican Young Lords Party, adopted the Panthers' revolutionary style and platform in an effort to combat similar oppression in their own communities and in the nation's prisons.

"That was the whole idea of being the vanguard of
the revolution: we looked out for other ethnic groups
and organizations. It's just about being fair."

Atno Smith (b. April 28, 1953) grew up in Newark, New Jersey, and joined the party as a "Panther Youth." After his time with the party, he went to work for the Central Railroad of New Jersey (now part of Conrail). He became president of the United Railroad Supervisors Association, which later merged with the United Transportation Union. He also worked for the Federal Railroad Administration of the US Department of Transportation, investigating the safety of railroad workers.

I became a Panther in the summer of 1968. At fifteen, I was one of the younger members. Captain Nicholas was the chapter head, and Ali Bey (Hassan) of the Panther Twenty-One was also one of the leaders. He was originally from Newark.

We were basically in high school, and we couldn't be like the adults, who were working for a living. When calling upon someone for a task, the officers knew exactly who had the ability to do what—whether it was taking a family down to the welfare office or trying to get public or private housing for a homeless family. I was given the responsibility of finding places where we could print literature. I used to track down copy machines and paper. If a church or any other facility had the means of printing literature, I knew how to get it printed.

High school was also a political situation because before I joined the Black Panther Party, we had organized a Newark Student Union to take up antiwar issues. We made alliances with the local Youth International Party (Yippie) group and Students for a Democratic Society (SDS), and we were able to bring out a massive amount of people from the universities and the community. We shut down a lot of the high schools and brought out a lot of those students too. Not only did we educate them about imperialism but we also shut down the commercial district in Newark over the US Army in Cambodia and the escalation of the war.

For some people, it was strange to see black groups and white groups and Latino groups working together. Newark was a segregated town. But there was a natural alliance with the Latino groups; we always had a good relationship with the Young Lords chapter in Newark. We formed coalitions with the white radical groups to bring out more people so that the Newark Police Department and the National Guard wouldn't have any opportunities to beat up on

individual people. We had strength in numbers. Amiri Baraka's people said that the whites were using us. We said in fact it was the government that was using us—they were recruiting and drafting blacks into the army. Meanwhile, in the United States, black soldiers didn't have the rights that white soldiers had.

One of my best friends, Joe Myron, was the president of SDS. I met him on the Rutgers campus in Newark. He was also a well-known friend of several Panther leaders in New Jersey. He brought together the Yippies and the SDS. He also brought out the Youth League and the Socialist Workers Party. They had ideological differences over Trotsky and Marx, but he was able to figure it out and bring them to the table to mobilize the antiwar movement.

I was active as a Newark Student Union member and as a member of the Black Panther Party Newark Chapter. The unifying factors among all these diverse coalitions were antiwar and also civil rights because I felt that the foundation of the Black Panther Party was built on the whole idea of fighting against the war in Vietnam, along with the civil rights struggle. I thought that Martin Luther King Jr. had reached a limit. Requesting your rights is one thing, but demanding your rights, like the Black Panther Party did, is another.

As a coalition, we took over the Essex Newark Legal Services Board because the people that were running it didn't have the interests of the people at heart. All they were interested in was going to conferences and traveling on legal services funds, when in fact, the organization was created to give legal advice and to help poor people with their issues. We went into the board meeting and had to literally threaten people that if they were not going to work for the people, then they should resign. We got enough votes to elect a young law student as director, and we were able to also facilitate with more community groups. There weren't any Latinos on the board, so we got the first Latino on the board. We also had to make sure that they recruited Latino attorneys that could communicate with the Latino population.

That was the whole idea of being the vanguard of the revolution: we looked out for other ethnic groups and organizations. It's just about being fair.

"We had comrades all over the country who helped us in so
many ways. It was a modern Underground Railroad."

Charlotte "Mama C." O'Neal (b. March 9, 1951) joined the Kansas City Chapter of the party, but not long after fled the United States with her husband and chapter founder Pete O'Neal, after he was convicted of transporting a gun across state lines. They currently reside in Tanzania, where they created the United African Alliance Community Center, which offers a variety of arts and educational programs. She is a musician, poet, speaker, and writer.

WHEN I WAS SEVENTEEN, I JOINED THE KANSAS CITY SCHOOL OF Human Dignity, and we started exploring African history. Of course, the civil rights movement was going on. Then I started seeing these images of the Panthers on TV and in the newspaper just about every day. It was just a really exciting time. I always have to laugh about this, but seeing the brothers in their black leather and their shades and their berets, they looked really good. Then, when I started hearing about the community service programs, that just cinched it for me.

I was in the twelfth grade actually, and I started skipping school to go to the Panther rallies. Then I started visiting the Breakfast for Schoolchildren Program and hanging out when I could at the Panther pads. I literally ran away from home to start living in the Panther pads. After I got my political education, training, and all the other things you had to do, I signed on the dotted line, and I was in.

That's when I met Brother Pete. He was the founder and chair of the Kansas City Chapter. I had cut out clippings from local newspapers of him and the other brothers announcing the formation of the Kansas City Chapter and had them on my wall. I never thought that I would actually meet him. To think that, here it is forty-six years later, and we're still together.

When he met me, I was being disciplined along with some other young Panthers for breaking some of the rules. To put it mildly, you were not supposed to be high during party business, and there were several of us who were zonked out of our heads. We had to do calisthenics in front of the whole community and carry each other on our backs. Then we had this little cabinet that was used for a kind of holding cell, and we were locked up in that for several hours. We were so zonked, we didn't know what was going

RULES OF THE BLACK PANTHER PARTY

CENTRAL HEADQUARTERS
OAKLAND, CALIFORNIA..

Every member of the BLACK PANTHER PARTY throughout this country of racist America must abide by these rules as functional members of this party. CENTRAL COMMITTEE members, CENTRAL STAFFS, and LOCAL STAFFS, including all captains subordinate to either national, state, and local leadership of the BLACK PANTHER PARTY will enforce these rules. Length of suspension or other disciplinary action necessary for violation of these rules will depend on national decisions by national, state or state area, and local committees and staffs where said rule or rules of the BLACK PANTHER PARTY WERE VIOLATED.

Every member of the party must know these verbatum by heart. And apply them daily. Each member must report any violation of these rules to their leadership or they are counter-revolutionary and are also subjected to suspension by the BLACK PANTHER PARTY.

THE RULES ARE:

1. No party member can have narcotics or weed in his possession while doing party work.

2. Any party member found shooting narcotics will be expelled from this party.

3. No party member can be DRUNK while doing daily party work.

4. No party member will violate rules relating to office work, general meetings of the BLACK PANTHER PARTY, and meetings of the BLACK PANTHER PARTY ANYWHERE.

5. No party member will USE, POINT, or FIRE a weapon of any kind unnecessarily or accidentally at anyone.

6. No party member can join any other army force other than the BLACK LIBERATION ARMY.

7. No party member can have a weapon in his possession while DRUNK or loaded off narcotics or weed.

8. No party member will commit any crimes against other party members or BLACK people at all, and cannot steal or take from the people, not even a needle or a piece of thread.

9. When arrested BLACK PANTHER MEMBERS will give only name, address, and will sign nothing. Legal first aid must be understood by all Party members.

10. The Ten Point Program and platform of the BLACK PANTHER PARTY must be known and understood by each Party member.

11. Party Communications must be National and Local.

12. The 10-10-10-program should be known by all members and also understood by all members.

13. All Finance officers will operate under the jurisdiction of the Ministry of Finance.

14. Each person will submit a report of daily work.

15. Each Sub-Section Leaders, Section Leaders, and Lieutenants, Captains must submit Daily reports of work.

16. All Panthers must learn to operate and service weapons correctly.

17. All Leadership personnel who expel a member must submit this information to the Editor of the Newspaper, so that it will be published in the paper and will be known by all chapters and branches.

18. Political Education Classes are mandatory for general membership.

19. Only office personnel assigned to respective offices each day should be there. All others are to sell papers and do Political work out in the community, including Captains, Section Leaders, etc.

20. COMMUNICATIONS — all chapters must submit weekly reports in writing to the National Headquarters.

21. All Branches must Implement First Aid and/or Medical Cadres.

22. All Chapters, Branches, and components of the BLACK PANTHER PARTY must submit a monthly Financial Report to the Ministry of Finance, and also the Central Committee.

23. Everyone in a leadership position must read no less than two hours per day to keep abreast of the changing political situation.

24. No chapter or branch shall accept grants, poverty funds, money or any other aid from any government agency without contacting the National Headquarters.

25. All chapters must adhere to the policy and the ideology laid down by the CENTRAL COMMITTEE of the BLACK PANTHER PARTY.

26. All Branches must submit weekly reports in writing to their respective Chapters.

[*The Black Panther*, Jan. 4, 1969, p. 20]

on. I had claustrophobia, and it didn't even affect me. It was drilled into us: never be nonfunctional because the police could vamp on (attack) you, and anything could go down. Plus you had to always carry yourself as an example for the community. That was really a serious infraction, and I learned a lot from that.

I've always been a very good typist and a good writer, even back in those days, so I would do a lot of the writing and secretarial work. I worked at the Breakfast for Schoolchildren Program and even sold papers and helped with the cleaning. Plus, at the weekly political education classes, I helped some of the brothers and sisters who weren't proficient at reading. There was always something to be done, and it was always exciting.

The case that Brother Pete was convicted on was carrying a gun across state lines. He received four or five years on that, but we arranged to leave. We had to leave in the trunk of a car because we were under twenty-four-hour surveillance both from helicopters and from the police parked in shifts outside of our apartment. It wasn't scary. That was just a part of what it meant to be a Panther, that things like that could happen.

We had comrades all over the country who helped us in so many ways. It was a modern Underground Railroad. From Kansas City, we went to Sweden first, where there was an organization that helped us get an apartment. Our ultimate goal was to get to Algeria, where comrades had established the international section of the Black Panther Party.

Brother Eldridge Cleaver and Kathleen Cleaver and some other comrades had set that up there. We had the status of an embassy. As a matter of fact, we could bring in people and cars without any hassle. The North Vietnamese were there and the North Koreans. You had the African National Congress (ANC). You had the South West Africa People's Organization (SWAPO). You had all of these liberation movements, and everybody interacted with each other. Being able to hook up with your comrades was just the most beautiful and strengthening thing, and it was like icing on the cake to have embassy status in the hub of all the world's liberation movements.

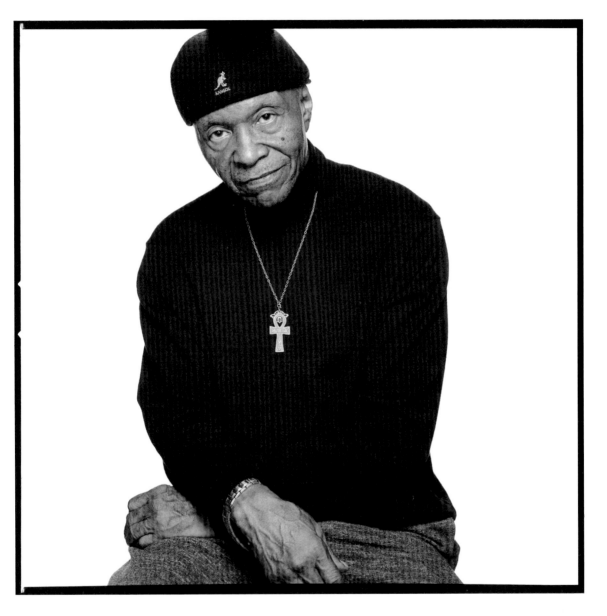

*"This case, our case, that of the Angola
Three, put a face on this injustice."*

Robert H. King (b. May 30, 1942) became a Black Panther and prison organizer during his thirty-one-year incarceration at Angola Prison in Louisiana, twenty-nine years of which were spent in solitary confinement. He was originally jailed on robbery charges but was later convicted of killing another prisoner and given a life sentence, charges he always denied. His conviction was overturned in 2001. He frequently travels to speak about his experiences and sells a form of pralines he calls "freelines," which he learned to make in prison.

Along with Herman Wallace and Albert Woodfox, King is one of the "Angola Three" and the first to have his conviction overturned. Wallace had his conviction overturned in 2013. He died a few days after his release. Albert Woodfox was released in February 2016 after spending forty-three years in solitary confinement.

THEY BUILT CAMP J (ONE OF THE SOLITARY CONFINEMENT UNITS AT Angola Prison) sometime in 1977 as an extreme punishment camp, and, man, I was there for two years. They didn't want any communication at all among inmates. I saw guys get really terrorized, brutalized, broke up. When I say broke up, I mean legs broken, arms broken. And the excuse was always that they fell in the shower.

Sometimes if there was an inmate that they did not like, and they thought they could get away with it, they would go in and brutalize that inmate. I was able to avoid that because I had been in prison for some time. Officers who had gone through the ranks all knew me, and they knew that if they would come at me then there would probably be some difficulties. So in other words, they did not treat me like they probably treated other lesser-known inmates.

While I was at Camp J, we won a court decree overturning the use of the dehumanizing rectal search. So they eventually sent me away from Camp J because I was trying to organize. They sent me back to Closed Cell Restricted (CCR; another solitary confinement classification at Angola). By this time, I was politically aware, and they were dealing with people becoming or already like me. They actually called our tier the "Panther Tier." So we were viewing our conditions differently, which we wrote about, sometimes using our typewriters, and shared with others. That's how we organized in prison. There were prisoner orderlies coming into the tier to feed

us. We would give them notes, paper, and things that we'd written to pass on to other individuals on the tier. Many of those orderlies lived in the main prison population. So we also sent what we called fliers and papers down there into the main prison population.

At one time we did not have TV on the tier, but they saw us rallying and discussing among ourselves, and they ended up putting in TVs. We considered them a distraction at the time, but nevertheless, they were also welcomed because we were able to see what was going on outside. Twice a week we would turn the televisions off after a minute, and we would hold political education classes. The officers didn't really like that because they could hear the things that we were saying. Not that we cared. We weren't hiding anything. We were speaking back.

It was always a quest to convert the guards. I mean that was a reflection of our commitment to ourselves and to the struggle to try to change things. I understand that legality in America and probably around the world is deified, it's made holy, and people think, "If it's legal, it's cool." I tried to show the guards that slavery was once legal. It wasn't until later that people saw it as morally reprehensible. But a person who accepts a job at Angola, they accept a downward swing. By downward swing, I mean that guards have to make sure that the rules and laws are not violated by an inmate if they want to keep their job. Many of them might have felt that it was morally wrong, but their job was at stake, their families' survival was at stake, and so if it was legal, it was okay. It didn't matter if it was morally wrong.

There was a glaring injustice about our case. We were poster children for people who were innocent in solitary confinement, while Mumia (Abu Jamal) was a poster child for people who were innocent on death row. When you look at our particular case, with three men who combined have done nearly one-hundred years in solitary confinement based on suppositions that obviously the court didn't believe and does not believe, well, you would have to say this case is one of the more egregious. Our case became known around the world throughout the past decade as people began to see more and more exactly the injustice that is so pervasive in this country. This case, our case, that of the Angola Three, put a face on this injustice.

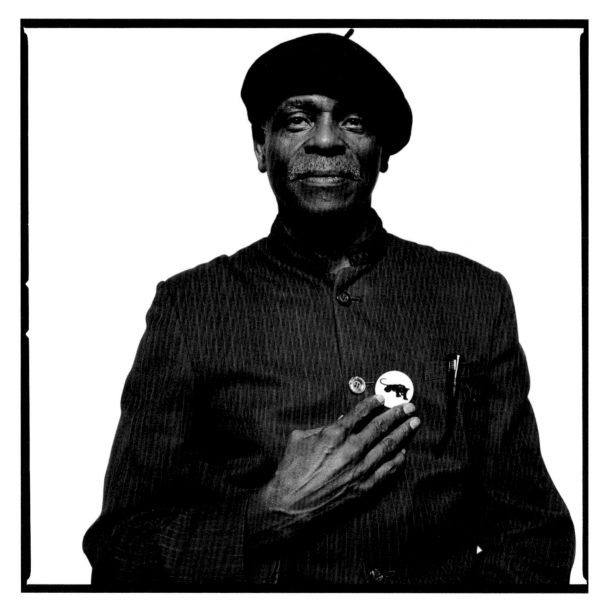

"When the party said, 'All power to the people,' it meant that."

B. Kwaku Duren (b. April 14, 1943) was the coordinator of the reorganized Southern California Chapter of the party (January 1977–March 1982). After his sister was shot and killed by the police, he helped establish the Coalition Against Police Abuse (CAPA), which became the lead plaintiff in a lawsuit against the Los Angeles Police Department (LAPD) ultimately settled out of court in March 1983 for $1.8 million and led to the disbanding of the LAPD's Public Disorder and Intelligence Division (PDID). He also worked as a paralegal and lawyer in the South-Central Office of the Legal Aid Foundation of Los Angeles from 1977 to 1990.

MY UNDERSTANDING OF THE ROLE OF THE BLACK PANTHER PARTY IS probably quite different than that of a lot of folks, who joined it emotionally. I joined it intellectually. I felt it was needed to build something that could effectively bring fundamental changes to America and to the world.

We still need a Panther-like organization, and people must understand that the Black Panther Party considered itself a vanguard of the revolution in America. There was going to be a revolution, and we thought that black people had to be in the leadership. That's reflected in a lot of my organizing.

In the initial period of reorganizing, we engaged the entire community—not just the black community, but the Mexican community, the white leftist community, the gay and lesbian community. It was an effort to get different kinds of perspectives by reaching out and forming alliances and coalitions.

The party's history and perspective gave it the ability to do that. The party was based in the black community, but it was not a nationalist organization. The party developed its own theory called "intercommunalism." When the party said, "All power to the people," it really meant that—not just to black people, but to the people as a whole, as opposed to the power system.

The system tried to, and still does to a certain extent, pit these communities against each other. You still have—less so now than during the 1960s and 1970s—competition between the people from Mexico and South and Central America coming to the United States intending to get jobs. The system encourages distrust and miscommunication between groups. It's a divide-and-conquer kind of strategy.

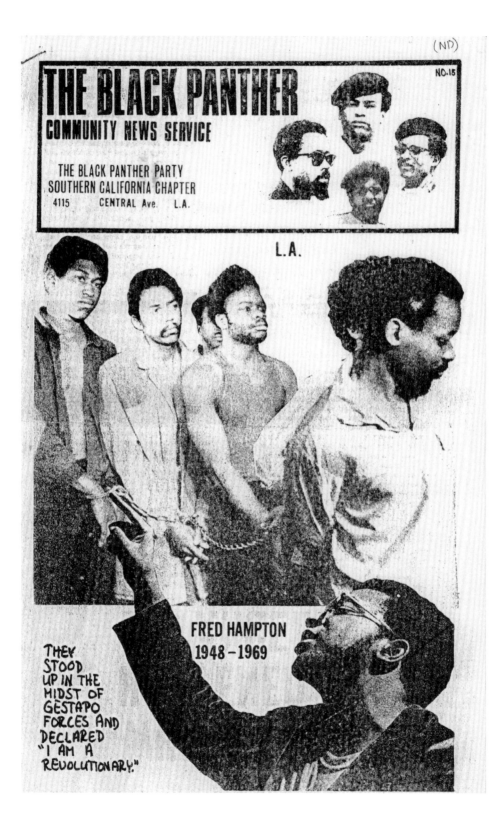

We built CAPA as the beginning group because both the Mexican American community and the black community were affected by police abuses of power, the function of which is to maintain the status quo. We both had an interest in opposing that force in our communities. CAPA was a political instrument to encourage a coming together of the black community and the Mexican American community.

We also did a lot in terms of trying to interface with some of the local gangs, Crips and Bloods. The original Los Angeles Chapter under Bunchy Carter actually came from his leadership of the Slausons, one of the largest black gangs. We tried to continue that legacy of organizing gangs and were quite successful.

I think there's a tendency of the "original" party members not to give credit to the organizing that came later. But I think that's incorrect. There were good comrades who came later from different segments of the community who participated and were genuine in their support of the Black Panther Party and who would give their lives if that were required. This tendency is reflected in the lack of continuation of the party, and I think all efforts to keep the party's spirit alive are very important.

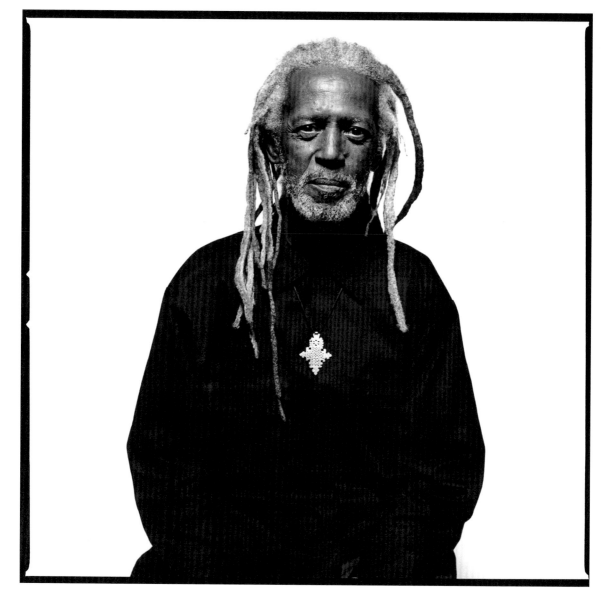

"The war is over, and they're still holding these people."

Ronald "Elder" Freeman (birth date unknown; d. October 8, 2014) grew up in Detroit and in the early 1960s moved to California, where he became a founding member of the Southern California Chapter of the party, along with his brother, Roland. He was a priest in the African Orthodox Church, was affiliated with the Marcus Garvey Universal Negro Improvement Association, and was a longtime prison reform advocate. Both brothers died of illness within a week of each other in October 2014, a few months after this interview was conducted.

My grandfather was in the Marcus Garvey movement, so having respect for yourself and being able to get your own and do for yourself were embedded in me since I was first able to understand words. I wasn't raised to be aggressive, but if somebody hit me, my parents would be mad at me if I didn't hit him back. What made me get involved and become politically active, though, was the 1965 Watts rebellion. I saw innocent black people being shot down by soldiers and the police, and ever since, I've been involved in one form or another in political activity in the black community.

All of that played a part in me eventually joining the Black Panther Party, because we were being shot down in the streets. The police were killing us, and there was no justice at all. We had to develop self-defense groups to defend our communities. We took that as our right and our duty directly from the Declaration of Independence and the Second Amendment to the Constitution.

In the party, people were put in positions where we could utilize the best skills they had. For me, I was always trying to stay ahead of everything. You had to make sure there was staff running the clinic, people working the breakfast program, people picking up donations, people distributing the paper.

They changed the ranking system in the party three or four times. I was officer of the day, then I was a lieutenant, then I was a captain, then I was sergeant, then I was sergeant major, and the last was field secretary for the Southern California Chapter. That was based on my ability to get the work done, not because somebody liked me or because I was popular. It was all based on the work I did, and I did a lot of work. One of my slogans was, "There are twenty-four hours in a day, so we need to do twenty-five."

Because of a murder charge in Los Angeles, I was forced to go underground. From that point on, I was not able to work at the offices or do the political work that was causing the growth of the party. In a lot of the cases that they had in the newspapers, the police were the ones that put the guns in there and then turned around, saying, "They've got illegal guns!" They know they're illegal. They're the ones who brought them. "They've got dynamite in there!" Yeah, because they're the ones who gave it to us. They criminalized all these people, and as a result we have people sitting in prison for forty, going on fifty years. If they were in Vietnam or Iraq, they would have been released. The war is over, and they're still holding these people.

I could see things changing. I thought my efforts and the work that I was doing and that other people were doing were going to really bring about social change. I believed that. I didn't believe that a lot of us were going to be murdered and jailed and that the government was going to respond in the manner that it did, because what we were talking about was the right thing to do in terms of education and jobs. They worked so hard to keep things from changing that it made me become more dedicated to seeing things change.

What people should see about the Black Panther Party is that it was a group of young black men and women that crossed racial lines and saw that if we wanted to see change happen in the United States, that aligning ourselves with people around the world that shared a similar fate as ours was where the Black Panther Party was at.

It was a matter not only of addressing the problems that we had in the black community but also of aligning ourselves with the brown community, the Native American community, the Asian community, the Palestinian community, the indigenous Australian community, people in India, and people in various parts of South America. They identified with the Black Panthers as a symbol for social change. There are young people even today in some of these countries who still admire the Black Panthers and have little organizations that are trying to do things in the spirit of the Black Panther Party back in the 1960s and 1970s. What I would want people to really see is that the Black Panther Party, whatever people will say, was for good, and we were willing to defend ourselves to bring about that good. That's nothing to be ashamed of, nothing at all. I'm proud of that.

The Black Panther Party and the Rise of Radical Ethnic Nationalism
Jeffrey O. G. Ogbar

The Black Panther Party, founded in Oakland in 1966 by Huey P. Newton and Bobby G. Seale, is the most iconic expression of the Black Power movement. It is, to many, the apotheosis of a new, militant, defiant, unapologetically black consciousness. From its name, uniform—which included a black leather jacket and black beret—it was quintessentially and boldly black. It is, therefore, often a surprise to witness the degree to which the Black Panthers worked with nonblack radical organizations. The alliances were more than mere professional partnerships. The Panther Party, in no uncertain terms, shaped, inspired, and significantly affected the ideological contours of various nonblack organizations across the country. From fashion to organizational structure to community activism and tactics, the Black Panthers fomented the rise of radical ethnic nationalism—a leftist expression of nationalism that simultaneously seeks important coalition-building with members outside of the primary ethnic/racial group. Organizations such as the Brown Berets (Chicano/a), the Young Lords Party (Puerto Rican), the Red Guard (Chinese American), the American Indian Movement (AIM), and the Young Patriots (white) were among the many groups founded in the midst of Black Panther Party popularity. They worked closely together, establishing unprecedented expressions of radical activism that transcended the narrow expressions of activism that typify nationalist movements.

Of course, no movement develops out of a vacuum. The Black Panther Party for Self-Defense was inspired by a series of forces: the activism and growing militancy of the Student Nonviolent Coordinating Committee (SNCC), the revolutionary nationalist group Revolutionary Action Movement; the black nationalist Nation of Islam; the winds of radicalism spreading throughout Africa, Latin

America, Asia and elsewhere; and organic expressions of radicalism in black communities nationwide. The BPP was also shaped by the multiethnic landscape of the Bay Area, where it was formed. Student activists in colleges in the area, such as San Francisco State, Merritt College, and the University of California at Berkeley were increasingly involved in antiwar activities as well as efforts to establish ethnic studies programs. Together students organized the Third World Liberation Front, which brought together students of color on campuses across the area.

Simultaneously, urban conditions in Oakland and other cities demanded different activism. Newton and Seale's ideological trajectory, therefore, must be understood as affected by a range of phenomena, including the multiethnic landscape of their immediate social and activist world. Although inextricably tied to the impulse of Black Power, the Panthers were also intimately familiar with other, nonblack radicalism. They were open to coalition-building from inception. Because conditions such as poverty, racial discrimination, police brutality, and social and political marginalization were conditions in other communities of color, interest in forming radical activist groups was strong in nonblack communities during the late 1960s. In San Francisco, the multiethnic activist landscape germinated dozens of organizations, including the most visible Asian American radical ethnic nationalist organization, the Red Guard, "greatly inspired by and patterned itself after the Panthers."[1] Its Eleven-Point Political Program, much like that of the Brown Berets and Young Lords, drew heavily from the Panthers' Ten-Point Platform and Program, even citing it verbatim in places.

Across the country other groups in various cities followed the Panther model. In Minnesota, Leonard Peltier, a leader in AIM, explained that the Black Panthers were "the ones who came out and showed us how to organize successfully."[2] In late 1967 David Sanchez and others in Los Angeles formed the Brown Berets, modeled after the Black Panther Party. In place of black berets, they donned brown ones and established patrols of police, much as the Panthers had. Additionally, they armed themselves and established political education classes and the Thirteen-Point Platform, which

quoted the platform of the BPP verbatim in many sections. They spread from Los Angeles to communities across the southwestern United States, engaging college and high school youth as well as street gangs in efforts to politicize the Chicano/a community. In a community burdened by similar forces to East Oakland, East Los Angeles, or South-Central Los Angeles, working-class sections of the Northside in Chicago witnessed the Young Lords, a Chicago street gang, start to withdraw from criminal activities and, affected by the spirit of social justice and activism, morph into a reformist youth group. By 1968, however, the Lords became a self-described revolutionary nationalist organization allied with the Black Panther Party. Significantly, the Lords were part of an enterprise locally known as the Rainbow Coalition, established by charismatic deputy chair of the Illinois Branch of the Black Panther Party Fred Hampton. The coalition included a group of uptown white activists and former gang members, the Young Patriots. Hampton insisted that the Black Panther Party fought against three evils: capitalism, imperialism, and racism.

Racial and ethnic divisions, the Panthers argued, were functions of the ruling class to divide the poor and exploited. Racial pride was fine, but it did not liberate the oppressed. A white Jesus, white Santa Claus, white angels, and overwhelming affirmation of whiteness in all arenas of America did not make the millions of whites living in poverty disappear. Nor did it stop poor whites from disproportionately being sent to fight and die in Vietnam. The Patriots, Lords, and Panthers famously provided security for each other at events, held press conferences together, and developed identical community programs to mitigate gang violence and police terror and provide breakfast for children, along with medical care.

In addition to the Young Patriots, several largely local, white, radical groups found essential inspiration in the Panthers, including the Chicago-based group Jobs or Income Now (JOIN) Community Union. In Michigan, there was the White Panther Party, which even donned the black leather jacket like the Panthers did. In New York a group of largely white ex–drug addicts sought to converge drug treatment programs and revolutionary politics in an organization

known as White Lightning. "Strongly influenced by the pamphlet 'Capitalism Plus Dope Equals Genocide' written by New York Black Panther Michael Tabor, Lightning saw drugs as a deliberate attempt to destabilize ghetto communities for corporate profit."[3] As a study of urban white activists explains, "In the Sixties white activists [such as White Lightning] were driven by the moral vision of civil rights [and] the radical program of the Panthers."[4]

Across the United States, the Black Panther Party loomed large as the high-water mark for black radical protest and activism. The social, political, and economic conditions that made the party appealing to young, black people in cities nationwide were the same conditions that made the Panther template attractive to other oppressed and marginalized young people—including whites. The Panther ideological platform, not constricted to narrowly defined black nationalism, was broad enough to inspire and welcome non-black people, while simultaneously affirming both racial and ethnic pride in a way that did not demand xenophobic pandering. Ultimately, the activist landscape was indelibly affected by the model of radical ethnic nationalism witnessed in the Panther example.

Jeffrey O. G. Ogbar is professor of history and founding director of the Center for the Study of Popular Music. He is the author of *Black Power: Radical Politics and African American Identity* (Johns Hopkins University Press, 2004), winner of an Outstanding Academic Title from *Choice* (2005), and editor of *Civil Rights: Problems in American Civilization* (Houghton Mifflin, 2003). His book *Hip-Hop Revolution: The Culture and Politics of Rap* (University Press of Kansas, 2007) won the W. E. B. Du Bois Book Prize from the Northeast Black Studies Association (2008). He is also the author of *The Harlem Renaissance Revisited: Politics, Arts, and Letters*, an edited volume (Johns Hopkins University Press, 2010). Ogbar's articles appear in the *Journal of Religious Thought, Journal of Black Studies, Souls, Centro,* and *Radical Society,* among other academic journals. Raised in Los Angeles, California, Ogbar is a member of Phi Beta Kappa international honor society; he received his bachelor's degree in history from Morehouse College and his master's and doctoral degrees in history from Indiana University.

THE GLOBAL PANTHERS
NICO SLATE

"Due to the hideous plot of American imperialism, the Third Dalit World, that is, oppressed nations, and Dalit people are suffering. Even in America, a handful of reactionary whites are exploiting blacks. To meet the force of reaction and remove this exploitation, the Black Panther movement grew. From the Black Panthers, Black Power emerged. . . . We claim a close relationship with this struggle."

—Dalit Panther manifesto, Bombay, 1973

ON AUGUST 15, 1973, THE TWENTY-SIXTH ANNIVERSARY OF INDIAN Independence, some 200 people marched through the streets of Bombay to mark what they called Kala Swatantrya Din, or Black Independence Day. The march was organized by a new organization with an unusual name: the Dalit Panthers. The word "Dalit," from the Marathi for "crushed" or "broken," has become the pre-eminent self-identifier for the more than 160 million people, once known as untouchables, who live at the bottom of the caste hierarchy in South Asia. By linking the words "Dalit" and "Panthers," the new organization drew on the legacy of the Black Panthers in order to define the Dalit struggle as radically transnational. It was more than the borders of nations that the Dalit Panthers defied. As their Black Independence Day challenged the idea of the nation-state as the embodiment of freedom, their engagement with notions of blackness transgressed racial borders. By rejecting racial and national borders in defense of revolutionary freedom, the Dalit Panthers followed in the footsteps of the Black Panthers.[1]

The Panthers inspired social and political struggles in Asia, Africa, Europe, Latin America, and the Pacific Islands. But in adopting

the imagery and ideology of the Panthers, activists outside the United States also shifted the focus to their own struggles, whether it meant challenging a caste system or opposing a local government.

While the Dalit Panthers were marching through Bombay, the Israeli Panthers took to the streets of Jerusalem and Tel Aviv. By organizing Israelis of North African or Middle Eastern descent, the Israeli Panthers inserted race into a national debate long focused on class and religion. In New Zealand, the Polynesian Panthers similarly wielded the Panther image toward very local ends like unmasking the brutality of settler colonialism and forging a radical conception of indigenous solidarity. The Polynesian Panthers went well beyond notions of blackness and of African descent in defining their relationship to the Panthers.[2]

In Europe, support for the Panthers ranged from the solidarity committees of West Germany to the more direct emulation of the British Black Panther movement. Unlike the Panthers of India, Israel, and Polynesia, European supporters could count on the cultural and geographical proximity of the United States and Europe. Personal connections with Panther activists fostered links in West Germany. For example, the former head of the German SDS, Karl-Dietrich Wolff, met Bobby Seale in California in 1969. Wolff proved influential to the growth of Panther solidarity committees. While European radicals met Panther leaders in the United States, Panther activists traveled to Europe as well. In Copenhagen, Jamaican activist Connie Matthews helped establish a foothold for the party. The presence of African American soldiers on American military bases, especially in West Germany, provided another source of potential Panther recruits in Europe.[3]

In 1969, Eldridge and Kathleen Cleaver helped establish a branch of the Panthers in Algeria. But their relationship with the Algerian government proved rocky, and Eldridge Cleaver spent much of his time traveling to North Korea, the Union of Soviet Socialist Republics (USSR), North Vietnam, and China. Many of the countries that offered the strongest support to the Panthers were in the communist world. Although West Germany refused to allow Eldridge Cleaver to visit, East Germany opened its doors to Panther activists and supporters.[4]

81

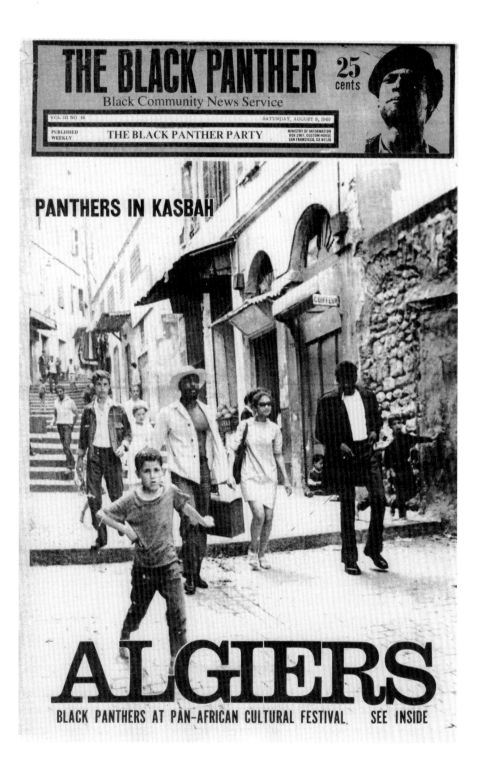

The iconography of the Panthers was often appropriated abroad in ways that demonstrated only superficial knowledge. Some communist supporters seemed less interested in the Panthers than in the opportunity to rub salt in an American wound. By contrast, the British Black Panthers mirrored many of the ideological and programmatic pillars of their American counterparts. For example, they rejected an exclusive black nationalism and instead fostered connections between Caribbean, African, and Indian communities. They also initiated several community-based projects. Based in the South London community of Brixton, the British Black Panthers helped run a Saturday school and contributed to the radical magazine *Race Today*.[5]

The global fame of the Panthers, an organization opposed to American imperialism, ironically demonstrates the global power of the United States itself. Many activists learned about the Panthers because of the ubiquity of American media. The fact that activists in so many parts of the world found the Panthers compelling demonstrated the influence of the United States on the global stage. It is telling that the Panthers found acclaim worldwide at precisely the moment that Cold War America was struggling to maintain its global predominance. But the global spread of the Panthers also demonstrates the resonance that many activists felt with the goals and strategies of the Panthers. Despite their limited knowledge of the Panthers and their program, the Dalit Panthers spoke for many by proclaiming "a close relationship" with a struggle they claimed as their own.

Nico Slate's research and teaching focus on the history of social movements in the United States and India. His first book, *Colored Cosmopolitanism: The Shared Struggle for Freedom in the United States and India* (Harvard University Press, 2012), argues that South Asians and African Americans learned from each other in ways that advanced their struggles for freedom. He is the editor of *Black Power Beyond Borders* (Palgrave Macmillan, 2013), a volume that tracks the global dimensions of the Black Power movement. His is also author of *The Prism of Race: W. E. B. Du Bois, Langston Hughes, Paul Robeson, and the Colored World of Cedric Dover* (Palgrave Macmillan, 2014). *The Prism of Race* examines a crucial moment in the history of race through the lens of a self-described "Eurasian half-caste," born in Calcutta in 1904, and his relationships with leading African American artists and intellectuals. Slate plans to publish a study of race in Los Angeles after 1965; a biography of Mahatma Gandhi focused on his diet; and a history of connections between India and the United States from the eighteenth century to the present.

CHAPTER THREE

A SISTER'S PLACE IN THE REVOLUTION
WOMEN IN LEADERSHIP IN THE BPP

WOMEN PLAYED AN INTEGRAL PART IN THE DAY-TO-DAY ACTIVITIES of the Black Panther Party. They also occupied important leadership roles within the party structure. As leaders, in the broadest sense of the word, women helped shape the Panther agenda, had significant input into the party's program, and worked to create a climate of gender equality worthy of a truly revolutionary political organization. Although they still faced considerable sexism within the party, they remained committed to the Panther platform as the best option for achieving political autonomy and challenging racial inequality. Women in key leadership positions at the national headquarters as well as within key chapters promoted a more equitable division of labor within the party, including men serving breakfast to school-children and women shouldering rifles to defend Panther offices.

"If I put energy somewhere, I want that to be what will uplift me and what will uplift the young people."

Ericka Huggins (b. January 5, 1948) was a leader of the Los Angeles Chapter of the party, along with her husband, John Huggins, who was killed in a shootout on the University of California at Los Angeles (UCLA) campus. She was the longtime director of the party's Oakland Community School and has created or contributed to a variety of educational and social justice programs with an emphasis on spirituality. She is also a professor of sociology and women's studies at several California colleges and universities.

I DO BELIEVE THAT PEOPLE'S VIEWS OF THE PANTHERS ARE CHANGING as time goes on because young people are more open to the truth, especially the last two or maybe even three generations of young people, because of the obvious violence all over our world. I notice that young people are looking for ways to organize because governments don't seem to want to take care of, for instance, education and health care. My heart is so open to young people because they can see past the mass media narratives to what we were really doing because they investigate, because they're finding out about the party's programs. That's really heartening. I get a lot of requests to travel and speak where they'll ask, "How did the party do it? How did the party create a school? How did the party create free clinics? How did you do that?" They want to know how we organized the people.

When mainstream journalists talk to me, they want to know, "What really happened?" whereas young people are looking back and saying, "Wow, fifty years ago you fed people? Forty-five years ago you created schools that were student-centered and community-based? You had clinics? You had bus-to-prison programs that were free? How did you do that without social media?" I love those conversations because I feel that young people are convincing themselves that they can do the same thing. After all, the median age of party members was nineteen years old.

The legacy of the Black Panther Party is the way in which we organized people. The most brilliant idea Huey Newton had, which Bobby Seale carried out, was that people participate in their own upliftment if they understand the necessity of stepping up to uplift their community. I heard Bobby say once, "We can't expect men and women in our communities to vote for a better candidate for

office or to create police patrols or programs that uplift if they have
to worry about, 'Do our children have shoes, is there food on our
own table, do I have bus fare to get my child across the city to a
hospital, a hospital where they have to wait for hours?'" "No" is the
answer to all those questions.

Our community survival programs helped people to see how
communities could be transformed by seeing it in their own lives,
and then they would want to support that which transformed them.
That's exactly what happened. All the community survival programs
were supported by volunteers from the community, not just party
members. Their social understanding grew when their lives were
changed without any strings attached. We did everything we did
so that people would feel empowered to make changes in the world
they live in and then go beyond that smaller circle to the larger one
and develop a global understanding. I saw this with my own eyes. It
was brilliant.

I reconcile the good and the bad things that happened in the
party by really looking at what's important for me to remember. If
I put energy somewhere, I want that to be what will uplift me and
what will uplift the young people.

Huey's most favorite program ever was the Oakland Commu-
nity School. When he was feeling burdened, he would come to the
school and hang with the children and feel better. I know this be-
cause I saw it.

That school was an oasis for everybody who stepped foot in it.
It was a school created by the Black Panther Party. It wasn't created
by the Oakland Unified School District. Party members poured
their blood, sweat, and tears into it. It had a profound impact and it
still does have impact.

There's nothing that can change the brilliance of Huey New-
ton before he became really sick. These programs live today because
of Huey, Bobby Seale, David Hilliard, Elaine Brown, Joan Kelley,
Phyllis Jackson, Norma Mtume, Donna Howell, Yvonne King, and
a host of other women.

The other thing is, when I reconcile, I forgive. I forgive myself,
first, and others. I'm talking about a true forgiveness, not just the

words "I'm sorry," which can be very shallow, but true forgiveness because what matters most is the love that the party had for people. It shined out of those programs.

We really didn't have a lot of sleep. We worked nineteen hours a day. There was nobody threatening us, nobody standing over us with some kind of weapon saying, "You need to work with those children after school."

There were many threatening things within the party and definitely outside of the Party. But the programs were the light of everybody's experience who had anything to do with them. That's how I reconcile.

The school was a major pilot for what education could be. The busing-to-prisons program made a difference in the lives of people so that a father or mother would not lose contact with their babies, children, and their loved ones. The people's free medical clinics saved lives, and the sickle-cell anemia research and education programs educated the community and saved people from pain and also saved some people's lives.

I'm just using these few examples to describe to you how I don't have to reconcile with what someone did or what someone said because I have, in my heart, all these experiences of the great good. I don't make excuses for the bad things that happened. I say that they happened if they happened. I say if I had anything to do with them, "Please forgive me." I'm not in denial about it, but I just choose where I'm going to put my energy.

*"We needed to come up with another mechanism
to bring in money, and that meant becoming more
mainstream so we could start getting grants."*

Norma (Armour) Mtume (b. November 11, 1949) was raised in East Los Angeles and was attending California State University Los Angeles when she joined the party. She began running a Panther medical clinic at the age of twenty while also serving as assistant finance manager in the Los Angeles Chapter. After moving to Oakland she managed the party's free clinic in Berkeley and later became the minister of finance for the entire party. She completed two master's degrees, in health services and marriage and family therapy. She also founded two community health service organizations, one of which, SHIELDS for Families, now has a budget of $26 million and a staff of 350 people.

AT THE PANTHER CLINIC HERE IN LOS ANGELES WE WORKED WITH US Army, Navy, and Marine veterans from the Vietnam War. They actually taught us a lot of medical procedures under warlike conditions because the police could attack your house at any time, even while you were sleeping. We were taught how to control bleeding, how to do CPR. We were actually taught how to do stitches. Then in the clinic we had some great, forward-thinking doctors who didn't feel like medicine was so sacred that other people couldn't learn it. A lot of things about medicine are not rocket science, you know. I learned to give injections and draw blood and give physical exams, to give women vaginal exams and pap smears, and how to operate laboratory machines and get the results to the doctors. We had a pharmacy in the clinic so I learned how to fill prescriptions and what various medications were used for what. I studied the Merck manual, which was like the bible for figuring out what was wrong and how to treat it.

One day in the Los Angeles clinic a man came in. He had fallen asleep smoking, and his bed had caught on fire. He was an alcoholic and had been drinking a lot. His friends or his relatives brought him to the clinic with second- and third-degree burns all over his body. We tried to convince him that he had to go to the hospital, that we couldn't treat him. But he trusted us and didn't want to go. It was just a real task to convince him. I can still see him now and the injuries that he sustained. That'll never go away because it made me understand better how distrustful many folks in our community are of the broader medical system. They don't want to have

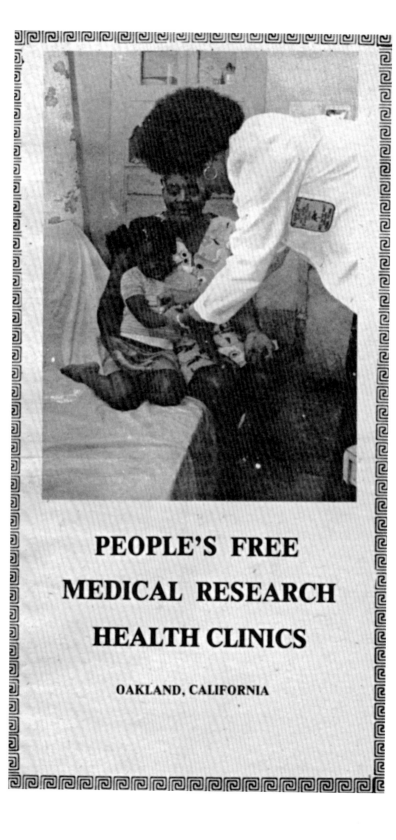

PEOPLE'S FREE

MEDICAL RESEARCH

HEALTH CLINICS

OAKLAND, CALIFORNIA

anything to do with it because of past experiences or something negative that they heard. There's just not that trust.

When I was minister of finance, I really gained some skills: how to write the checks and build the general ledger. I took a class at one of the city colleges to learn the ten key. I basically learned how to do everything in about three months, and I was off and running. We actually had two nonprofit corporations: Educational Opportunities Corporation (EOC), for the Oakland Community School and other educational activities, and the EOC Service Corporation, which provided youth and senior activities, food programs, and everything else that wasn't educational. I was keeping the books on those along with the party's records.

At the same time, we were applying for grants and talking with public officials to find out what other kinds of programs we could get involved in. We figured we had to get involved in the mainstream somehow in order to get the money to sustain some of our operations. Money coming in from the newspaper had to go toward reprinting the newspaper and taking care of people in the party and the facilities. So we needed to come up with another mechanism to bring in money, and that meant becoming more mainstream so we could start getting grants. It was actually a really big, very sophisticated operation for some twenty-four-, twenty-five-, and twenty-six-year-olds to be running.

At SHIELDS for Families, the nonprofit I cofounded almost twenty-five years ago, I was the chief operating officer and the finance officer, so I continued to do my finance work and the things I had learned in the party about managing people and managing facilities. My interest in health and numbers continued throughout my career. It's been a blessing to be able to merge those two and be able to do the things that I really like. What I'm most proud of is that I was able to be this back-office type person who helped build institutions to better our communities. A lot of people don't know about me, and that's okay. I know what I did.

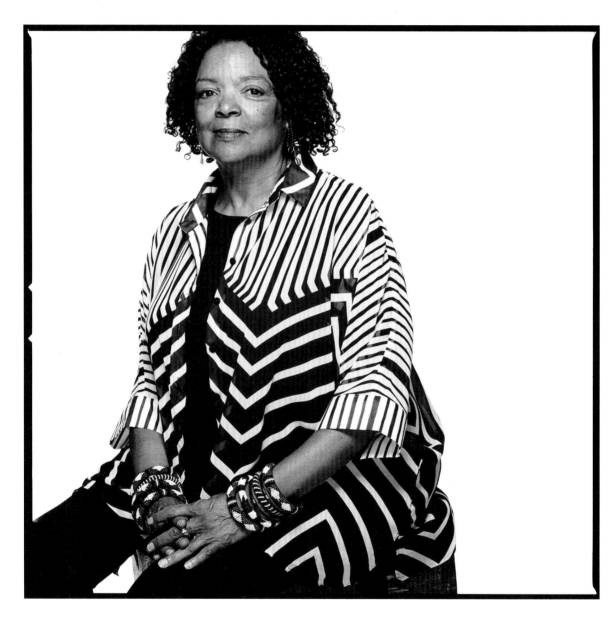

"We don't have to be the hero when we join.
You become the hero through practice."

Phyllis Jackson (b. September 15, 1950) grew up in Tacoma, Washington, before joining the party at the National Headquarters. She served as a communications secretary and ran a voter registration campaign. She is an associate professor of art history at Pomona College, teaching arts and cinema of Africa and the African diaspora.

MY FIRST INTRODUCTION TO THE PARTY WAS IN JULY 1969, AT THE United Front Against Fascism conference at the Oakland Auditorium. The keynote speaker was a guy named Bobby Seale. I had never heard of him. He gave a long speech, and at the end, almost in a sigh, he said, "And to all you college students, please, come home. The white man's not going to teach you anything on those college campuses about how to free your people." I can see in retrospect that it made me feel responsible. After the conference, I walked into the office like I was volunteering as a candy striper. I was wearing a little dress and little pumps and said, "I'm going to be here for a few more weeks. I'm just visiting from Washington, and I'd like to volunteer my time." It makes me laugh every time I think about it.

They put me to work sorting petitions demanding police officers live in the cities they patrolled, the notion being that they would be less likely to brutalize and murder black people if they had to return that evening to the same community. I'm good at following directions, so I just started doing it. Then, by the time I was supposed to leave, I decided I wasn't going to. I was going to drop out of college. My dad actually thought they had drugged me. That was the first question he asked. "What have they given you?" I was the family quiet one, the crybaby, the shy one. Nobody could understand because I never got into trouble. I was never called to the principal's office. I was more like the one working in the main office.

My dad's response was, "If this is the way you're going to treat your mother, as far as I'm concerned, I only have three daughters now. Do not call the house to talk to your sisters. I don't want you influencing them." I was disowned. This was a man that never even spanked me.

I think my experience was not uncommon, particularly for the women. It was far more frightening for parents who still had this

notion that women needed a man to take care of them. I don't know any other way of putting it. I made a movie in the 1990s called *Comrade Sister: Voices of the Women of the Black Panther Party*. Among the same thirty questions I asked everyone, one of them was, "What was your family's response?" Even in the movie, there were people talking about how their parents came to Black Panther Party offices demanding that their kids come home. This one comrade, Haven Henderson, from the Winston-Salem Chapter, said her mom came down in a fur coat and a Cadillac and said, "What are you doing down here? Come home!" Other people were being put out of their homes.

In the party, there weren't roles, so to speak. Your role was to do what people taught you to do and to do it well. You tell Phyllis something you want done, and she just gets it done. That was my reputation.

I remember the first time I was pulled from the field, where I was selling newspapers, to run off 50,000 leaflets for Woodstock. I joined in July. Woodstock was in August. That's how fast things happened in the party. I could run that machine so that my leaflets were flawless. When they put a guy on it, half of them would get stuck. I could make that sucker sing. One day, somebody came up to me and said, "You're taking over Mojo's donation collection route." That was a good thing about being a good old country girl: I knew how to drive a stick shift. Later, I was assigned to San Francisco to live and work under Sam Napier, circulation manager of the newspaper, who was in charge of Central Distribution. We sent out all the papers, all the posters, all the cards, all the buttons around the world. Then I became communications secretary at Central Headquarters, which was at 1048 West Peralta Street. I was the one answering the phones: "Black Panther Party Central Headquarters, may I help you?" with my son on my shoulder. Then I did a stint on the security cadre for Bobby before becoming his secretary.

When Bobby and Elaine (Brown) were going to run for office, I was told to report to Ericka (Huggins) at Central Headquarters. I did, and she explained to me that the Central Committee chose me to run the voter registration program. To me, it didn't make sense. I considered myself a rank-and-file person, and I suggested someone else I admired, but Ericka said, "No, we think you'd do a really good

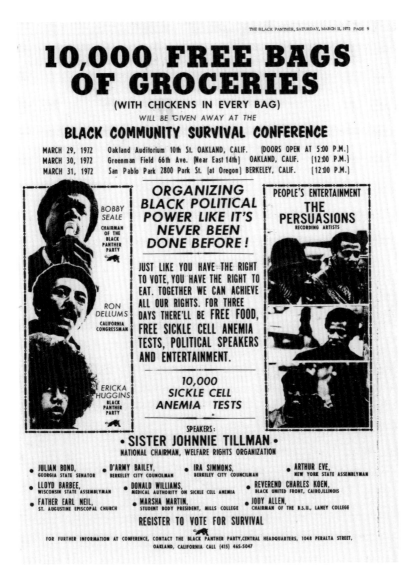

job." I tell you this to illustrate that in the party, people observed you and saw what your skills were. You didn't apply for a position. You were selected and assigned based on what you had done previously.

I wasn't the campaign chair. I was the person that got people out there door-to-door. I didn't know a thing about voter registration. I wasn't even registered to vote. The party just did that with everything. We were very much improvisers. When we did a clothing giveaway, we just opened up the window on the ground floor and handed the clothes out the window. I had never heard of a radiothon, but we held one anyway as a fund-raiser for the (Oakland)

Community School. I set up a phone bank with receivers that people could hear even in the loud auditorium. Don Cornelius* put us over $10,000 with a $1,000 donation. But because I was in the party and not watching TV, I didn't know what *Soul Train* was.

All of this was about being committed to the outcome and working out the process. You got out of yourself and literally displaced your own personal desires for a larger one. There was no wavering on it. Just do it. Get it done. It doesn't mean that we didn't have trepidation about police attacks, but you didn't operate out of fear, as a lot of people operate every day. You operated out of a real grounding command of your own personal agency and desire to be valuable.

I wasn't one of the people who helped invent the philosophy of the party. I didn't really contribute to that. That theorizing was mostly done by Huey P. Newton. That man was brilliant. He had such a firm sense of self and self-respect that he came up with an idea that transformed the consciousness of millions of black people in terms of what they have a right to expect out of life. Everyone has their strengths and weaknesses, and to know him only by his weaknesses is to misunderstand not only his brilliance but also his revolutionary commitment to people around the world against imperialism, white supremacy, and male supremacy.

Revolutionaries are made, not born. They have to construct their lives consciously along a set of revolutionary principles. Bringing about change is something all of us can do, or being active in an organization is something all of us can do. We don't have to be the hero when we join. You become the hero through practice. It's not that I'm a bold person. It's that I practice being bold. All of us can practice that. I'm actually a really shy person, with bold moments. Those are conscious. You actually have to work against your childhood training. You have to work against whatever you were born with. That was possible for me through a set of principles that still stands today—the Ten-Point Program and Platform—as a theoretically sound, historically appropriate response to the interlocking systems of domination that construct our lives.

* Creator and host of the long-running TV music show *Soul Train*.

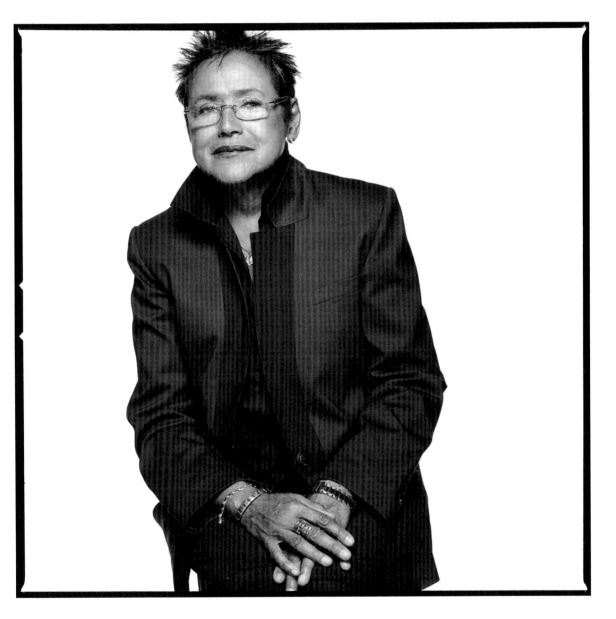

"Our goal was not feeding breakfast but
creating the conditions for revolution."

Elaine Brown (b. March 2, 1943) chaired the Black Panther Party from 1974 to 1977 and was the only woman to head the party. She is the author of two books, *A Taste of Power* and *The Condemnation of Little B.* She is presently executive director of the Michael Lewis ("Little B") Legal Defense Committee and chief executive officer of Oakland and the World Enterprises, a nonprofit organization that develops for-profit businesses for cooperative ownership by formerly incarcerated people, the first of which is an urban farm in West Oakland (where the party was headquartered).

The Black Panther Party's powerful, free Breakfast for Schoolchildren Program, by which we provided free breakfasts daily to thousands and thousands of schoolchildren all over the United States for years, was more of an organizing tool than a social service program. Our goal was not feeding breakfast but creating the conditions for revolution. For example, this effort sparked the people to demand that schools throughout the country provide free breakfasts, and the people won. Our strategy was to inspire and organize the people to fight for their human rights, including the right to have food. If the people could force schools to serve free breakfasts, maybe they would demand that the establishment provide free dinners, housing, health care, and so forth, toward fundamental, revolutionary change. We called our free food, free clinics, and similar programs "survival programs," operating under the slogan, "Survival pending revolution."

Defining ourselves as the revolutionary vanguard (after the Leninist analysis of the need for a vanguard organization), we tried to develop strategies to create the conditions for revolutionary change in the United States. This, of course, is why the government came down on us with all guns blazing. I assert that the Black Panther Party put forward the greatest effort ever in the history of this country for black liberation and left an indelible legacy.

When Huey P. Newton, the guiding ideologue, cofounder, and leader of the party, decided in the early years that the party would patrol the streets of Oakland with guns to check police brutality, it wasn't to establish the party as the community police. The strategy was to educate the people as to their basic, human right to defend

themselves against our oppressors. Today, we've lost that thread of revolutionary consciousness. The neoliberal agenda that has overtaken the country has inculcated blacks to believe, like racists, that all the wrongs we suffer in the black community—poverty, mass incarceration—are from self-inflicted wounds, as Obama would say it. We, ourselves, are disconnected from the relationship between our ongoing oppressive condition and how and why we got here. We are disconnected from the question of freedom.

Today, fear has gripped the people, most significantly, young people, blacks, liberals, progressives. For example, when I talk with college students, I often say, "Look, you're mad because the college is investing in private prisons." Notwithstanding that, even if the college would disinvest, nothing fundamental would change as to the mass incarceration of blacks, as to mass incarceration; a victory of disinvestment would inspire the students to seek other victories, to move to address other outrages. So, I urge them to take action. Use the party's example, sit in or lock it down. The students don't want to do it because they're afraid. Afraid to lose their scholarships or Pell Grants. Afraid to lose their jobs or housing. And, this, without respect to the big fears of going to jail or getting hurt or even killed. That kind of consciousness and commitment has been lost in the night of time.

They have the tools: the Facebook pages, Internet sites, cell phones. They use them but not to organize action. Action is not some protest march. There are a million people out there marching for this or that, from time to time, none of which protests address or move on an agenda of revolutionary change. None of which have come to constitute a mass movement. The last hint of the prospect of a mass movement in the United States was the Occupy movement, which, although unorganized, was powerful in that it established in the mass mind the fact that there are two Americas—the very rich, the 1 percent, and the rest, the 99 percent—instigating an instant of outrage, leaving behind that consciousness.

The police murder of Michael Brown in Ferguson, Missouri, in 2014, became significant with respect to the many, many other disregarded police shootings and murders of blacks only because

the people tore up that city. The world was forced to pay attention. Similarly, the only reason the Oscar Grant case in Oakland spawned powerful actions is because the people tore up that city. I am happy the people acted in this way, despite the lack of organization and the pathetic outcomes. It demonstrated that the people have the power. But there is still no serious, organized effort to address the ongoing, rampant police brutalization of blacks, the issue in these cases.

Despite everything, there is no real scrutiny of police actions today, certainly not by any government agency. People are making challenges, such as putting cameras on police; some cops have been arrested, though most have not. But at the end of the day, what does "police scrutiny" mean? It might be a tool to move the agenda, but if the result is replacing a racist police chief with a bootlicking Negro, nothing will have changed at all.

We have come to a place where we accept these little pacifications, like changing one police chief for another. We have come to a place where all we really want is a pair of Nikes, and we are willing to take any job that will provide us the money to buy Nikes. We have come to a place where we would sign up as a prison guard to get those Nikes, without any consciousness of the nexus between why we don't have money to buy Nikes, much less make our own Nikes, and the mass incarceration of our people.

The correct analysis has to be there. This is what the Black Panther Party attempted to do, to raise consciousness as to our oppressed condition and what change will be required to bring about our freedom—which is the goal. We have to understand what the hell is wrong here. If we think it's singularly a question of police brutality, we'll marginalize all the other ills and lose sight of freedom. We have to know what we want, analyze how we might get there, organize, and act—quoting Che Guevara, as we did in the party: "Words are beautiful. Actions are supreme."

But we've been driven into a corner by fear, overcome by the propaganda of the capitalists and government, which are one. The Black Panther Party should be studied as to what we did and why we did it, therefore, and not from a superficial point of view as to the look and feel of the party, not from some aging party member's

personal recollections of his or her activities in the party, not focusing on questions like what it was like to be a woman in the party.

The party had a big agenda. We carried out incredibly big and powerful and effective actions. We produced our own newspaper for thirteen years. We launched and supported our various survival programs, including free groceries, free health clinics, low-cost housing, our model school. We formed active coalitions with other ethnic organizations and other organizations representing oppressed groups—from the American Indian Movement (AIM) to the Brown Berets (a pro-Chicano/a organization) to the Gray Panthers (an elders' rights organization), disabled rights groups, women's and gay liberation organizations—knowing we all stood on common ground, oppressed by a common enemy. We formed international coalitions with the Mozambique Liberation Front (FRELIMO) in Zimbabwe and other liberation organizations in Africa and developed formal relationships with socialist governments in China and Cuba and North Korea and Vietnam.

So, it is my hope that blacks and radicals and progressives particularly will study the party's history to, perhaps, resurrect and adapt some of the things we did that might be relevant and useful today, or criticize and discard what is not useful, toward revolutionary change in America.

REVOLUTION, STRUGGLE, AND RESILIENCE

WOMEN IN THE BLACK PANTHER PARTY

RHONDA Y. WILLIAMS

Ericka Jenkins was a student at Lincoln University when she decided to trek west to join the Black Panther Party for Self-Defense, founded in 1966. After reading in *Ramparts* magazine about the campaign to free Huey Newton, the Black Panther Party's cofounder with Bobby Seale, she and her soon-to-be husband, John Huggins, headed to Los Angeles. After they arrived, both immediately found factory work before eventually becoming full-time activists. Within a year, their lives would change in unimagined ways. Three weeks after welcoming his baby girl, John Huggins was gunned down, along with Alprentice "Bunchy" Carter, on the campus of the University of California at Los Angeles (UCLA) by members of US, a cultural nationalist organization. In 1969, Ericka Huggins found herself incarcerated as one of six women in the New Haven Fourteen.* After her exoneration and release in 1971, she and her daughter moved to Oakland, California, where she became a teacher at the Intercommunal Youth Institute and eventually the director of its successor, the Oakland Community School, until 1981.

Like Ericka Huggins, Kathleen Neal left Barnard College to join the black freedom struggle, beginning with the Student Nonviolent Coordinating Committee (SNCC). In 1967 she traveled west to San Francisco, where she linked up with the Black Panther Party. By 1968, her political and media acumen propelled her to a leadership role within the party's Central Committee as the communications secretary. At the time, this made her the highest-ranking

* Leaders of the Black Panther Party in New Haven, Connecticut, were accused of conspiring to kill Alex Rackley, another Panther, because they thought he was a police informant. Several Panthers confessed, but the prosecution accused Ericka Huggins and Bobby Seale of ordering the hit.

woman in the party.[1] She had by then also married the party's enig-matic Minister of Information Eldridge Cleaver.

In her capacity as communications secretary, Kathleen Cleaver stood before a crowd in Merritt Park in Oakland on April 12, 1968. It had been only eight days since the assassination of Martin Luther King Jr. and six days since a shootout between the Black Panther Party and police during which her husband was injured. Although very much relieved that Eldridge, whom the police shot and ar-rested, had not been killed, Kathleen noted that a seventeen-year-old named Bobby Hutton had not been so lucky.

With characteristic calm, she read a telegram sent to Hut-ton's grieving family by Betty Shabazz, the widow of Malcolm X. The cable boldly declared: "Crimes against an individual are often crimes against an entire nation." After reading the communi-qué, she shared her own message, which summarized the travails of those heady days and prophetically foreshadowed those of the twenty-first century. "From the streets, from the flying of this bul-let in the air into the flesh of a black man, a whole structure pro-ceeds: walls of courthouses, bars of jails, locked keys, billy clubs, police."[2] She continued:

> Bobby Hutton took his stand; he gave his life. And here we are, we have our lives. He added something to them. It's up to us, to whether we can treasure that and carry that forward, or if we'll allow the walls of the jails and bullets of racist dog police to increasingly intimidate and encircle and murder us until we degenerate into a state maintained purely by brute police power. This time, this day, is not far off.[3]

For Ericka Huggins and Kathleen Cleaver—and for hundreds of Black Panther Party women and men—the forces of history, family, and then contemporary racial and economic inequalities, both at home and worldwide, propelled them into the liberation struggle. Whether poverty and racial discrimination, housing and educational inequality, assassinations of activists and politicians, po-lice brutality, or the Vietnam War, these injustices fueled people's

activist engagement and provided trenchant examples of why they must speak truth to power.

The names and stories of these black women revolutionary internationalists come to us through news articles, oral interviews, commemorations, documentaries, and still surprisingly few memoirs, autobiographies, and biographies.[4]

Wherever they joined the party, Panther women influenced and sustained one of the most prominent organizations of the expansive era of Black Power politics.[5] Their motivations for doing so were as expansive as Black Power itself. For example, after witnessing police misconduct, sixteen-year-old Tarika Lewis became the first woman to join the party, in 1967. She worked for the newspaper, contributing to the content as a cartoonist.[6] Tondalela Woolfolk recalled that, in early 1969, "I walked into the Harlem office and said I wanted to be a Panther" after she met Ericka Huggins and learned more about "the economic and political roots of the oppression of black people."[7] She lived communally with other Panther women in a "tenement slum" and worked as a state food inspector while selling newspapers as a member of the Ministry of Information cadre in New York. She also helped with the free Breakfast for Schoolchildren Program. Kiilu Nyasha, also known as Pat Gallyot, joined the party in 1969 after her job with the Johnson administration's so-called War on Poverty was phased out.* Ineligible for unemployment and needing to support her nine-year-old son, Nyasha applied for public assistance, which offered a paltry $25 a week. Her circumstances, coupled with an awareness of various efforts such as the Free Huey campaign and antiwar protests, led her to join the party in New Haven, where she worked to provide support for Panthers incarcerated there.[8]

Across the nation, Panther women learned from and worked with local black activist men and women, such as those black welfare recipients who, with New Haven Chapter members and a New

* In 1964, President Lyndon B. Johnson declared a "war on poverty" and subsequently introduced legislation that established programs to deal with national poverty in the United States. These programs included, for instance, the Community Action Program.

York women's liberation group, organized a rally on November 22, 1969, led by women to support the Panthers in New Haven and to highlight injustice at home and abroad. Panther women staffed and directed schools, child-care and medical clinics, free breakfast programs, and bus-to-prison programs. Their educational and health-care activism exposed institutional inequalities. According to Madalynn "Carol" Rucker, a party member in San Francisco, these community initiatives simultaneously addressed quality-of-life issues, offered a pathway for empowerment, and represented "another tactic for revolution."[9]

Panther women also greatly contributed to the party's ideology. In 1968, Kathleen Cleaver wrote the essay "Racism, Fascism, and Political Murder" for the *Black Panther* newspaper. In this work of political theory that called for action, Cleaver exposed concerted political repression through police and military power. She argued that after King's assassination the media failed to report "the repression against the militant black organizers and spokesmen in black ghettoes across the nation." Cleaver maintained, "The color line is the basis upon which wealth and power is distributed in this country; racism on the part of white institutions and white citizens forces black people to remain poor and powerless."[10]

Panther women traveled internationally and minced no words when analyzing oppression in the United States and worldwide. Connie Matthews, the party's Scandinavian representative, argued, "In order to rid the world of oppression and racial tensions, capitalism and imperialism must be destroyed."[11] The party maintained a revolutionary Marxist-Leninist proposition that extolled "proletarian revolution"; consistently argued for the eradication of capitalism, fascism, racism, and imperialism; and dismissed black capitalism as an option.

Panther women's vigorous critiques and activism also resulted in their arrests and imprisonment. The most well-known "political prisoners" were Joan Bird and Afeni Shakur in New York, Ericka Huggins in New Haven, and Assata Shakur in New Jersey/New York. Joan Bird and Afeni Shakur were two of twenty-one New York Panthers arrested in April 1969 and charged with conspiracy

to bomb numerous public city sites, including a police station, department stores, and the botanical gardens. All of the defendants were acquitted in 1971. A former member of the Black Panther Party and Black Liberation Army, Assata Shakur, nee Joanne Byron, was stopped in 1973 on a New Jersey highway, shot, and then charged with the murder of a New Jersey state trooper. After more than six years in prison, she escaped from the Clinton Correctional Facility for Women in New Jersey and surfaced in Cuba, where she has lived in exile ever since. There were numerous others who remain unknown to the broader public. Eighteen-year-old Shellie Bursey, a member of the National Ministry of Information staff, serves as one example.[12] This Panther woman, standing on her First and Fifth Amendment rights, refused to answer questions when interrogated during a federal investigation into the workings of the *Black Panther* newspaper. As a result, she went to jail.

Although both Panther men and women experienced beatings, surveillance, and incarceration, Panther women confronted gender-specific personal, intimate, and political challenges. Candi Robinson, a member of the Ministry of Information in Oakland, wrote a letter describing Bursey's arrest and the very specific degradation Bursey experienced. When Bursey arrived at Santa Rita Women's Prison in October 1970, "The pigs took her tampons and underwear and gave her a sanitary napkin with no belt to hold it up." The letter continued, "Shellie is a strong revolutionary with no feeling or self-sorrow . . . She is only interested in the people's struggle and therefore cares for her people as a whole rather than herself."[13]

An earlier article, on November 22, 1969, in the *Black Panther*, announcing a joint Free Our Sisters rally for the six Panther women among the New Haven Fourteen, also called attention to the inhumane treatment of black women: "In a final attempt to destroy the will of these revolutionary women, the ruling class is degrading one of the most beautiful experiences of women—childbirth." The article continued, "Besides denying them the most elementary human right to pre-natal and maternity care by qualified, sympathetic doctors, they are forcing these heroic women to give birth in the presence of brutal, dehumanized prison guards."[14]

In their efforts to expose oppressive power and vie for people power, Panther women filled a number of roles—some of which reinforced gender ascriptions and others of which challenged gender hierarchies. Panther women served in formal leadership roles within the party as well as seeking electoral office in their communities. Elaine Brown led the party after Huey Newton fled to Cuba to avoid a murder charge, appointed black women to administrative positions within the party, and ran for Oakland City Council, albeit unsuccessfully.[15] As strategists and tacticians, Panther women deployed their political expertise in organizing outreach, media, and protest campaigns. They sold newspapers, distributed party paraphernalia, and served as community liaisons. They also wrote columns, editorials, and articles in the *Black Panther* newspaper covering a range of views and issues, such as the black woman as "revolutionary" and police brutality against men and women.

Neither the Black Panthers' revolutionary ethos and agenda nor Panther women's struggles against state or societal violence, however, exempted or shielded them from patriarchy, sexism, and intimate violence within the party itself.[16] Panther women—just like other women, in the words of Ericka Huggins—confronted "sexist and abusive thinking" and "male chauvinism."[17] Huggins continued, "Men and women don't stop being in the roles we were trained to play because we join an organization, right? The socialization was there before we joined the BPP."[18] As a result, Panther women confronted and challenged the "-isms" not only outside but also inside their organizational ranks.[19]

The lives of Panther women indubitably reveal a great deal: black women's radical activism, varied expressions, and sites of revolutionary internationalism; the range of societal inequalities experienced by black people and black women more specifically; and the prophetic work of the Black Panther Party as well as its contradictions. Their struggles expose even more: the adversities and resilience as well as the spirit and poetics of living activist commitments. The first stanza of Ericka Huggins's poem "On Hearing Soul Serenade," which she wrote on June 7, 1969, while incarcerated, reads:

I am in jail and I am alone with Frances, Rose, Peggy.
I am a woman. Frances[,] Rose[,] and Peggy are
women. They are strong and I hope stronger than I.
maybe I am tired or maybe two years of working
with, fighting for the end to oppression and
brutality has weakened me—I have no right to
be tired, but I am. tired of not being able to
work and struggle without the invisible enemy's
attack.[20]

To channel her energy and particularly to stay "present" for
her baby daughter when she visited, Huggins also practiced yoga
and meditated. "I taught myself to meditate to still the fear in my
heart," Huggins explained. "I'm so glad that I was able to do that.
You can imagine that being away from a baby for two years means
that the bond between that parent and that child is broken."[21] Gloria
Abernethy also recalled the difficulties of parenting a baby and try-
ing "to make our life as 'normal' as possible—walks, regular trips to
the doctor, etc. After I started working on the paper full time, there
were times where I had to withdraw from her, and let her just be
the party's baby."[22] Abernethy also worked in one of the party's free
medical clinics. Numerous Panther women, like Huggins and Ab-
ernethy, became biological mothers in the middle of the liberation
struggle they helped lead and sustain, and this often meant addi-
tional personal responsibilities, hardships, and sacrifices. Even with
these serious challenges, however, the Black Panther Party spoke to
Panther women's revolutionary hopes and provided an apparatus to
enact antioppressive struggle.

Ultimately, an emphasis on the quotidian strivings and human-
ity of those suffering oppression and their rights to just treatment
and dignity undergirded the politics of the Black Panther Party.
On that score, the party's Ten-Point Platform and Program is just
as significant today with its focus on self-determination, full em-
ployment, an end to police brutality, fair trials, and education "that
teaches us our true history and our role in present-day society." As
a result, numerous Panther women have remained actively engaged

in the liberation struggle in their own ways. They have become lawyers, professors, social service providers, and community institution builders. Norma Mtume, who directed two different free medical clinics as a Panther Party member, cofounded SHIELDS for Families, a nonprofit serving children and youth in Los Angeles.[23] Continuing to address some of the issues that concerned her as a party member, Madalynn "Carol" Rucker started a consultation and training program focusing on substance abuse, mental health, domestic violence, and other health issues.[24] Yasmeen Sutton works for Greenhope Inc., which helps women navigating substance abuse and the criminal justice system in New York.[25] For these Panther women and other activists today, securing the basic necessities for a quality life—health care, land, food, and housing, alongside justice and peace—remains the world's crucial, enduring, and unfinished business in the twenty-first century.

Rhonda Y. Williams, an associate professor of history at Case Western Reserve University (CWRU), completed her PhD at the University of Pennsylvania. She is the founder and director of the Social Justice Institute at CWRU, the founder and director of CWRU's postdoctoral fellowship in African American studies, and the author of two books: *Concrete Demands: The Search for Black Power in the 20th Century* (2015) and the award-winning *The Politics of Public Housing: Black Women's Struggles Against Urban Inequality* (2004). The coeditor of the Justice, Power, and Politics book series with the University of North Carolina Press, Williams is the author of numerous articles and book chapters. These include "The Pursuit of Audacious Power: Rebel Reformers and Neighborhood Politics in Baltimore, 1966–1968," in *Neighborhood Rebels: Black Power at the Local Level*, ed. Peniel E. Joseph; "'To Challenge the Status Quo by Any Means': Community Action and Representational Politics in 1960s Baltimore," in *The War on Poverty: A New Grassroots History, 1964–1980*, ed. Annelise Orleck and Lisa Gayle Hazirjian; and "'Something's Wrong Down Here': Low-Income Black Women and Urban Struggles for Democracy," in *African American Urban History Since World War II*, ed. Kenneth L. Kusmer and Joe W. Trotter. She is also the coeditor of *Teaching the American Civil Rights Movement* (2002). As an educator and scholar-activist, she has delivered many presentations locally and nationally, appeared on MSNBC and Democracy Now!, and participated in local activist campaigns in Cleveland where she resides. She is from Baltimore.

CHAPTER FOUR

BLOCK BY BLOCK, DOOR-TO-DOOR
BUILDING COMMUNITY SUPPORT
BY SERVING THE PEOPLE

EQUIPPED WITH LITTLE MORE THAN ROTARY PHONES, NEIGHBORHOOD maps, and knuckles for door knocking, rank-and-file Panthers organized throughout the country, tailoring their messages and services to the unique needs of their own communities. Selling the party newspaper was required of every Panther, and those revenues were crucial to keeping the party going, but for many members, the programs were the real lifeblood of the party. By providing free breakfasts for schoolchildren, free health clinics, food and clothing giveaways, eviction intervention, buses to prisons, and even a free ambulance program in one chapter and a model school in another, the Panthers constructed mutually supportive community networks that fortified the party's growth and membership and even protected some Panther offices during police raids. However, as the party continued to come under increasingly intensive assault and as it split into two warring factions, that early swell of adulation receded just as quickly.

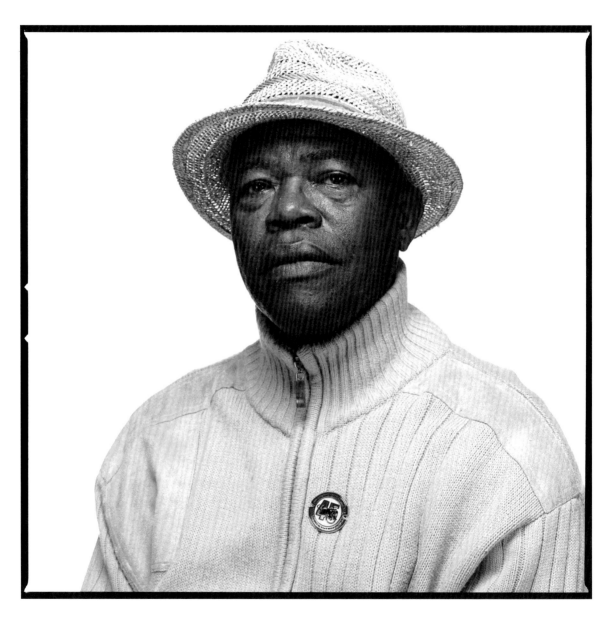

"It all started by going door-to-door. How else were you going to know who was in your territory?"

Billy X Jennings (b. September 8) finished high school in San Diego and moved to Oakland to attend college and avoid the draft. The first day of his summer classes at Laney College, he found himself in the middle of a rally to free Huey Newton, who would later make Jennings his personal aide. In the party, Jennings ran the East Oakland office as well as Bobby Seale's main campaign office when he ran for Oakland mayor. He currently runs itsabouttimebpp.com, an extensive archive of Panther materials and underground newspapers.

IN THE EARLY DAYS, WHEN I JOINED THE BLACK PANTHER PARTY, YOU had to go through a six- to eight-week training period. One of the things that went along with that training period was working in the community, where we implemented the Ten–Ten–Ten program. Every party member had a section to work in. My particular area was Brookfield, which is now off of Ninety-eighth Avenue, right next to the freeway over by the Oakland Coliseum.

Say I'm trying to get some information out. I would take a ten-block square area. In those ten blocks, you had ten people that you could contact. We're talking about telephone trees. I'd get on the phone. I'd call my ten people. I'd say, "We're going to have a rally down at the courthouse because some brothers were killed for no reason. Could you call ten people?" Boom! Those ten get on the phone and call another ten to get the word out.

It all started by going door-to-door. How else were you going to know who was in your section? The church lady wouldn't stop and talk to you on the street. If you came up on her stoop, though, she might engage you in a conversation. That door-to-door thing was very important because it let people know there was a Panther in the neighborhood, and if they had a question, they had someone to ask. We had a grievance board. Instead of calling the police, where they might come and take both of you to jail, you could call the Panther office. We'd come out there and try to settle the argument. If there was a barking dog, and a guy got off his shift at 12, he didn't want to hear the damn dog. Maybe we would bring the dog in or do something else. There were various little things in the community that we did that people really liked about the party.

To get food for the breakfast program, we went to mom-and-pop stores. They would tell us, "Oh, we're a small business. We don't have that much. We can only give you a gallon of milk, maybe two loaves of bread, and some grits." We'd say, "Okay," because if you multiply that by twelve mom-and-pop stores, you've got something. You start out with the basics. You start with getting contributions from those in your community, then you start going to the bigger institutions, such as the grocery stores and the churches, to ask for donations.

Sometimes they'd give you money. One church gave us a van so we could go to San Leandro, where they had an egg depot. There was a place in Oakland we could go and pick up milk that didn't get delivered the day before. We would use it the next day at the breakfast program for cereal. People from the church would start volunteering, and the minister would soon start talking about the good work being done by the Panthers.

You would knock on somebody's door. It might be a college student. They are progressive, forward thinkers. You might find somebody who just came back from Vietnam. He would say, "Hell, yeah! Call me, because I've been out there. I know how this shit is." There were church people who liked us because of our social programs. For instance, the people living directly behind Central Headquarters at 1048 Peralta would call us whenever the pigs came around to spy on the office. We had all these different eyes out on the terrain. We needed them because, at that time, Panther offices were being attacked, and we needed people. "Hey, our offices are being surrounded. We need your support. Could you come to our office and bear witness?" Having those eyes might act as a deterrent for the police, who tried to do things in the darkness.

I'm going to tell you this story here. We had an office on Ninety-ninth Avenue. It was the community center. The police department was drooling at the mouth to raid our office. This was around 1970. There was an alley in the back that wasn't lit up, so the police would be back there doing all kinds of mischief. What would give them away was our next-door neighbor's dog, named Nigeria. Nigeria would bark like hell, and that's how we knew there were police back there. If somebody else was walking through the alley, Nigeria might bark a few times, but that would be it. If police were out there, he would keep going. That let us know to be on guard.

One day, he gave their position away. I guess they were trying to pull a raid. The dog went crazy. The people of the neighborhood woke up, and they all came out so the police couldn't do what they wanted to do. The next day, the police came and let Nigeria out of the gate and then shot him, claiming that he was running around the neighborhood biting people. The people of that neighborhood got so mad at them that they put lights in the alley. Nobody could sneak around after that.

I know party history because of the various roles I played. Not only that but working at central headquarters, I received phone calls every day from all over the country. Detroit, Michigan. Des Moines, Iowa. Toledo, Ohio. Pittsburgh, Pennsylvania. There are a lot of hidden stories that haven't been told.

The work the party did with unions is never covered. In 1971, General Motors (GM) workers were about to go on strike. At that time, they had a big production plant in Fremont, California. Out of that came a group called the Black Panther Caucus, organized by Ducho Dennis. Panthers working there organized the workers and supported the union. I've got pictures of Panthers bringing food out to workers and, in the background, people walking with picket signs. The heads of the union and the Black Panthers aimed to negotiate a contract to prevent them from going on strike.

Not only that, Ducho was able to organize buses of workers and people to go down to support the United Farmworkers and Cesar Chavez. He made that initial contact. We worked closely with teachers unions in the city of Oakland, and when the teachers were going to go out on strike we aligned with them. Those stories are never talked about.

After people found out that I was building an archive, they would donate things they had at their houses because they wanted to put them to good use. Just recently, Hurricane Sandy in New York and New Jersey destroyed a lot of homes. A union organizer from Staten Island went home to help his mother fix up her house, and he found a stack of *Black Panther* newspapers from 1971 and 1972. He sent them to me, maybe thirty Panther papers. Then there was a university that donated material because we have a large collection not only of the *Black Panther* but also underground newspapers, with a few thousand in it.

Every day, I find different things, or people tell me different things. I find something that's connected to something else that I didn't know it could be connected to. I try to read the underground newspapers because when young people come here to do research, I try to be right there with what they need. At least three or four students a month come here from different parts of the world. I had one that came here from New Delhi. As long as the party's history is recorded right and young people can look into our history and find something they can use in today's society, then that is my reward.

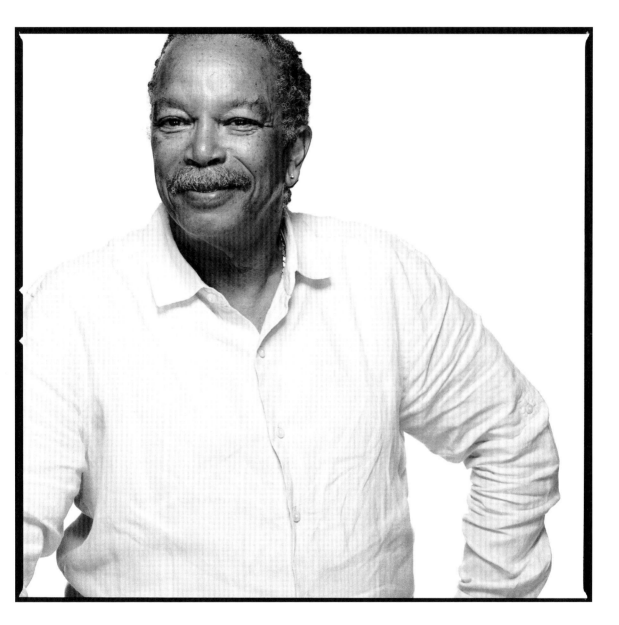

*"I think for us it was a lot deeper than that because we worked,
ate, slept, laughed, and fought together for years and years."*

Steve Long (b. March 8, 1950) grew up in Brooklyn, New York, where he joined the party. After moving to Oakland during the party's consolidation, he was involved in all aspects of producing the *Black Panther* newspaper, eventually running the entire operation by himself. He later built his career in commercial printing. The main client of his last company was Howard Quinn Printing in San Francisco, which happened to be the former printer of the *Black Panther* newspaper. He is the communications director of the National Alumni Association of the Black Panther Party.

I WENT BY THE HARLEM OFFICE IN THE SUMMER OF 1969 AND SAID, "I want to volunteer. I want to help out on the breakfast program. I'll do anything." The guy said, "You come to this church at 5:30 or 6 o'clock on Monday morning, and we'll work on the breakfast program." Going from Brooklyn to Harlem, I woke up very early and jumped on the subway. When I got there, nobody was there. I waited and waited and found out that a bunch of party members had gotten arrested. I stayed throughout the day, feeding everybody that showed up at the breakfast program, even some adults. I then went to the office and went out again to sell papers. I experienced everything from arrests to survival programs on my first day in the party.

I came back the next day and the next day. It got to the point where, rather than going home at 9 or 10 o'clock every night, I started staying in an apartment with four or five other prospective members. That was the beginning of the adventure.

I remember there was a knock on the door. Without really thinking, I made a naïve mistake and just opened the door. It was the police. The guy said, "You're going to die," and he walked away. That's all he said. They knew where we were. The threat itself was no big deal. After growing up in the projects it was part of everyday life. But that visit brought it home for me: this organization was considered very dangerous by the authorities.

I worked everywhere, Brooklyn, Queens. We used to have different campaigns with different advertisements. We took a bucket with some wheat paste and a big brush. The paste would freeze because it was New York in the winter. I forgot who came up with the idea, but we used to pee in the bucket to warm up the paste. You

mixed it around, and it worked. We sold newspapers on the train, in the subway stations. We sold papers in high-rise buildings and the projects so we could stay out of the damn cold. I got really sick a couple of times. I was nineteen years old and diagnosed with an ulcer. For a long time, all I ate was yogurt.

I guess I never really knew I was a full-fledged member until I was transferred to Connecticut. Bobby (Seale) and Ericka (Huggins) had gotten arrested along with almost the entire New Haven Chapter. They needed people to keep the office open and help secure their freedom. I was out selling newspapers somewhere in New York. We were supposed to call in every two hours because people were getting arrested under the pretense that they were loitering or illegally vending. I called in and was told to come back to the office.

When I got there, myself and another guy, Twymon Meyers, who was later murdered by the police, got bus tickets to New Haven. When we arrived in New Haven, we were greeted by the police. They said, "Welcome to New Haven, Steve and Twymon. Wasn't Doug supposed to come and pick you up?" Doug was Doug Miranda, the captain of the New Haven Chapter. They knew our names. They knew who was supposed to pick us up. We waited there for quite some time before we were picked up. That was a pretty serious wait.

It was infiltration. There were people who worked inside the party giving information to people outside the party. I couldn't tell you who they were, but that was a scary experience to be greeted by name by the police in an unmarked car in a city you just arrived in.

Moving out to Oakland was actually a little bit scary for me because you had read about all these folks in the newspaper, and all of a sudden you're right there with them. We were not privy to a lot of the high-level stuff. We were given information about X and Y to interpret and to try to carry out on the street in some kind of practical application for the people. Where there were differences between this person and that person, that wasn't the concern of the rank and file. Your concern was getting up in the morning and making sure you had the information you needed from the officer of the day. You did your job. The policy and theory weren't your responsibility.

People used to leave the party without notice. One day Benny Harris left, leaving myself and a woman named Phoebe to print the paper. I'm surprised that she stayed as long as she did. She had two young daughters, twins, and the work was incredibly fast paced and demanding. One day she left, and all of a sudden it was just me. Until then I had been a "gofer," so to be thrust into that position was a little bit scary, but at the same time I knew I could do it. There was no more crew. It was just me. During the last days of the party, it got pretty tense, and that was probably the saddest part of it, to see people that you'd worked with for a very long time just slip away in the night. I still had faith in the vision; I still had a desire to continue. I guess I wasn't ready to give up.

As time went on, we started publishing every two weeks. Then it was once a month. It was sad for me when it stopped because the newspaper used to be one of the things that I looked forward to, especially for Emory's art pieces for the back page. Sometimes those were the selling point of the newspaper. No matter where you were, you didn't have to explain what it was because it was very visual.

After that went away, I worked at the (Oakland Community) school for a while. Then, in the summer of 1982 the school, well, everything, just closed. Everything was done.

What does it all mean? For me as an individual it was probably the most formative period in my entire life, and it's influenced everything that I've done since. As members of an organization, many of us consider that we didn't complete our task. Consequently, the rise of the National Alumni Association is a continuation on some level of what we were doing.

I suppose it's a bond that not too many people will ever experience. Guys in the military call themselves bands of brothers. I think for us it was a lot deeper than that because we worked, ate, slept, laughed, and fought together for years and years. To have it end so unceremoniously was difficult for a lot of people, and a lot of people are still dealing with that separation.

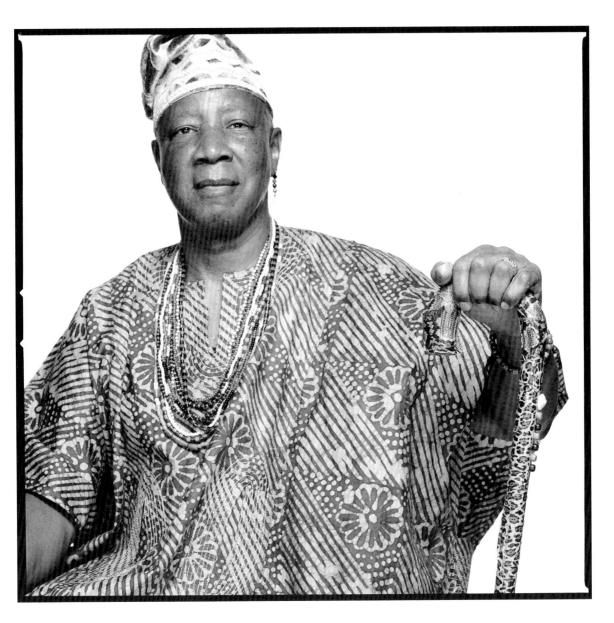

"I knew the police tactics. They would line up in front of the office and just start shooting."

Esutosin Omowale Osunkoya (formerly Charles Brunson, b. September 18, 1943) grew up in Miami and served in the Air Force, finishing up his stint near Sacramento, where he settled and became a mail carrier for the US Postal Service. He was the founder and defense captain of the Sacramento Branch of the Black Panther Party. Later, he ran group homes for neglected and abandoned children in Washington, DC, and then moved to Miami, where he worked with Haitian refugees.

WE HAD A SENSE THAT A RAID WAS IMMINENT, AND I KNEW FROM other shootouts across the country that somebody was always shot or killed, and most people got arrested. I didn't want that to happen to us in Sacramento, so I had an evacuation plan. I knew the police tactics. They would line up in front of the office and just start shooting. Well, that's exactly what they did. While everybody was running out of the park, we made sure they got through the office and out the back door, through the alleys and away from that area. Then we abandoned the building with nobody getting shot up.

David Hilliard* asked, "Why did you abandon the building? We told you to sandbag the window there." I had always argued in Oakland that sandbags wouldn't save our lives. Sandbags could only hold off so much before we were overrun. No Panther branch or chapter ever attacked a police station or home. They always came to our homes or offices. I knew that we couldn't defend those places. We had to abandon them. The police had enough equipment to stand out there for two days shooting us up, and we would still come out on stretchers or in handcuffs. It worked for us because nobody in the Sacramento Branch was ever arrested, shot, or killed.

The black folks of Sacramento came out in droves and helped us fight all night long. I always felt that if we hadn't been successful in doing what we were doing, the people wouldn't have helped us at all. We would have been in big trouble. We didn't understand at that point the extreme response that we were going to get for being Panthers. We just thought we were trying to help our community.

* Former chief of staff of the party and de facto leader during one of the periods of heaviest repression of the party.

Obviously, they were thinking further ahead on how to deal with us. If you look at history, no black settlement in this country was allowed to flourish. It was always destroyed first.

Don Cox[†] was impressed that when the police attacked us, no one was killed, so he sent me to Washington, DC, to start up a new chapter. I didn't leave Sacramento right away because I felt that if the authorities knew I was leaving town to organize elsewhere, I probably would be dead before I got to the East Coast anyway. I had to pretend that I was no longer affiliated with the Panther Party to take the heat off me. Myself and my lieutenant of education, James Mott (Saturu Ned), drafted up a letter that said I was expelled from the party because I was a thief who stole money. That worked perfectly.

I got to DC in December of 1969. I didn't help organize the chapter there until March of 1970. By that time they had decided the Black Panthers would have a constitutional convention in DC around September. Therefore, we had to work fast in getting things off the ground. I not only helped coordinate the chapter there but also started the breakfast program and opened a clinic there. I was working as an orderly at a hospital, so I came in contact with some nurses and doctors who wanted to help get a clinic started. We also had a busing program to Lorton Prison. I ended up networking and organizing up and down the coast because I thought we could protect each other better that way.

In 1970 Huey Newton finally came to the East Coast to speak at a plenary session in Philadelphia for the Black Panther constitutional convention before coming to DC. I knew him in 1965 or 1966, but the man who came out in 1970 was not the same man who went into prison in 1967. It became even more clear when I came out to Oakland to talk with them about DC. Huey didn't even recognize me. He didn't remember me. There was something strange going on. I didn't understand at that time the mind-inducement drug program that the FBI or CIA had instituted on him.

After the government compromised him, we were finished, without even realizing it. It was devastating to watch him deteriorate like

† Former field marshal of the party.

that. His whole personality had been completely altered. I was impressed with him at the beginning, but later I wouldn't have followed him across the street, let alone across the country. After that, each time I went out there, I never went to his penthouse. I didn't know the people surrounding him, so I stayed away. I came in specifically when they needed to talk to me about DC, and then I went back.

It was 1972 when they decided to run Bobby Seale for mayor. I came back out here and met Huey at Bobby's house. He was explaining how Oakland was going to become the base of operations for the Panthers. We would bring everybody out here and then send them back after Bobby became mayor. I thought that was the logic of a lunatic. This city, Oakland, where organized crime had a long-standing foothold, would suddenly become part of the Panther program? I couldn't see that happening. I argued that if you want to break down all the chapters on the East Coast and in the South, leave skeleton crews because we had viable programs that people depended on. Huey said no, close all the programs too. In my mind, I was thinking, "You close all the Panther programs across the country and bring everyone to Oakland, they could just wipe us out in one swoop."

Bobby Seale was trying to tell me that it was all right, we should just follow the program because Huey had a lot on his mind. I said the only thing on his mind were vacuum cleaners, the way he was sucking up bottles and bottles of Remy Martin, and I couldn't remember ever signing up for that.

I went back to close the chapters, but I also left them an option. Those that wanted to continue the programs would have to take the Panther symbol off the wall and just keep the programs going as community services. That worked out in DC, which kept the clinic. It worked out in Baltimore and Richmond and some places in New York as well. Meanwhile, they brought everybody out to Oakland in 1972.

Bobby Seale lost the mayoral contest, and by 1973, we started hearing things about drug dealers being robbed and other crimes being committed by Huey and his group. By the time 1974 came, a lot of people from the East Coast and the South wanted to go back

home, but the "whisper group"—that's what we called Huey's body-guards because they were always whispering to each other—would go to the apartments of people trying to leave and start throwing things around.

I had another group of people that would be there before the whisper group arrived because all these people came out to Oakland on my word. I brought them out, and I wanted to make sure they got back safely. By the time the whisper group started threatening me, I knew that my time with the party was going to be limited. We were going to end up shooting each other, so I stayed away from them except when somebody wanted to leave.

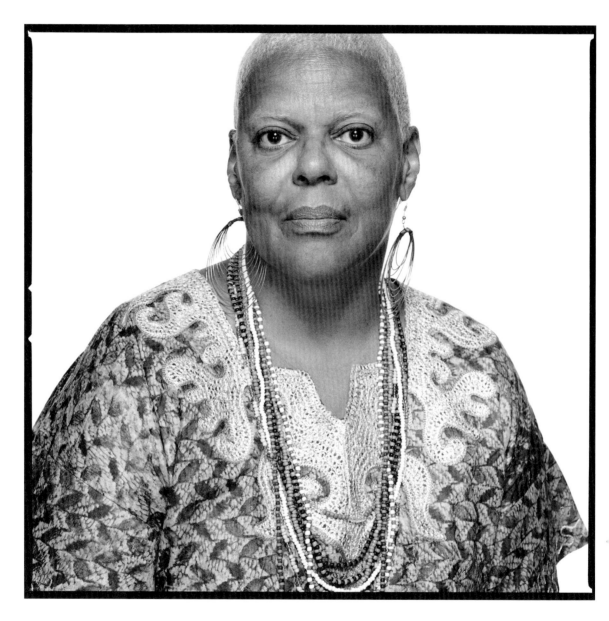

*"There were too many different personalities for everybody
to think we were always happy and laid back."*

Margo Rose-Brunson (b. June 14, 1950) was raised in Oak Park, Sacramento. She joined the Sacramento Branch of the party, where she helped run the day-to-day office operations and was in charge of newspaper distribution for the branch. She later worked for the California Department of Motor Vehicles and as a teacher at Bella Vista High School, both in Sacramento.

MY FRIEND SHARON ALREADY KNEW ABOUT THE BLACK PANTHERS and said she wanted to get me involved with this group. I said, "I don't want to hear any women talking and whining. I don't like to be around a lot of people if they're not really doing anything. And I'm not going to wear any Muslim bowties or tie up my head. It's hot in Sacramento."

She said, "No, it's something different."

We followed (Esutosin) Omowale (Osunkoya). I said, "That nigger is the police, girl. Look at him going to his trunk, taking his clothes off. That's indecent exposure." We found out he worked for the post office, and he was taking his uniform off and going to these Black Student Union meetings. We thought he was police. I went to the meeting, and I listened to them, and I accepted it. I accepted it because I needed direction. I didn't want to treat people like they treated us, so I had to change the hatred I had for white people to something better. I'm just being honest with you.

The youngsters that came into that office and joined the Black Panther Party still had to go to school. They could not come in that office until at least 4:00 in the afternoon. We'd be sitting out in front of the office, and we wouldn't let them do anything but say "hi" and be on their way. They would say, "We should be sitting out here ourselves. We can't even go into the office to say 'hi' to our captain."

I said, "Keep stepping. Go home. Keep it moving." Their education was important to us, and we didn't want their families to feel that we had their kids and that they weren't getting their education—because every single last one of them graduated. Their parents stuck around. I tell you, if anything had jumped off at those breakfast programs, those parents would have taken them out. Those are the same people that fought for us when they raided our office.

We ran our office in a way that fit the community. Oak Park was a very upstanding black community. We didn't need anything. We had a post office. We had a clothing store. We had a baby store. We had a liquor store on one corner. We had a black newspaper. We had a five and dime, which you always need. We had a restaurant, where everybody ate. If you had a dollar for a soda and a box of rice, man, you were rich.

Because people worked, sometimes there were just two women in the office, Sharon and I. So we had security rules. One of the rules was that there were office hours. If you wanted to see Omowale, you had to call and make an appointment. You just couldn't walk in there. We didn't do that. And if he didn't want to come out, you would have to leave and then come back.

They came down from Central Headquarters. Big Man* was with them. John Seale.† June Hilliard, David's brother. Well, we didn't know who they were. When we were in the office, we locked the door. I opened up the door, but I stood there. They said they were from Central Headquarters. I said, "Oh, we didn't know you were coming. Nobody alerted us. The captain's not here."

They said, "Well, we'll come in and wait."

I said, "Okay." I attempted to search them, and they said, "No, sister, that won't be necessary."

I said, "Well, if you want to come in here, that's necessary, and it's going to happen."

They said, "Do you know who we are?"

I said, "That's not the subject yet. We haven't finished with the first part. You can't come in unless we search you. If you've got weapons on you, you have to leave them in the car or your whole body can stay in the car." We didn't let them in. I shut the door. Click. I called Omowale and told him.

When Omowale pulled up they came in, and they were mad. They wanted me reprimanded. I'm looking at him like, "Man, you better go in that back with that meeting. I don't like that tone."

* Elbert "Big Man" Howard was one of the earliest party members.
† Brother of Bobby Seale.

One thing about our office, we never let anybody talk to Omowale in a disrespectful way. On the spot, anybody would check them. We never talked to each other like that. If we had a problem, we used to eat with each other, and if we couldn't resolve it, Omowale made us sell papers together. He made us work together. That's how we resolved it. That meant we had to talk to each other.

I explained to them, "If you come here like that again, and we don't know you're coming, the same thing is going to happen. I'm protecting this office. With two women in the office, what would you have thought if we just let you in and then you were able to do something to us?" That was never going to happen because Sharon had her hand on the sidepiece under the counter. They didn't really like it. I've had so many confrontations with those people. I have, really, and all men. All men.

I'm saying this to you because I don't want people to think we were not human. There were too many different personalities for everybody to think we were always happy and laid back.

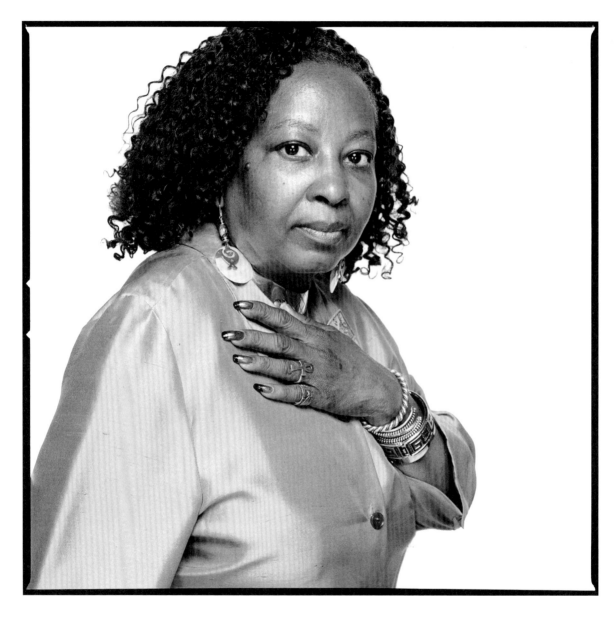

"Everything just stopped, the meetings, the teaching.
Everybody just dissipated and went their own route."

Patrice Sims (b. June 26, 1951) joined the Newark, New Jersey, Chapter of the party. She later worked as an arts teacher.

I FIRST MET UP WITH PARTY MEMBERS WHEN I JOINED RUTGERS UNIversity Black Student Union. Some members were classmates and friends from my high school. We started studying the history of revolutions in other countries, such as Cuba and China. We were studying the teachings of Mao Tse-tung and Che Guevara and also about the Black Panther Party, its missions and ideas, because they were just coming out at this time also.

Mainly, I was learning about what they were about and tried to find out for myself what was really possible to do. I became involved mostly with the political education classes, which comprised studying other revolutionary countries and their theories and trying to compare and contrast them with what was going on right then and there with the civil rights movement. I also worked a lot with rescue programs for children in the community, and I sold a lot of papers in Newark.

I got to talk to people and teach them about what the party was about and also raise money. I was a quiet person, and that's one thing that brought out the confidence in me. Sometimes I would stand on the street and talk for maybe thirty or thirty-five minutes and get a feel for what a person was like and interested in. Then they'd buy a paper, and I would get them interested in the party too. I felt a sense of worth that I was actually doing something for the community. For me, the Black Panther Party was this moment of personal growth. I was exploring new ideas, new learning, and new ways of looking at things and had to roll all of that information into one.

What really stood out was when the Black Student Union and the Black Panthers here in Newark got two buses to go to Washington, DC, to attend a protest rally against discrimination and racism and poverty. There were thousands of people standing up and saying, "No more." It was really awesome to see all those people there for a common cause. That's one thing that stayed in my mind a long time.

The other was the "split" of the party. It was shocking and devastating that two of the men so vital to the party (Huey Newton and Eldridge Cleaver) came to disagree so much. In Newark, we didn't know which way to go. The party was gone as far as we were concerned. It was like a bad, bad breakup. Everything just stopped, the meetings, the teaching. Everybody just dissipated and went their own route.

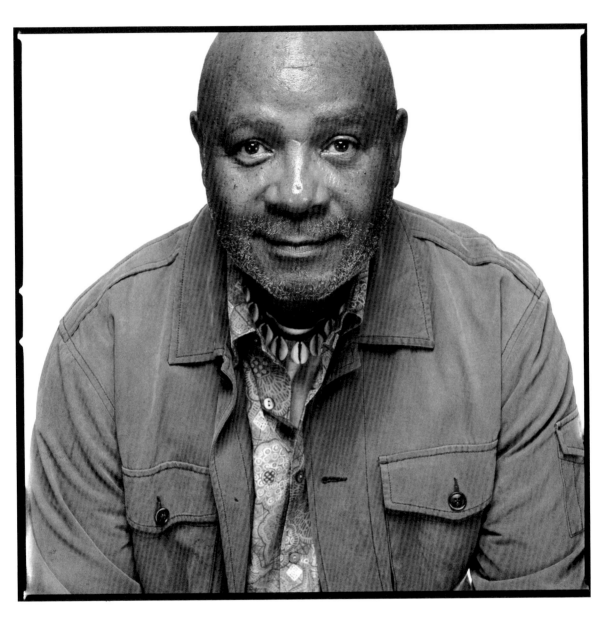

"It was about being involved with an organization that was respecting the civil rights movement and those who wanted to do more than turn the other cheek."

Emory Douglas (b. May 24, 1943) grew up in the San Francisco Bay Area and joined the party in 1967, a few months after its inception. He became minister of culture, and his artwork and design became a cornerstone of the *Black Panther* newspaper. He published a monograph of his work, *Black Panther: The Revolutionary Art of Emory Douglas* and has had exhibitions at the Museum of Contemporary Art in Los Angeles and the New Museum in New York.

I KNEW I HAD THE ARTISTIC SKILLS TO MAKE A CONTRIBUTION AFTER they started the newspaper, but that was not necessarily my reason for joining the party. It was about being involved with an organization that was respecting the civil rights movement and those who wanted to do more than turn the other cheek.

The first issue of the paper came out on April 25, 1967—the Denzil Dowell paper.* They worked on it in what used to be called the Black House in San Francisco, which had a lot of cultural events downstairs. Sonia Sanchez, Ed Bullins, Amiri Baraka, Marvin X. All those folks used to come through there. Eldridge (Cleaver) lived upstairs.

I believe Elbert (Howard) wrote the article and Bobby Seale was cutting and pasting and laying it out on a legal-sized sheet of paper. Bobby Seale also typed out the first masthead on that sheet. That was the first issue of the *Black Panther* newspaper. I told them I could help them improve it and went home to get my materials, but when I came back, Bobby said they were just about finished, but they were impressed that I returned. That was when Huey and Bobby said they were going to start a tabloid paper, and they wanted me to be the paper's revolutionary artist. They had a whole vision of what the paper would be about, to tell our story from our perspective and to be like a double-edged sword: it could praise you on one side and criticize you on the other. Then we talked about how it would have large captions and photographs so that those in the

* Dowell was killed by the Richmond, California, police while fleeing an alleged burglary. The Panthers took up his cause and galvanized the community in what became one of their earliest organizing successes.

THE BLACK PANTHER – April 25, 196?

The BLACK PANTHER

VOLUME 1 APRIL 25, 1967 **NUMBER 1**

P.O. BOX 8641 OAK. CALIF. EMERYVILLE BRANCH

BLACK COMMUNITY NEWS SERVICE

PUBLISHED BY THE BLACK PANTHER PARTY FOR SELF DEFENSE

WHY WAS DENZIL DOWELL KILLED

APRIL FIRST 3:50 a.m.

"I BELIEVE THE POLICE MURDERED MY SON" SAYS THE MOTHER OF DENZIL DOWELL.

Brothers and Sisters of the Richmond community, here is the view of the family's side of the death of Denzil Dowell as compiled by the Black Panther Party for Self Defense, concerned citizens, and the Dowell family. As you know, April 1st, 1967, Denzel Dowell (age 22), was shot and killed by an "officer of the Martinez Sheriff's Department", so read the newspaper.

But there are too many unanswered questions that have been raised by the Dowell family and other neighbors in the North Richmond community. Questions that don't meet the satisfaction of the killing of Denzil. The Richmond Police, the Martinez Sheriff's Department, and the Richmond Independent would have us black people believe something contrary to Mrs. Dowell's accusation. That is, her son was "unjustifiably" murdered by a racist cop.

There are too many questionable facts supporting the Dowell family's point of view.

These questionable facts are as follows:

1. Denzil Dowell was unarmed so how can six bullet holes and shot gun blasts be considered "justifiable homocide"? (Con't Page 2)

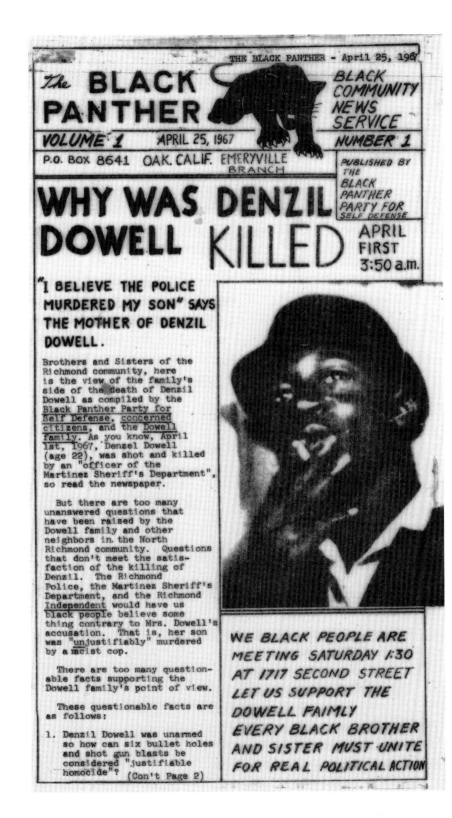

WE BLACK PEOPLE ARE MEETING SATURDAY 1:30 AT 1717 SECOND STREET LET US SUPPORT THE DOWELL FAIMLY EVERY BLACK BROTHER AND SISTER MUST UNITE FOR REAL POLITICAL ACTION

community who couldn't read or didn't want to read the long editorials could learn from just seeing the pictures or the captions.

It was about the third or fourth paper, I think, when Huey asked me to do this artwork of a pig on four hoofs. They were going to include the badge numbers of the pigs harassing and intimidating people in the community, the bad actors. It just so happened that the first badge number that we put on there was of a policeman named Frey, who got killed when Huey got shot. That's when the Free Huey movement started.

Our people responded in a humorous way to the art, so I knew that people had some emotional connection to those iconic images that transcended the black community. The pig drawings were something that people began to identify with as a symbol of oppression across borders. It was a visual language, but a visual language that reflected the party and its politics and ideological perspective through the Ten-Point Platform and Program. Also part of the artwork was listening to people's feelings and expressions about issues and interpreting those things, sometimes in a very positive way. When I drew images of black folks in the community, some people said they could see their uncle in the images or they were reminded of their father. They thought we were making them heroes or putting them on stage in the artwork itself. That was the evaluation after the fact, but that's what was really going on, and that's how they identified with the images.

When the paper became a twenty-four-hour, seven-day-a-week, 365-day operation, most of my time was either spent at the office working or even sleeping there day in and day out. At the same time, we had agents and police follow us everywhere. They used to tell me, "Well, since you won't talk to us, we need to take it to another level." So they used to try to harass me, and I would tell people out in the community, "Hey, this guy is the police or FBI."

During Huey's trial we had a skeleton crew at the office. One day I had to get some paper and materials at the paper shop. When I came back, there were five or six guys out in front of the office, shouting, "Auction! Auction! Building for sale!" I didn't pay it any mind at first. Then I went in and closed the door. They continued

saying that, so I went back out and said, "This isn't for sale. This building isn't for sale."

They got very aggressive, and at that point I understood what was going on. I walked back in and closed the door. I went upstairs and looked out the window, where I saw a guy in a green car pull up. These guys outside started talking to the guy in the green car at the corner, and because I was looking down, I was able to see the guy in the car hand one of them a gun.

I explained what was going on to the comrades in the office and then drove down to the courthouse to let them know what was going on. Court was recessed at that time, and just as I was explaining, the same guy who took the gun was coming out the back with the police. I pointed to him and said, "This is the guy, right here, who was just at the house."

I guess in their report on me they said, "Watch out. He's a hothead. You have to approach him differently." I assume they thought I was going to respond or react, and they would have an excuse to start something. No one was immune to this.

The art was well known, but I was not. I never felt that I needed more credit for the work because I felt that the work would stand for itself if it was relevant. And it could always be improved to a consistent level based on what we had to work with, which we were able to do most of the time, not all of the time, but most of the time. You could say I did about 85 or 90 percent of the work, but there was still a huge volume of graphics that other artists contributed. I was always teaching people who worked with me. Some were much better artists than I am. I just had to show them how to integrate the politics into the artwork that they were doing and give them the opportunity to display their work on the back of the paper.

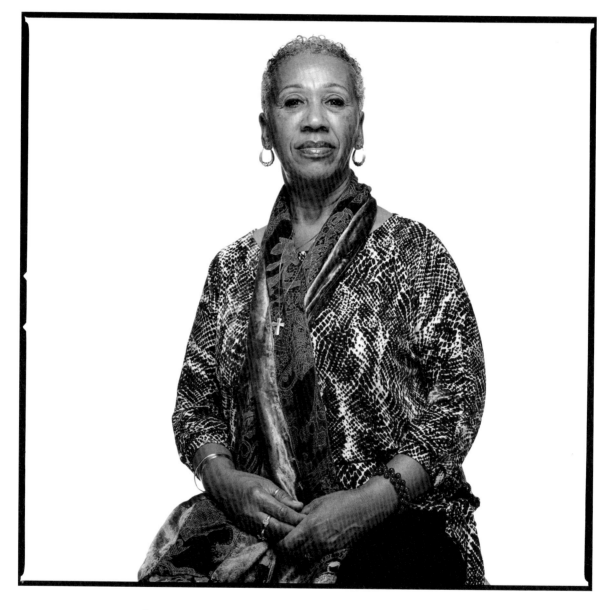

"Even someone like me was able to contribute."

M. Gayle Dickson (aka Asali, b. June 27, 1948) is a lifelong artist who drew for and helped put together the *Black Panther* newspaper in Oakland. She was also a teacher at the Oakland Community School. She received a master of divinity and is an ordained minister.

EMORY (DOUGLAS) HAD US WORK TOGETHER AS A TEAM. THERE WERE about five of us, and we'd talk over ideas and come up with what to put in there. Putting together the newspaper was fun, but it was also deadly serious. It had to be error free and really content rich.

We had a warehouse in Oakland that we had purchased. The graphics department, where I worked, was upstairs on the second floor. Benny the printer was downstairs. We had everything right there. The editorial room was right next door to layout. We'd work around the clock. We'd sleep there. We'd eat there. It was an exciting time. It was a time of self-development whether I was aware of it or not. It was also very intense. I was eight or nine months pregnant and working on the paper when I dropped an X-Acto blade on my stomach. It didn't stab me deeply but that's how driven we were.

We had a typesetting machine that came up to about eye level, and we would sit at the machine and type in codes—F42 to indent, F5-space to get a certain character—to get those articles out. They came out in strips, which we proofread and corrected. Then we waxed the backs of those strips, cut them, and laid them in place. I and another woman named Leslie, I believe, did a lot of the typing. We had a friendly competition. How fast could we get stuff done without errors.

"I only had one error."

"I had none."

That developed my speed and actually became a survival tool when I left, because I was typing 120 words a minute.

We had another little competition to see if we could lay a correction down over a misspelled word without using a tool to line it up. Those kinds of things were tiny, but they helped develop your work ethic and pride. After that, the papers were folded and stacked, and we'd take them to the airport. Strangely enough, the police

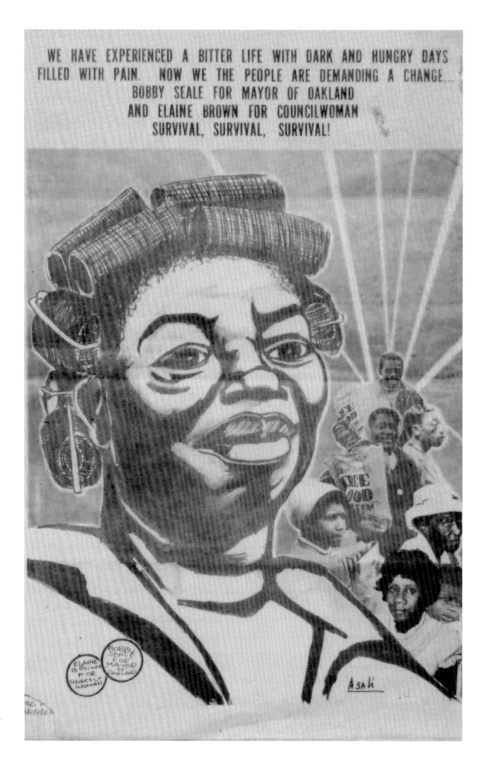

never hassled us on the way, even though we must have driven 400 miles an hour to get them to the airport on time.

After about two or three years on the paper, I transferred to the Oakland Community School. It was a survival program and a very good one at that. I was a preschool teacher for cognitive skills. I was looking at child development and using art as a tool to get them kindergarten ready. I also used food and art to teach communication and basic skills. For some of us like myself not to be certified teachers, we taught those kids, and they learned so much. The school became so popular, to the point that there were too many kids.

When you have an environment where children are encouraged to grow, they will grow in a positive direction. My fondest memory was of a young girl who could not formulate her words. She just made sing-song sounds. After coming back from a field trip, while the kids were napping, I drew the trip with stick figures—leaving school, riding over the Bay Bridge, the fish below, all the way to the site. When the kids woke up we went over the story, and I told everybody, "You have to tell your parents what you did today." Her mother came to pick her up, and she took her mother to the drawing and explained the entire trip. She was articulating clearly! We could understand every word. I remember her mama looking at me with such happiness. That's how I used art as a tool.

I could draw. That was me. The school was a new experience where I was able to use my art as a tool. It was a learning, growing experience. I didn't follow a lot of the stuff that was going on inside or outside the party. I knew the large picture, but I didn't know the details. Just think about that. Even someone like me was able to contribute.

"We believed in what we were doing and never really questioned it."

Christine Choy was born in the People's Republic of China and moved to New York City when she was fourteen years old. She cofounded Third World Newsreel, a film company focusing on people of color and social justice issues. As a documentary filmmaker, she has produced and directed more than eighty films, one of which, *Who Killed Vincent Chin?*, was nominated for an Academy Award. She is a professor at New York University's Tisch School of the Arts.

I WAS A VOLUNTEER FOR WBAI* IN HIGH SCHOOL. ONE OF MY DUTIES was covering the Panther Twenty-One trial at the Tombs.† There were lots of supporters outside and inside, including a lot of white people. Because I came from China, they thought I was a big-time Maoist, which I was not. I understood it because in China we had to study Marxism-Leninism and dialectical materialism, and we had to memorize everything in Chinese. At the time, the Panthers were studying the same things. They were reading the Red Book. I fit in quite well, and through covering the trial I got to know some of the leaders indirectly. Of course, the Panther Twenty-One were acquitted, and soon after I started doing errands for them because they trusted me.

My parents were not with me. I was here by myself. I did whatever I wanted to. I believed in socialism in many ways. I really felt that black people were very much oppressed. That ideology came when I was young. In all the movies we saw in China, all the black people got beaten up. We saw films about African liberation. I was born in China under communism. I was brainwashed in many ways, but I really believed in anti-imperialism, anticapitalism, antiracism. We had to leave China because my father was in the underground movement before the Cultural Revolution. We moved to Hong Kong, which was colonialism; then we moved to South Korea, which was neocolonialism. That was the first time in my life I saw racism. The black GIs and the white GIs were segregated in Korea. They even had different hookers. My school was right in the middle of the city. It was an overseas Chinese school. I saw the

* A publicly supported radio station in New York City.
† A nickname given to a series of downtown jails in New York City.

literal segregation very clearly. Then I moved to Japan, a monarchy. By the time I came to America, I had all the "-isms."

I was a Panther Youth. I was not that important. I did the running around for the big shots. For the constitutional convention* in Philadelphia, I was in charge of the Asian American contingency. I was also asked to visit different chapters of the Panthers, mostly on the East Coast, to talk about communism in China and show films. I was able to get some films from the Chinese embassy in Ottawa. That's why the FBI started visiting me. They had all these pictures of me in and out of all these embassies and consulates that didn't have diplomatic relationships with the United States, but they had UN observer status. They asked me, "Why were you visiting these enemy embassies and consulates?"

I said, "I'm distributing films." Newsreel ended up with quite a large collection of films from Angola, Mozambique, Cuba, North Korea, China. Those were all enemy countries. Later on, I did ask for my FBI file. It was really funny. They used so much Wite-Out™.

There was a fancy, five-star department store called Bergdorf Goodman. Black people going in there were kept under a very watchful gaze. When Panthers wanted to buy briefcases and things like that, it was my duty to go buy them. I bought lots of them, which was really crazy. Panthers liked briefcases. The top people carried them. Once I went in with an African American girl. Rosalind was her name. We got caught using other people's credit cards. It was the first time we ever got caught. They obviously didn't arrest Asians. We looked so innocent. No one ever suspected Asians. Asians didn't steal. We were bookworms. Those were some of the things I did. There were some others that I cannot talk about.

Those days I was really proud to do something against the system. The government was doing all these terrible things to black people. Fred Hampton got killed. In the antiwar movement, so many students were arrested. There was Watergate. You just felt

* The Black Panther Party called for a gathering of diverse revolutionary groups to assemble and craft a new constitution that would shape their ideal society. The so-called Plenary Session of the Revolutionary People's Constitutional Convention, held at Temple University in Philadelphia in September 1970, drew thousands of people, but a new constitution never materialized.

you had to do something to try to destroy the government. Obviously there wasn't enough power to be able to do that. The government had the military.

Ultimately, by the time I was nineteen, the movement died out. A lot of my friends got killed, so I got scared. Organizing youth was very easy because we were innocent. We believed in what we were doing and never really questioned it. When you get older, then you start questioning a lot of things. It was an interesting period, I must say. We were so dedicated.

*"The community was standing with the Black Panther Party to say,
'This is something that we want. This is something that we need.'"*

Nelson Malloy (b. September 22, 1946) helped found the Winston-Salem Chapter of the Black Panther Party in North Carolina, and he also ran the chapter's free ambulance service. He was shot by fellow Panthers and left for dead in the aftermath of a botched assassination attempt (in which Malloy was not involved) to silence a potential witness in a murder trial against Huey P. Newton, the charges for which were eventually dropped.

THERE WAS A GROUP OF US TALKING ABOUT THE ILLS IN OUR COMMUNITY. The Black Panther Party became a vehicle to change those conditions. We wanted to do more than simply talk. We wanted to bring about meaningful change, to stop the police brutality, to stop the discrimination, to do something to help black folks get a better education, better jobs, better pay, and better health care.

Now a lot of times we can identify a problem, but very seldom do we come up with a solution ourselves. We take it to the powers that be, and we hope, pray, and leave it in their hands to implement a solution. One thing about the Black Panther Party, we believed that we could identify a problem and then institute a solution, as with the Joseph Waddell People's Free Ambulance Service, where I was the executive director.

For a while in Winston-Salem, black morticians and funeral home directors were the ones who took black folks to the hospital. At some point, they lost the authority to do that, and the Forsyth County ambulance service was ordered to pick up everybody. But they often told black people, "Well, you're really not that sick, so we're not going to transport you." On more than one occasion, that person became very ill, and even then, they were refused again—and died. These things were making headlines because people were complaining. At that point, we said, "Enough people have died, enough people have been discriminated against. We're going to start our own free ambulance service to deal with this problem."

We applied to the national and local Episcopal church for help. One prominent member in Winston-Salem said, "You guys stand about the chance of a snowball in hell of getting the support of the Episcopal church in Winston-Salem to start a free ambulance service. You are the Black Panther Party." We overcame negative

publicity surrounding the Black Panther Party, the onslaught of the FBI, and the Winston-Salem Police Department to get the ambulance service started, so I think that was one of the most important things that we did in this city.

We transported a whole lot of white people with our services too. We would never have been able to get a certificate to operate if we discriminated. This service was for anybody and everybody who needed it. In fact, we had a contract with a racetrack, Bowman Gray Stadium, where these white folks raced cars every Saturday night, like NASCAR. If somebody got hurt, we would scoop them up between our calls. A couple of guys got hurt—I can remember this so clearly—they got banged up on the track, and because we were the Black Panther Party, they refused to get into the ambulance.

That free ambulance service was one of the most profound programs that we worked with, and what made it so beautiful was the fact that it was able to operate because of the warm and tremendous support we received from the people in the community. That was the key to that program from beginning to end, to demonstrate to the Episcopal church to get our grant and to the city and county to say that it was not just the Black Panther Party alone. The community was standing with the Black Panther Party to say, "This is something that we want. This is something that we need."

Most of the folks who went through the training to be attendants, they were community people. These people would take the time after they worked all day to ride thirty miles, fifty miles to these various community colleges to get their certificates as emergency medical technicians. They were the backbone of this ambulance service who made it possible for us to be successful in its operation. They also went out and helped collect donations to keep the service operating.

Often the question is asked, "Well, how many members were there in the Winston-Salem Chapter of the Black Panther Party?" We never throw out a specific number because we had strong, hands-on community support, the key to our success not only with the ambulance service but with all the other programs that we operated. We had lots and lots of community volunteers who went far

beyond ordinary service to make them successful because they believed in them. The party was under constant assault, so people were not running over each other to become members of the Black Panther Party. But they could be committed to work with our programs and support us in those types of efforts. They saw a need for them, so they put sweat equity into making sure these programs were successful.

The journey of doing it all was something that just blew your mind. It was unbelievable. We had a saying, "Use what you got, to get what you need." We used that phrase in all of our undertakings. We didn't have much, but whatever we had, we were able, through the power of persuasion, to make people believe and understand what we were trying to do. Whatever would persuade a person to give us a hand or cut us a break or sell us something at a lower price. Man, it was really a phenomenal time.

I like to think that in some small way by our participation, by our dedication, we could stand on the shoulders of our ancestors and be mentioned, maybe in the back row, of people like W. E. B. Du Bois, Frederick Douglass, Martin Luther King Jr., Malcolm X. That we would be mentioned to some small degree as playing some sort of role in the overall struggle for the liberation not just of black people but the liberation of all people from oppression, discrimination, and exploitation.

I was a member of the party from 1969 to 1977, so that's roughly eight years of my life. I put my life on the line for my people and for the Black Panther Party, only to have two members try to kill me. Without going into the details of it all, it was an assassination attempt. It was an understatement to say I was crushed, devastated. Any word I could use would not adequately define how I felt at the moment that it happened and for a time thereafter. I thank God that I survived it.

I have my own idea about what happened and how it happened. I'm at a loss as to why it happened like it did because I don't think things had to unfold the way that they did. I guess only me and whoever else might have been involved can answer that question. I guess I'll leave it at that.

People often say, "Wow, man, how did you survive it? How could you keep going and still try to make some sort of contribution and be of some service to your community and to people? Why would you not be bitter and denounce the organization?" You sum it up like this: being bitter, being angry, that will not change my condition of being paralyzed. That probably would just usurp too much of my energy and would probably affect me even more negatively. Individuals in the party did this, but that didn't negate the party I knew and the party that I was a member of and the things that motivated me in terms of what the party stood for in the Ten-Point Platform and Program.

We wanted decent housing, we wanted full employment for our people, we wanted the power to determine our own destiny, we wanted education for our people, we wanted an end to police brutality and murder, we wanted an end to wars of aggression. That assassination attempt didn't change that full foundation of beliefs that the party was founded on. That didn't change that in my mind. I guess that's kind of a strange way of telling you how I felt. People say, "Hey, what you saying ain't making no sense." But it makes sense to me.

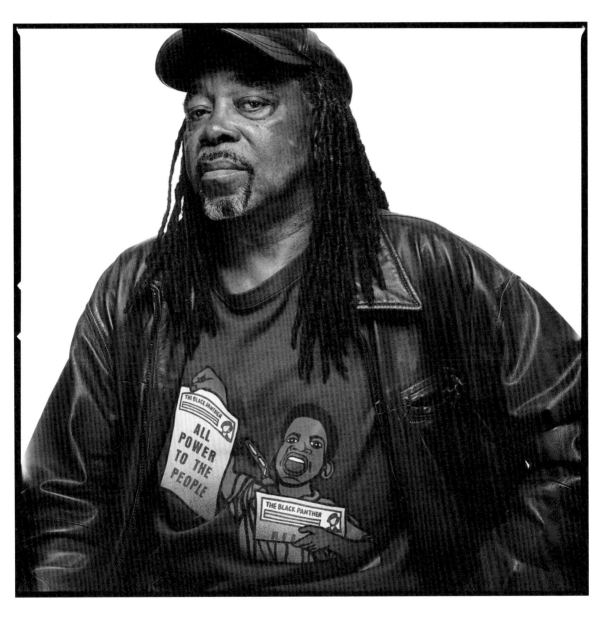

"*I joined because of macho bullshit, but I became a servant of the people.*"

Richard Brown (b. March 23, 1941) grew up in San Francisco, where he joined the party. As one of the San Francisco Eight he was charged in 2007 with the 1971 killing of a San Francisco police officer, charges later dropped. He worked at the Ella Hill Hutch Community Center in San Francisco as a coordinator for programs involving jobs and education. He was also a judge for a San Francisco community court program, an alternative to criminal court.

I joined for the wrong reasons. I joined out of machismo. I joined for the gun. I joined because we were standing up and talking about fighting the police. When the police pulled people over in the community we would stand there and watch with our guns to ensure that they didn't murder or brutalize them. The people in the community quickly pointed out that that was all well and good, but they had so many more problems, and that's when we started our social programs. I joined because of macho bullshit, but I became a servant of the people. One of the greatest things I did was participate in the Breakfast for Schoolchildren Program to help feed children every morning and take care of the elderly. Before that I was just a regular brother on the block, surviving day to day. A little thug, so to speak. But I hated the way that I was raised and the things that had happened to me in America. We were second-class citizens, told that we would never amount to anything. We were treated as criminals in our community and bullied by the police. I didn't want my sons to grow up in that environment.

I did a little bit of everything, but I was very good at organizing the community. That was a role that I loved. A brother by the name of John Bowman, deceased now, taught me a lot about working with people because at that time I didn't trust many people. I was a loner, and he convinced me that because I was older I had a lot of influence, and I had to help educate people and help organize because I was accepted in the community.

We organized block by block. We would pick someone's home and ask him or her if we could hold education classes there. We helped organize that way by talking to people and getting them to understand the power of community. I just happened to be good at

that. I sincerely believed in what I was saying, and I was respectful to elders, who saw that I had love for the people.

I was a 24/7 Panther. I got arrested a lot, so much so that at one point members of the Oakland Chapter said that they weren't going to bail me out anymore. I got busted three times in one week. That was the type of relationship I had with the police: if they weren't trying to kill me they were trying to lock me up for life. That was one of the tactics they used to drain our resources and undermine the party. I got arrested so much, and we always paid them, so the bail bond agencies realized that the more they released us, the sooner we would be back, and they could get more money to release us again. I was good business for them.

My case was extreme because like I said, I was a 24/7 Panther. The police focused on all of us who were. That's why Bunchy Carter and John Huggins* and Fred Hampton† and others were murdered—because they were relentless and great organizers, making them a tremendous problem.

I was there every day in their faces doing something. They realized early that something had to be done about me, which was why I was framed several times and sent to the penitentiary. Each time I got out on appeal because they just railroaded me—every time except one in which I was truly guilty, and I am not ashamed of the fact that I was guilty.

That one time was for bank robbery. When I say that I was always doing something, I was always doing something. There

* Carter and Huggins were leading members of the Los Angeles Chapter killed on the University of California (UCLA) campus in January 1969 in a gunfight with members of rival organization US. An investigation into COINTELPRO by the Church Committee later revealed that the FBI had purposely provoked tensions between the groups.

† Hampton was a highly charismatic Panther leader from the Illinois Chapter who was by all accounts a brilliant organizer who forged strong alliances with other revolutionary groups. Considered a serious threat by the FBI, he was killed in his sleep by Chicago police working closely with the FBI. Panther Mark Clark was also killed in the raid. The city of Chicago and the federal government later paid $1.85 million to settle a lawsuit brought by the families of Hampton and Clark as well as other survivors of the attack.

were brothers and sisters in jail who needed bail. The Breakfast for Schoolchildren Program always needed money. We always needed money for attorneys to fight cases such as Huey's and those of other Panthers arrested throughout the United States. We always got donations from a lot of different people, but they were never enough. I decided that if I robbed a bank and got away with the money in the vault and not with the tellers, I would be able to help a lot of brothers and sisters throughout the United States. Unfortunately, I got caught.

Sometimes the police would threaten me. They would pass by in a patrol car and take out their guns and point them at me while I was working in the community. They called me the "N" word and told me they were going to kill me. I got threatened two or three times a week. At one time, honestly and truly, at the infamous Northern Station in San Francisco, the police had on the bulletin board my picture and a picture of the car I was driving along with a reward for the cop that killed me. I found out about it. I told an attorney. He went to the police commissioner, and he made them take it down. That was the attitude that they had toward me and the attitude I had toward them. We hated each other.

There was a lieutenant at Northern Station who was sincere. One time I got picked up for nothing, and they didn't even wait until I got inside the station. They started beating on me in the street with flashlights, stomping me and kicking me. They fractured my jaw that time. Unfortunately for the cops, all the witnesses were white, and they tried to stop it.

The lieutenant came in and wanted to talk to me. He honestly and truly wanted me to press charges against the officers who did that. In my mind that wasn't the way that I was going to get back at them. He stayed in my cell for almost an hour. He really wanted to understand what the Black Panther Party was about, why we were doing it, and if there was any way that we could eliminate the barriers between the party and the police and try to work together. He saw that we were trying to clean up our community from crime and drugs and prostitution, and technically that's what he was trying to do, even though a lot of the cops were on the take back then.

I told him about the Black Panther Party and what we were trying to do. He kept saying that we should be on the same side, and I kept telling him that was not going to happen. I said, "It's not possible as long as you have thugs like the ones that just beat me up working for you. How the hell am I going to be on your side?"

They will never forgive the Black Panther Party because we exposed them for what they truly were. Before the Black Panther Party the police were feared throughout every black community in the world. They were the bullies. They were the big dogs. When they came through everybody cowered. They could kill people. They could beat up people. They could frame people.

The Black Panther Party stood up and showed everybody the police were nothing but bullies. They hated the fact that little brothers and sisters, little thugs standing on the corner, organized and beat their ass to a certain extent. That's something that they have to live down, and they hate us for it.

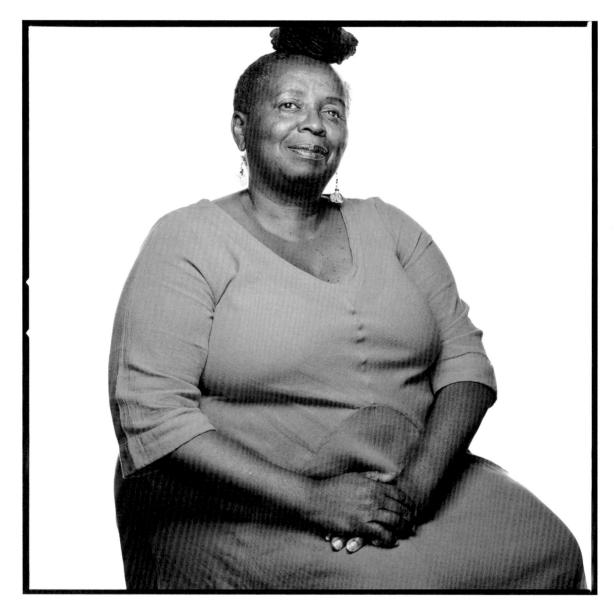

"They said if you die, at least die fighting back."

Hazel Mack (b. June 12, 1951) was a member of the Winston-Salem, North Carolina, Chapter of the party. She graduated from Temple Law School and serves as regional managing attorney for Legal Aid of North Carolina. She is also founder and board president of the Carter G. Woodson K–12 Charter School.

The earliest memory of my life was sitting at the end of a cotton row while Mommy and Daddy picked cotton up and down. Now, I never thought I was poor. I never went hungry. But at a certain age, you realize the price and the pain that your parents paid to give you the basics of life. I was sixteen in the middle of the 1960s, and the consciousness of what the world was like outside of my immediate surroundings started to flow in. At that point I came to understand that things were not right at all. That rushes right in on most black children around the teenage years.

After the killing of (Martin Luther) King (Jr.), I parted with the idea that it was okay to let people beat you down in the street and put dogs on you. I didn't understand that, so the party became far more attractive. They said if you die, at least die fighting back.

I came up in the church in Sunday school. You participate in the programs. So being a part of and organizing something wasn't foreign to me. Bringing programs to the community—that's what really attracted me to the party. Our focus here in Winston-Salem was very much on the survival program. We probably were not as tied to the National Headquarters as most people. Geographically, we were somewhat isolated, but we trained. We sent family members out to Forsyth Technical College and brought back that training in order to alleviate the suffering in our community. We had a breakfast program and a clothing and shoes program. We had a pest-control program because housing conditions were so bad. People had all kinds of infestations. We would periodically give away bags of groceries in different parts of town. My personal favorite was giving away 1,000 bags of groceries with a chicken in every bag.

We had a free ambulance program because it was needed here. That's not something that existed anywhere else. It was a bold

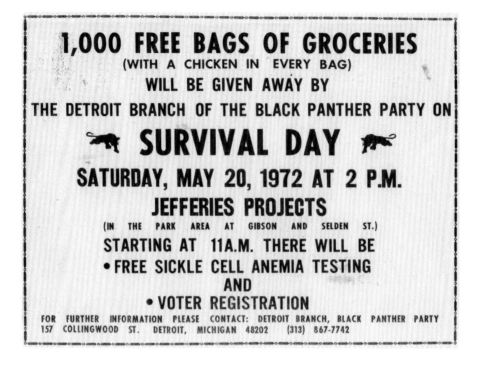

move. The community was very upset about the lack of service and access to the hospital. The National Association for the Advancement of Colored People (NAACP) and other organizations took the approach of confronting the leaders, to rally people. We took the approach that we will provide you the service. The support was overwhelming for that program. We didn't charge people. We took donations. We took whoever called. We actually served many low-income white people.

Our community was very receptive. We have people now that still talk about those days, children we served in the breakfast program who are now grown. We were taught, in terms of organizing, that it wasn't a matter of just giving something away free. It was also necessary to harness, to educate. We used those programs to get people involved in the policies of the community.

Because we had done the breakfast program and the food program, when we wanted to start the ambulance program, we already had addresses and phone numbers for people. The programs were a means of getting trust from the community in the belief that we were there to serve them. Because of that practice, we got the participation.

With J. Edgar Hoover and COINTELPRO, the media wanted to produce a narrative that the Black Panther Party people were antiwhite. Not true. That we were violent. Not true. We believed in self-defense. The party always had alliances. Fred Hampton used to say, "Black power for black people, yellow power for yellow people, brown power for brown people." All people should have power and conscious control of their destinies. Even in Oakland, there were many white people who supported the Black Panther Party, and we had the Young Lords in New York, who were Puerto Rican. So that was a myth that served the people who were not our friends. That was not what we were taught, and it's not what we practiced.

Those misconceptions are what the people in control wanted the public to have. It's the same way it's done today. People in power control the means of communication. That's why one of the first things people do when they overthrow a government is to get the lines of communication under control.

All of us experienced those things with COINTELPRO. They would follow us around. That is what they did. I guess that was their job. They wrote letters to organizations in the community in the name of the party during times when a heated issue might exist in order to create division. For example, they would write to members of the NAACP outlining our supposed disagreement with them, whatever the issues were. This happened all the time. It got to be a real joke because people would bring us the letters. Oh, yes. We knew each other. These were people you grew up with. The thing about the black community in the South is that we were all lumped together in one place. You met each other no matter what your status was. You could be well-to-do or poor, but you knew people. You knew their families, their mothers, and everybody.

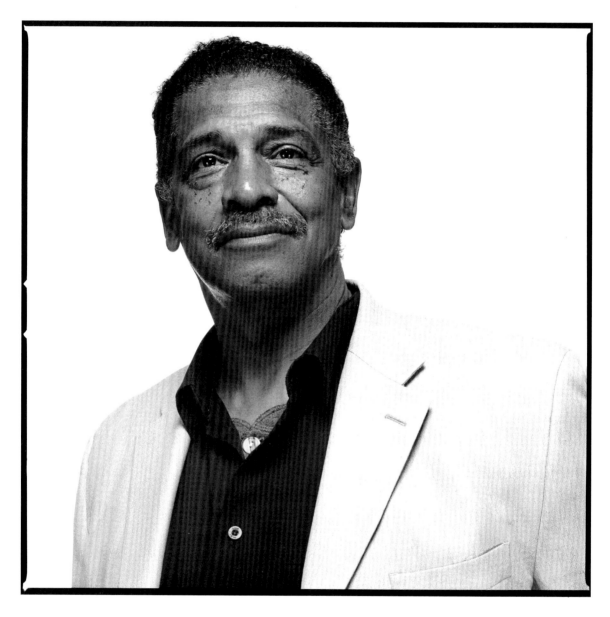

"The other side could see that we were dangerous.
We were galvanizing people of faith, normal people,
some conservative, some in between."

Saturu Ned (formerly James Mott, b. July 6, 1949) grew up in Sacramento and joined the Sacramento Branch of the party. After moving to the San Francisco Bay Area, he became the fourth member of the Black Panther Party band, the Lumpen. He also taught at the Oakland Community School. He serves on the city of Oakland's Commission on Aging and also works with community colleges in Oakland to improve college retention, transfer, and graduation rates for young African American men.

The other side could see that we were dangerous. We were galvanizing people of faith, normal people, some conservative, some in between. We had students, the antiwar movement. I would tell local businesses, "We are going to make sure that people respect your business because we're going to let the community know that you are helping and giving back to feed the children, so they have a wonderful education." The word got out. They were just as happy. Their business increased. They were giving sausage, eggs, whatever products they had willingly every week by the dozens because they were using this as a write-off. The people would come in and thank them. "Thank you for helping feed my child. Thank you, Mr. Jones." It became a wonderful relationship where those businesses in the community actually were giving back, which they don't do anymore.

Wednesday night was distribution night in San Francisco. That's where all the party members would be assigned for the most part, other than a skeleton crew at the facilities in the houses, to put the newspaper together. We would start singing songs, doo-wopping and singing popular music. That's how we started to get together. They'd go around on the truck, and those three would start singing—Michael Torrance, Clark Bailey, and Bill Calhoun. So Emory proposed the idea of creating a cultural group, and he introduced me as the fourth member.

We all came up with the name the "Lumpen." The lumpen are the dispossessed. The folks in the community—folks from the hood, as they would say today. In Marxism-Leninism, it's the "lumpen proletariat," the working class. That's what Frantz Fanon wrote about in *The Wretched of the Earth*.

We performed at a lot of colleges. We performed all over New York, New Haven. We actually sang at a concert scheduled right across from where Bobby Seale and Ericka Huggins were locked up in New Haven, charged with Alex Rackley's murder. The day we went, the community in New Haven had been totally saturated. We expected a lot of people to be out there. It was cold. It had been snowing. I think it was probably about five degrees. We got there, and in the park area they had this little bandstand, but they wouldn't allow us access to electricity. A few brave souls showed up. I asked, "Where is everybody, man?"

"They were told if they showed up, they were all going to get arrested or might get killed by the police and the feds."

I said, "Really?"

They said, "Yeah. But we don't care. We came anyway."

We put on our performance, and you could hear across the street in the jail, "Right on, brothers! Sing that song!" In the meantime, I want you to imagine the scene: these guys standing around the perimeters—cops and some plainclothes FBI agents. They sounded like a bunch of wise guys from *The Sopranos*, the way they were cussing us out, making hand gestures.

After we finished and broke down the equipment, we were driving to New York because we were supposed to meet the chapter there, where we were doing some concerts. We got an escort from the feds. They were very courteous. We told them, "Well, we're leaving now. Make sure you keep up."

The Oakland Community School had already started, but we really focused on it after Bobby Seale's campaign. It had an unbelievable effect in the community. That's where a lot of the other later survival programs started. It had a tremendous community martial arts program. We recruited a lot of people out of the Sixty-ninth Street Village. Felix Mitchell. Remember him? The heroin kingpin at that time. We recruited all his young people, and he loved it. He started buying them school clothes; he started not selling his wares to the parents in the village. He told the kids they could no longer be runners and work with him, so there was an influence even on that particular end in cooperating with the "no drug zone." We're

talking from A to Z. That period was a good, important time because of the Oakland Community School. We had so many wonderful children, and we proved a point: it received an award from the California state legislature for educational excellence.

At the ceremony, some of the Republicans were sitting there with their arms crossed and those little frowns, but when the kids got to speaking, they opened up, they smiled, they all stood up. I'd never seen this before. Huey P. Newton stood up in front of them, and somebody handed him a bouquet of flowers. I looked at one of the other guys. "Can you believe this?" We brought national attention to the educational aspect of the party. That's where the concept of "each one teach one" was developed. The method of teaching that we developed was uncanny.

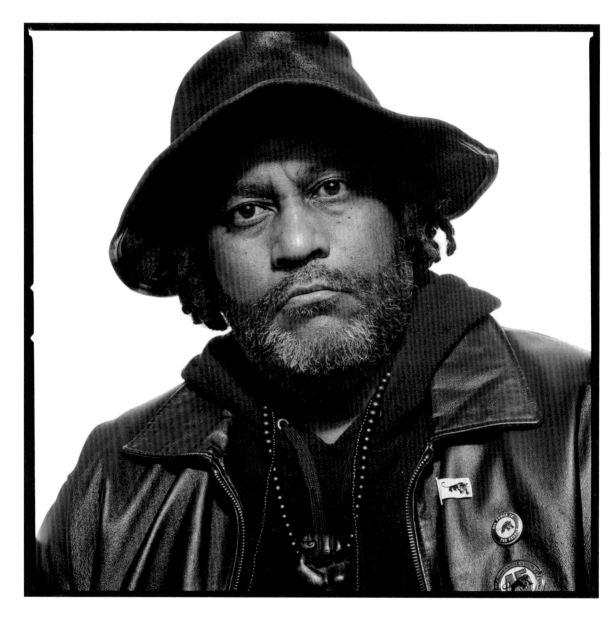

*"They blame us for the way the world is
because we didn't complete the job."*

Brother Sadiki Shep (b. November 8, 1954) grew up in the Bronx, New York. He studied and organized at Hunter College, where he was involved in student government and played on the baseball team. He eventually played a season professionally in the Single A league. In addition to his ongoing organizing activities through the Zulu Nation, he works with youths at group homes and community centers.

I JOINED THE PARTY IN 1973 BASICALLY LOOKING FOR SOMETHING. Unfortunately, in 1973 the split was in full bloom. I was a rank-and-file member, but I didn't really know anything about it. My coordinator went to California because Huey had called everybody from throughout the country to consolidate. She went out there supposedly for the weekend and didn't come back for two months. When she finally did, she said, "I'm done. I wish you luck, but I'm done." Another supervisor, Robert Jordan, originally from the DC Chapter, came up to me in Times Square one day and gave me $10 for a paper, which was a big deal back then, because they were still selling for a quarter. He said, "I'm done. I'm gone." I thought, What the hell is this? Everybody's leaving.

I was on Huey's side and was told to watch out for what we called "Napes," or Jackanapes, meaning the other side. I only had one confrontation. It was right on 125th Street in Harlem. I was selling the Panther paper and a group came up to me and said, "What are you doing? You can't sell that here."

I had a little bit of knowledge, and I was nineteen at the time, so I said, "Look, I don't give a fuck what y'all say. Y'all had something good, and y'all fucked it up. I'm just trying to carry it on." I was armed and ready, and we were two seconds from killing each other, but an elder stepped in and said, "Whip, he's young. He doesn't know. Just leave him alone," and they walked away. I found out years later that the main person who confronted me was (Cyril) "Bullwhip" (Innis Jr.).

People think it was a West Coast, East Coast split, but that's not true. On the West Coast, the Los Angeles Chapter was expelled, but the Seattle Chapter stayed. On the East Coast, the Philly and Baltimore Chapters stayed. I know that because I used to send papers to them.

My whole thing was just to keep it going. That's why I ended up taking over newspaper distribution. Folks were leaving. They didn't want to deal with it anymore, and so I was able to utilize Hunter College and do my distribution through the student government. The college didn't know it was paying to have the papers shipped to campus, but I did it anyway. I used to drive to Kennedy Airport to pick up the papers that were flown in from Oakland and then split them up and ship them out to different sections on the East Coast. A lot of times I would get there, and the papers were left out in the rain and were destroyed. Other times I would pick up the papers, and they smelled like urine because someone had pissed on them. That went on until around 1980, when the paper officially ended.

The thing that kept me going was the reaction from the community. I could go anywhere in New York City and sell the paper. I could go to Eighth Avenue back then, when Times Square was hooker heaven and full of derelicts, and people with nothing would say, "Oh, here, this is all I can give you, fifty cents," because they wanted the paper. They respected the paper. I had a street organization—I'm not going to use the word "gangs" because we don't call them that anymore—that came out and helped sell the paper too.

My basic field of work is in child care. I run residential centers for youths, group homes, and community centers. When we were young, we looked down on what we called the "Uncle Toms"— those who turned the other cheek and wanted to get into the system. We called them sellouts. Today, a lot of young people look at us as the new Uncle Toms. They tell me, "Y'all fucked it up. Look at the world and the way it is; you didn't do what you were supposed to do. What are you doing now?" Still being active as a child-care worker, I hear all of this. They blame us for the way the world is because we didn't complete the job. They don't know, of course, what COINTELPRO was about or that there were those forced into exile, those killed, those still in prison. When they begin to learn about it, their opinions change, but overall, most youths feel we didn't finish the job, and they blame us for it. In many ways, they're right because a lot of people did forget their jobs and forget the struggle. They stepped off.

I'm continuing that struggle. I understand what my destiny is supposed to be, has been, and will be. That's to carry on the struggle so that those who come after me will hopefully not have to live these half-butchered and oppressed lives that we are still enduring right now, and change this planet to what it's supposed to be: one where everybody can have his or her needs fulfilled and be able to contribute what he or she can to society. As we say, our struggle continues, and that's what I'm about.

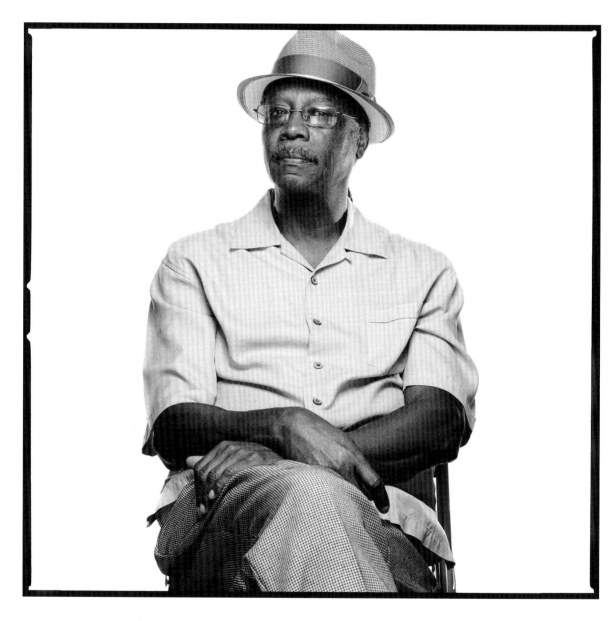

"They knew we were prepared to deal with them with a method and a language they understood."

Larry Little (b. February 21, 1950) grew up in Winston-Salem, North Caro-
lina, where he helped start the Winston-Salem Chapter of the Black Panther
Party. He later became an alderman on the Winston-Salem City Council and
was instrumental in installing a historical marker commemorating the chap-
ter's contributions. He is currently associate professor of Political Science at
Winston-Salem State University.

I was still out in California for training when I got the call
that Fred Hampton had been murdered in Chicago. Our National
Headquarters captain, Calvin, from Des Moines, Iowa, said, "It's
probably not true, Larry. Let's call Fred's house." When I called and
asked, "May I speak with Fred, please?" a voice said, "This is Fred."

I said, "Damn, Fred. I heard you'd been murdered."

The voice said, "Y'all comin' over? We got a few people that
are gonna start coming over."

It was a policeman trying to disguise his voice. He didn't re-
alize the call was coming from Berkeley. The next day on national
television, that same person spoke with his back turned to the cam-
era. It was the same voice. He talked about this vicious shootout
they were in with the Black Panther Party. He made me pause. It
became very clear that we could be murdered in our beds. At that
point, I had to make a decision: Was I ready to die for the people?
And I knew that I was ready to die.

The first thing we did when I got back to Winston-Salem was
fortify our offices with sandbags and dig a tunnel so that when they
attacked our offices we had an escape. Of course we had already
started the free breakfast program before I left for California. We
were able to get other programs going too like the ambulance service.

At that time, the county was in charge of the ambulance ser-
vice, and they told black people that we were misusing it. They said
if people called, and the ambulance attendants felt that they were
not in an emergency situation, they would have to pay right then or
the attendants would leave and the injured or ill person would have
to call a cab. They were leaving a lot of people at home, and we had
people who died. We said we had to respond to this. So we took
Panther members to the community college to become certified

emergency medical technicians. We went all over, raised money, got the nursing students that worked at Winston-Salem State to help us with the program, and got a grant from the national Episcopal church for $35,000, with which we bought a brand-new ambulance to run the Joseph Waddell People's Free Ambulance Service, named after our comrade killed in prison.

The Ku Klux Klan (KKK) said it supported the Panther ambulance program because if we were taking care of the "niggers," then the county ambulance service would be available for the whites. We dealt with the KKK very effectively in Winston-Salem and nearly drove it underground.

One time the KKK said that black children had lice and that they were going to stop all black kids who got off the bus and inspect them before they could go to the white school. We told them they were not going to do any such thing. They arranged for a meeting, and we met them and told them that it would not happen. We also tried to educate them. We talked about how we were both oppressed; they were white trash with nothing, and we were black people with nothing, while the Rockefellers and Howard Hughes owned every damn thing. In the end they agreed not to do it.

As we were getting out of the meeting, the head of the KKK said to me, "Larry, I heard you say black is beautiful several times. I want to show you black beauty." He tells this white lady behind the counter at the store we were in to show me black beauty. She brought out a black AK-47. He said, "Larry, if things get out of hand, we're going to show you black beauty."

Now the following is the honest to God truth. I told him, "Look out the back window of this place, and you'll see a white van filled with black men and women armed to the teeth. Look out the front door. You'll see a white Mercury Montego and a blue station wagon comfortably armed with brothers and sisters. If I'm not out of here in the next minute and a half, then you're going to see what kind of power we have." We just left like that, and afterward, when the KKK reared its head in Winston-Salem, its members knew we were prepared to deal with them with a method and a language they understood.

Apart from the ambulance program, we also gained national attention on behalf of Joan Little. She was not related to me, but she was an African American woman. In 1975 she was in jail in a small town in North Carolina called Little Washington. A white deputy came to her jail cell with an ice pick and put it to her temple and made her perform oral sex. At one point he put the ice pick down, and she grabbed it, smashed it into his chest, and killed him. After she escaped, North Carolina declared her an outlaw and said any citizen could shoot her on sight. Our people got her out of that area. We also obtained a copy of the ambulance report, which said when the attendants came to her jail cell, the guard's trousers were down by his ankles and there were spermatozoa on his thighs. We said that established that she had been raped, and she had a right to use deadly force to defend herself. A jury of six blacks and six whites found her not guilty by reason of self-defense, the first time in the history of the southern United States that a black woman was found not guilty for killing a white man who had raped her.

I'm thankful that the Lord allowed me to survive, and I can teach my students about what we did and the mistakes we made and let them try to prepare for the future. Frantz Fanon said that each generation of youths will discover their mission, and upon discovering it they must decide to either fulfill it or betray it. My job is to help them understand their mission so that they can fulfill it.

The thing that hurt so much was when the party lost its way in Huey Newton's drug habits and horrible decisions. I have to tell these young people the truth. You never idolize someone like that. You just don't do that with anybody.

He was a very brave person in many ways. When he had the shootout, and the cops got killed, he became a cause célèbre. It rallied so many people around the party because they saw that Huey was a brother who would defend himself and not just talk the talk but walk the walk. He galvanized people all over the world to fight for his freedom, and that gave us great impetus. It was just a handful of people when he went to prison. When he came out, we had chapters all over the country, thousands upon thousands of members. He couldn't handle that. He didn't have those kinds of organizing

skills. The organization had metamorphosed and grown exponentially. When they infiltrated the party, they got people close enough to turn him into a maniac.

But had he not taken that strong stance in self-defense, who knows? We wouldn't have gotten a chance to be recognized all over the world. You have to do a critical analysis. There were great things about the brother, but then that mercurial personality of his and the drug abuse led to some God-awful decisions.

I'm at a point where I feel I need to set the record straight. I spoke at the Fortieth Anniversary in 2006 and alluded to the madness going on in the Party. After I finished speaking, all these reporters said, "We want to talk to you about that."

I said, "I'm not going to talk about the madness because that's all you will write about." We get whipped up so much, and we're shell-shocked because folks will let you talk for an entire hour and they'll only report the negative. We've been burned so many times, and that's why the comrades are reluctant to talk about Huey's demons.

Now it's ten years later, and I feel for the sake of history that I should talk about my experiences and observations. Some things should be left unsaid, but some things need to be shared so that we're not romanticizing. We did difficult work in the Black Panther Party. Comrades were being killed or going to jail for long periods. Many families were destroyed. But we made an impact, and I want the record to reflect our strengths and our weaknesses.

The Black Panther Rank and File
Jama Lazerow

A series of problems frustrates any attempt to accurately characterize the rank and file of the Black Panther Party. Despite the enormous amount of ink, celluloid, and sound expended on the group since its inception a half-century ago, we still know precious little about its actual history, in great measure because it has garnered relatively little attention from professional historians, and thus its legacy remains largely in the hands of the censorious and the celebrators.[1] Both have given us more image than historical reality.

Moreover, the geographical spread of the organization was great—from its origins in the Bay Area of California to scores of communities in every region of the United States (and several places abroad)—although there were significant differences by region (e.g., West Coast versus East Coast), city (e.g., Chicago versus Des Moines), and even within cities (e.g., Harlem versus Brooklyn). Meanwhile, the party's evolution and devolution over its fifteen-year history render snapshot portraits dangerous. Even identifying rank-and-file Panthers is problematic: membership criteria varied in space and time; community workers close to the organization but not officially members were often critical in day-to-day activity; and some local Panthers appear "ordinary" from a national, or even regional, perspective although, at times, they acted as leaders, even if without official titles. One must account as well for those Panthers—and there were many—who were in fact informants or other paid agents of the state. Until we have many more finely textured local histories, our view of who the Panthers were will remain, at best, blurry.[2]

Still, at least, the rich diversity of Panther personnel and experiences can be glimpsed in a place away from the limelight of Oakland, Chicago, and New York—New Bedford, Massachusetts. Though a small city of about 100,000 known more for whales than

Panthers, New Bedford was linked by cadre and family connection to Boston, sixty miles north and the regional hub of Panther activity—and through Boston to National Headquarters in California. Here, the originator of the group in late 1969, and active, if off and on, throughout its existence until mid-1972, was agitator and community activist Frank "Parky" Grace.

A second-generation American, he grew up in New Bedford's South End, the heart of the Cape Verdean community in the United States but as a teen moved to the West End, which, though composed of Afro-Americans, Afro-Indians, and West Indians, was known as the Negro section of town. Although he came to identify as black, like most New Bedford Panthers, he understood his identity as fluid. From a working-class family and working at various jobs after dropping out of high school, he became a gangster as a teen and, referring to the Panthers' targeted recruits of "brothers on the block," would proudly call himself a "voluntary lumpen." To avoid jail, he enlisted in the army and was sent to Vietnam; on his return in late 1968, he entered a local community college, fell in with some white New Leftists with whom he traveled to Washington in 1969 to demonstrate against the war, ended up on the wrong bus back home, and found himself at the headquarters of the Boston Black Panther Party. He became their itinerant organizer in New Bedford. When rioting broke out there the following summer, first in the West End and then in the South End, he facilitated the movement of a cadre of Boston Panthers into the community. They stayed—and he remained active—for the next two years.[3]

Among that cadre, for example, was Johnny "Butch" Viera, another Cape Verdean and gang banger, originally from New Bedford, who had almost killed Grace during a gang fight when they were teenagers. His girlfriend was Cathy Perry, another Boston Panther who had grown up in that city's Chinatown, the daughter of a Chinese mother and Cape Verdean father. Already recruited to the party—or at least its activities—by the time these Boston Panthers arrived, was Russell "Buffalo" Rebeiro, another native to New Bedford and a Cape Verdean Vietnam veteran (he had enlisted in the marines and had been among the first combat troops in

Vietnam in early 1965). There was also Kim Holland, born in New York of Afro-American college professors and civil rights activists, a fifteen-year-old high school student who had been on picket lines since she was a little girl and who now lived in the West End and worked with the same white New Leftists Parky Grace had encountered on his return from Vietnam.[4] Holland was active in the local organization until it dissolved in the spring of 1972.

Certain elements of this New Bedford Panther story stand out: the significance of ethnicity and family connections; the role of outsiders, white and black; the influence of the street, school, and Vietnam. But, for now, that story can constitute only a collection of stories that itself is a small part of a much larger one. If we are ever to know the historical Panthers, we need to know much more about the complex assortment of people—such as Grace, Viera, Perry, Rebeiro, and Holland—who constituted the flesh-and-blood reality of the Black Panthers rather than the image we have constructed of them.

Jama Lazerow is the author of *Religion and the Working Class in Antebellum America* (1995); editor, with Yohuru Williams, of *In Search of the Black Panther Party: New Perspectives on a Revolutionary Movement* (2006) and *Liberated Territory: Untold Local Perspectives on the Black Panther Party* (2009); and author of the forthcoming *The Awakening of a Sleeping Giant: New Bedford, The Black Panthers, and the 1960s*. He teaches history at Wheelock College in Boston.

On the Black Panther Party's
Health Activism
Alondra Nelson

Among the least known and most important of the Black Panther Party's activities was its health-care activism. Yet by 1972, when the organization's founding Ten-Point Platform and Program was revised to include a demand for "completely free health care for all black and oppressed people," this was one of the party's deepest social and political commitments. This BPP activism was wide in scope and challenged many forms of medical discrimination. Equally important, although the Panthers' health work dealt most centrally with disease and healing, it placed these matters in the context of their broader political strategy. The Black Panthers' politics of health care and race combined two emphases: defense against biomedical neglect and a demand for full human rights.

Poor blacks were not only medically underserved but also overexposed to the worst jeopardies of medical practice and scientific research. The Black Panthers and the communities they served confronted the paradox of the general neglect of poor and black people's health-care needs, on the one hand, and disproportionate enlistment of these same groups into the riskiest elements of biomedicine, on the other.

The Black Panther Party response was similarly multifaceted. Across a national network of neighborhood-based clinics, working with community members and volunteers from the medical professions, the activists provided basic medical care. First aid and basic services—including testing for high blood pressure, lead poisoning, tuberculosis, and diabetes; cancer detection tests; physical exams; treatments for colds and flu; and immunization against polio, measles, rubella, and diphtheria—were available at many of the People's Free Medical Clinics, as the BPP's facilities were named. A diverse array of services was available at the clinics, including screening for

sickle-cell anemia, optometry, well-baby exams, pediatric care, and gynecological exams. For the most part, the party attended to basic health needs that might have otherwise gone unconsidered or untreated. Working with collaborators, the activists reportedly screened thousands for sickle-cell anemia—a genetic disease that predominates in persons of African descent. When treatment for more complex or serious health-care issues was required, an effort was made to provide referrals to other facilities or other medical professionals.

The People's Free Medical Clinics exemplified the party's commitment to total well-being. Highlighting the importance of social conditions, the Panthers touted their well-known breakfast program and grocery giveaways as ameliorating the malnutrition that often accompanied poverty and thus as contributing to community members' healthfulness. A person entering a party clinic might also receive help from a "patient advocate" with paying bills or dealing with a problematic landlord; this individual might also be encouraged to attend a political education class in which writings by Malcolm X, Frantz Fanon, and other political thinkers would be discussed.

Medical institutions could be dangerous for African Americans because of the poor quality of care available as well as racist assumptions that affected diagnoses and treatment. Lesser known is the fact that in some instances black communities mobilized against efforts to experiment on their members, plans sometimes supported by unsound theories about their pathological bodies and minds. The Black Panthers engaged in public debates in which they disputed research studies based on these assumptions. As was shown with its campaign to block formation of the Center for Study and Reduction of Violence at the University of California at Los Angeles (UCLA), a highly controversial project based upon the hypothesis that the diseased brains of blacks and Latino/as were a significant source of social violence and that invasive neurosurgery could be a method of behavior modification. In successfully challenging the formation of the center, Panthers sought to protect those at risk of overexposure to medical power.

The Black Panthers' foray into health-care activism reveals that the group, although skeptical of mainstream medicine, was not

antimedicine. The activists appreciated that biomedicine was necessary and could be put to useful purposes if it was loosed from market imperatives and carried out by trusted experts. Between its founding in 1966 and its formal end in the early 1980s, the party blazed a distinctive trail in US political culture, linking a right to health to its radical vision of the good society.

Alondra Nelson is dean of social science and professor of sociology at Columbia University. An interdisciplinary social scientist, her research and writing addresses the intersections of science, technology, and social inequality. Her books include the multiple award-winning *Body and Soul: The Black Panther Party and the Fight Against Medical Discrimination*, *The Social Life of DNA: Race, Reparations, and Reconciliation after the Genome*, and, as coeditor, *Genetics and the Unsettled Past: The Collision of DNA, Race, and History* and *Technicolor: Race, Technology, and Everyday Life*. Her essays, reviews, and commentary have appeared in the *New York Times, Washington Post, Science, Boston Globe*, and on National Public Radio.

CHAPTER FIVE

THE SINGLE GREATEST THREAT
THE COVERT WAR AGAINST THE BPP

ALTHOUGH SOME PANTHERS WERE COMMITTED TO FOMENTING REVO-lution in the United States through a clandestine Panther Under-ground, the vast majority operated lawfully. This mattered little to local, state, and federal law enforcement agencies, which saw the Panthers as a violent and lawless threat. Under the highly secret and illegal (given the propensity of agents to violate the Constitution as well as a variety of federal, state, and local laws) Counterintelli-gence Program (COINTELPRO), excerpts of which are included in the Appendix, FBI Director J. Edgar Hoover set out to eradicate the BPP through a campaign of harassment and disinformation de-signed to "expose, disrupt, misdirect, discredit, neutralize, or oth-erwise eliminate" organizations such as the Panthers. FBI agents surveilled the party and used paid informants who regularly dou-bled as agents provocateurs. Panther offices were routinely bugged, and members, through the use of false missives, were set against each other as well as other revolutionary groups, sometimes result-ing in violent altercations. One such example was the 1969 killing of Panther leaders John Huggins and Alprentice "Bunchy" Carter on the University of California at Los Angeles (UCLA) campus by rival organization US in a conflict stoked by the FBI.

In the end, the program was highly successful in creating fear and mistrust among party members that deepened existing divisions

within the party. Some of the FBI's harassment campaigns also resulted in the incarceration of Panther members on a variety of charges, some of whom remain behind bars and maintain their status as political prisoners. The existence of COINTELPRO was first revealed after a group of white activists calling themselves the Citizens' Commission to Investigate the FBI broke into an FBI field office in Media, Pennsylvania, where they discovered documentation confirming the existence of the illegal program. Soon after, Hoover declared an end to the program. COINTELPRO was later investigated by the Church Committee, which issued a scathing report on COINTELPRO, laying the blame directly on FBI senior officials.

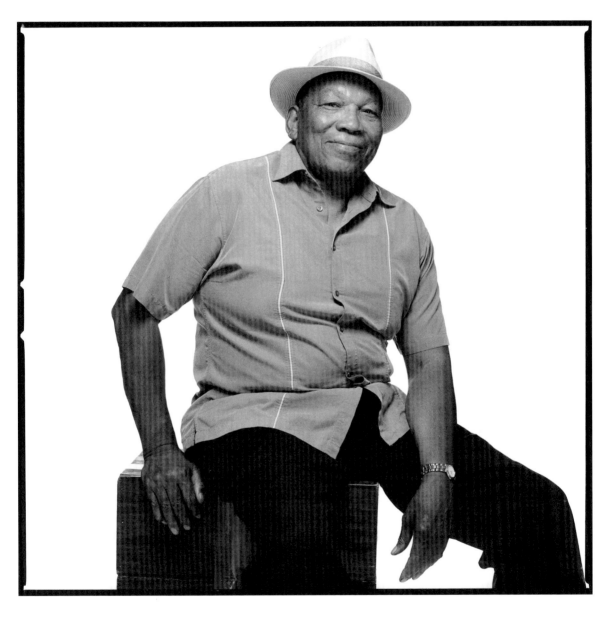

"The FBI wanted to misdirect us from our goals and principles and make it look like we were the criminals and like we were out to terrorize the community so that no one would identify with us."

Melvin Dickson (b. November 15, 1940) grew up in West Memphis, Arkansas, and joined the US Marines out of high school, after which he moved to Oakland. He worked and lived in the same neighborhood as party founders Huey Newton and Bobby Seale and joined the party after Newton went to prison. He helped found the Oakland Community School and the Commemoration Committee for the Black Panther Party.

You cannot talk about the party without bringing up the heavy infiltration by state and federal agents because it started from the beginning, particularly in the early years with the setup and assassination of people like John (Huggins) and Bunchy (Carter). There were other incidents, such as Fred (Hampton) in Chicago. His chapter was infiltrated. That stuff was real.

The FBI wanted to misdirect us from our goals and principles and make it look like we were the criminals and like we were out to terrorize the community so that no one would identify with us. It was just the opposite of that. The agents weren't so much trying to catch us breaking the law. They were looking for ways to set us up. The party members were disciplined, man. We were not attempting to break the law. That was not our role. We didn't consider ourselves criminals. We were revolutionary in the sense of serving the people, body and soul.

I'm not saying everybody in the party was an angel because we made mistakes. We made quite a few. But the errors were honest errors. The other kinds of mistakes we made came at the hands of agents and people who worked with the FBI and COINTELPRO, some of them from within the party. Those are two different things that I think are important to recognize.

The overall meaning of the party to me is that it made a difference, not in a negative way but in a positive way. It gave people a look at the condition not just of black people but of people throughout the country and around the world.

Anatomy of a Setup No. 2

As told by
Melvin Dickson

It was amazing how we got busted in the mountains of Oregon. It was snowing. This was December or the first of the year. We were driving back from the constitutional convention we had in Washington, DC. There was snow all the way. We had two station wagons and a Volkswagen—nineteen of us—and I was in charge of the caravan.

It was my time to sleep when we pulled into a service station to get some gas. We were on our way out when one of my comrades woke me up and told me, "Mel, Little John and the other guy stole some car tire chains from the service station." That woke me up. I said, "What? What did they do that for?" We didn't know it, but we had what we called agents provocateurs on that route. They were from the branch in Tacoma.

I raised my head up, and I looked out of the car window. I saw the service station attendant on the phone. I said, "They're going to bust us." I had to make a decision. Should we keep going or go back there and try to explain? I said, "No, let's keep going. Maybe he won't call, or maybe he didn't see it, and we can handle the situation." I wasn't sure, but something told me we were going to get busted, and we did. The service attendant had called the Oregon Highway Patrol, and when we got to the top of the mountain, it looked like an army was waiting for us. Man, those lights lit that place up. I just told everybody to be cool because we couldn't react up there. We were in no position to defend ourselves. We weren't even prepared for that going back home.

I think we spent about a week there in jail. Out of the nineteen of us, the only ones who talked were Little John and the other guy. I can't recall his name. Through the chapter, we got in touch with a lawyer in Seattle who represented us very well. They had to release

us because the rest of us hadn't stolen anything. The guys who stole the stuff were provocateurs. We found that out. They went in and talked to the police and the FBI and whoever else was there. They let us go, and they stayed there. We were separated. Something went down, so we knew.

That was not the first time on that trip that those guys tried to do that. I know because they stole typewriters and tried to get them in our cars. I told them, "No, don't put them there. We don't steal. Take them back." They managed to get them in the cars somehow. I found out on my way back, so I had to dump them because I wasn't going to drive across the country with those hot typewriters.

Those guys had infiltrated one of the branches from Tacoma. They weren't really close to us in Seattle. At the time, we didn't know at all. We thought they were all right, so we said, "Well, yeah, those guys can go with us," and they became part of the caravan. Sure enough, they set us up. It was their job to infiltrate the party and do things like that to discredit us. We didn't know that then, but maybe a year or so after, lots of studies came out. Peace activists broke into the FBI office, and they got lots of information showing what the FBI was doing against the party. Now, most of these provocateurs had some kind of criminal record, so the police had leverage on them. They still do that, and that's what groups have to be conscious of today.

When we got back to Seattle, Washington, we had to settle that score with those guys. Some things happened. I won't go into all the details of it. After that, we didn't hear anything about them from Seattle because they weren't allowed there anymore. We weren't going to allow them cats to come into our area. They knew better, anyway.

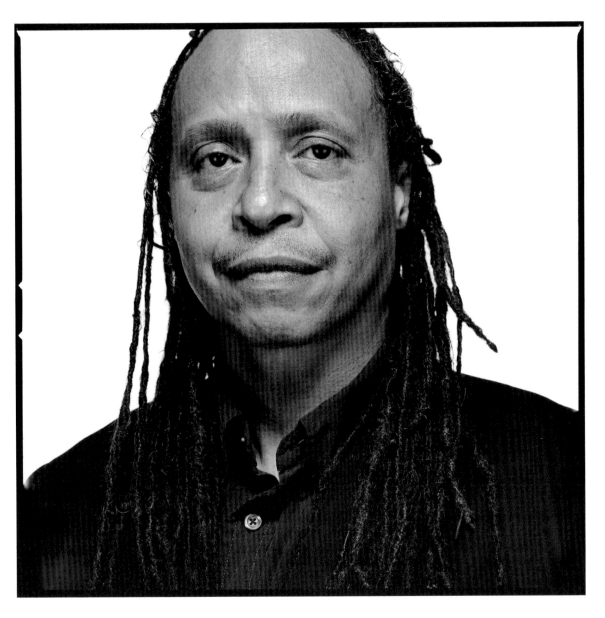

"That's what makes the legacy of the Black Panther
Party matter—because we loved beyond ourselves."

Jamal Joseph (b. January 17, 1953) was one of the Panther Twenty-One in New York. He later spent five-and-a-half years in Leavenworth Federal Prison for harboring a fugitive wanted for the Brinks armored truck robbery. During his incarceration, he wrote his first play and earned two college degrees. He is professor and former chair of Columbia University's Graduate Film Division, artistic director of the New Heritage Theatre in Harlem, and director of IMPACT Repertory Theatre, a youth leadership and arts training program in Harlem. He is the author of a memoir, *Panther Baby*, along with *Tupac Shakur Legacy*, an interactive biography. He is also director of the feature-length film *Chapter and Verse*.

As we neared the end of the Panther Twenty-One case, and as things began to disintegrate within the Panther Party, a lot of us went underground. We just left the movement. We were on the run. We had warrants on us, but we still wanted to fight. So we decided to take the fight to the drug dealers, because the heroin epidemic in New York City was insane. If you went down 116th Street, it was like an open-air market. Drug dealers were selling drugs with full immunity, with cops not coming into certain areas or looking the other way because they were getting paid off, and with women and kids dying of overdoses on a regular basis. So we started kicking in the doors to those drug dens and, at gunpoint, taking the drugs away, flushing them down the toilet, throwing them in the sewer, and giving the money to community programs.

 Coming out of one such raid, I was arrested with another member of the Panther Twenty-One, and we were beaten and tortured for a couple of hours, until our fingerprints came back. When they matched our fingerprints and found out that we were these fugitive Black Panther leaders, they stopped beating us. They gave us some paper towels, let us clean up a little bit, gave us a bologna sandwich and some cold tea, and let us eat. I thought they were preparing us for round two, because Panthers in the military who talked about torture said it's always like a hot and cold kind of thing. They torture you, then they let you rest because they want to break you, then they torture you again. It's done in cycles.

 I was taken into a detective squad room and handcuffed and chained to a chair. They had realized that we were these fugitive

Panther leaders and that the lawyers were going to come and the press was going to come, so the beating was actually over, but I didn't know it.

They wanted us to be positively identified, so they sent for two undercover cops: Gene Roberts and Ralph White, whom I had known as Yedwa.* Yedwa came into the room, and he had his gold detective shield. He got promoted as a result of infiltrating the Panthers. He looked at me and said, "Power to the people, Jamal."

I said, "What's happening, Ralph?"

I wasn't going to give him the satisfaction of answering him with the revolutionary greeting. I was pretty beat up. My jaw was cracked, my left eye was swollen shut, my ribs were cracked, my face was really swollen.

He said, "Man, you look pretty messed up, there."

I said, "Well, you know your pig buddies have been torturing me for the past five hours."

He was pacing the floor in front of me. He had on sneakers, and he was bouncing on his toes, and he said, "Jamal, I know you hate me. And I know you're going to get a lot of time. And I know you're going to be upstate in prison getting in top shape so that when you come out you can hunt me down and kill me. But that's cool, man, 'cause I'll be training too, and I'll be ready."

I remember turning my chair, kind of hopping it, so I could look him right in the eye with my good eye, and I said, "Ralph, you're probably right that I'm going to get a lot of time. And you're definitely right that I'm going to be thinking about a lot of stuff. But I'm not going to waste a single, solitary second thinking about you." And I turned away, and he stood, I don't know if it was three minutes or ten minutes, but he stood quietly in the darkened room, and then he left. And I know that there in the dark—beaten, bloodied, and chained—making that decision that it wasn't about him, that it was about me, that it was about what I believed in, that the boy finally became a man.

* White/Yedwa recruited and mentored Joseph in the party. His status as an under-cover agent was revealed during the Panther Twenty-One trial.

If you ask any Panther, "What were you taught to believe above all other things? If there was a single guiding principle, if there was a brainwashing principle, what was it?" I can guarantee you that everybody will say, "We were taught to love the people and serve the people." I guarantee this. So I take that away.

The other takeaway, as we're approaching the fiftieth anniversary, in the "season of the Panther" so to speak, was the goal of the Black Panther Party. We didn't want to make every man, woman, and child Black Panthers. If we did our job correctly, the Panther Party would become obsolete. We wanted to teach the community and the people the possibility of struggle through our own example. If we did that successfully, you wouldn't need a Black Panther Party because everybody would be politically conscious and politically aware and come to this moment of transformation.

It's this idea of love, this undying love for the people. It's love that would make you get up at 5 o'clock in the morning in an apartment that was freezing cold to wash up in cold water and go across town and cook breakfast and serve fifty to a hundred kids that weren't your kids. It's love that would make you work in the welfare centers and the housing takeovers, and organizing the schools, and then do those community patrols, and then sell newspapers and try to raise money for political prisoners. And it's love that would make you, when you were exhausted while riding the bus to go home to get a few hours of sleep, and you saw the cops had somebody against the wall with their guns drawn, that would make you get off that bus and stand between those cops and those drawn guns for someone that you hadn't met before but that you understood was your brother or sister. That was love. That was that undying love for the people. And I think that's what makes the legacy of the Black Panther Party matter—because we loved beyond ourselves.

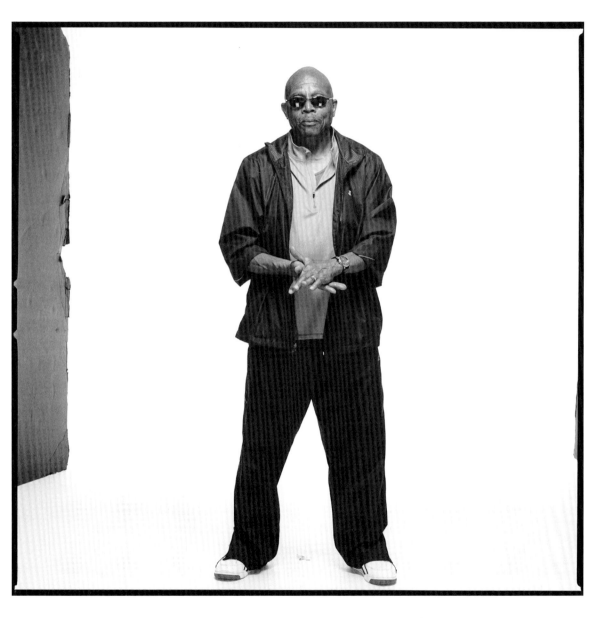

*"He told me point-blank, 'You guys won't even
wind up as a footnote in history.'"*

Steve McCutchen (b. October 21, 1949) grew up in Baltimore, Maryland, and was a founding member of the Baltimore Chapter. After relocating to Oakland, he was the assistant coordinator of the West Oakland campaign office for Bobby Seale's mayoral campaign. He was later an insurance investigator and math teacher in the Oakland School District.

I HAD BEEN AN HONOR STUDENT ALL THROUGH MIDDLE SCHOOL AND high school. When I decided to break from what people expected of me to join the Black Panther Party, that caused a lot of friction. My family thought I had lost my mind. My father considered the Black Panther Party nothing more than a bunch of thugs. He told me point-blank, "You guys won't even wind up as a footnote in history."

After that, I knew there was going to be too much conflict, so I asked my defense captain if I could stay at the office, and he said sure, we had plenty of room. I'd be there operating if they needed me.

Because of my writing and speaking abilities, I was made lieutenant of information. I was responsible for coordinating all the information that went out of our office into our community. I wrote articles for the *Black Panther* newspaper and prepared television and radio commentary to talk about the Black Panther Party's programs and activities, the actions against the Black Panther Party, and those against other poor people in Baltimore, Maryland.

Other than that, whenever we were called on in terms of duties or activities for the day, whether maintaining our office, working with people in the community and in the neighborhoods, whatever those activities were, they all were part and parcel of what the Black Panther Party encouraged not only in its members but also in every other person. We wanted to show people that "we can do this and you can do this also."

On May 1, 1970, the Baltimore Police Department raided the homes of members and former members of the Black Panther Party based on a case that they said they were building. I happened to be one of the people they were looking for. The police had started to cordon off the area around the office in preparation for the raid, but we had gotten to the news media and informed them. When that happened, people from the neighborhood came out of their homes

and even from other areas to block the police from coming near our office. We had people blocking the alleyways, sitting on their doorsteps and rooftops, observing all through the day and even occupying the streets. These were just citizens, and they did this for five days.

Most of the supporters out there were black, but we had a number of supporters from white groups, churches, and different organizations that would also come to the office, bringing us food, medical supplies, and offering legal advice all during that crisis period.

Because I was one of the people named in the incident, I could not venture outside, so I was basically a hostage in our office. We continued our regular routines in terms of maintaining our facility and conducting classes. We still invited people in for community meetings. But those of us involved in the incriminating statements had to stay out of sight because we did not know who could be in there with ill will.

As the news media continued their coverage and as the community support continued over those days, the Baltimore Police Department decided that it was best not to try to attack our office because there was no way they could get close to our office with ground vehicles or personnel. The people protected us with their bodies, and in fact, prevented a firefight between the Baltimore Police Department and members of our office.

The idea of the Black Panther Party was to put ourselves between oppressive conditions and the people, along with those who would violate the rights of black and poor people, but these people put themselves between the police and the Black Panther Party to protect us. I never would have imagined it. It showed me that we did have the support and following of people who believed in the efforts of the Black Panther Party. It was a reaffirmation of what I had decided to do two years earlier when I joined the organizing efforts of the Baltimore Chapter of the Black Panther Party and what the Black Panther Party represented as an organization.

The case they were building came to be known as the "bag of bones" case. The police said they were looking at members or former members of the Black Panther Party who might have been

involved in the murder of a reported police informant. At the time, one of our attorneys was Bill Kunstler. He had come down from New York to defend one of the individuals involved. The investigators had a bag of bones that they brought to court and said, "These are the remains of the victim." Bill Kunstler basically said, "All you have is a bag of bones. How can you tie this bag of bones to my client or to the Black Panther Party?"

Those of us charged and arrested were all released, all twenty of us. That was it, and eventually everyone on that case was exonerated except for one person who served five years based on a malicious prosecution and false accusations.

At that time, we thought about engaging in background checks, but we didn't have the protocol. People slipped in for different reasons and disrupted the activities and the direction of different chapters of the Black Panther Party. Those things happened because we didn't have the awareness to focus on who could be there to undermine our efforts. We were willing to trust people based on what they were willing to offer in the party's efforts to raise the consciousness and positions of the black community and poor people in the United States.

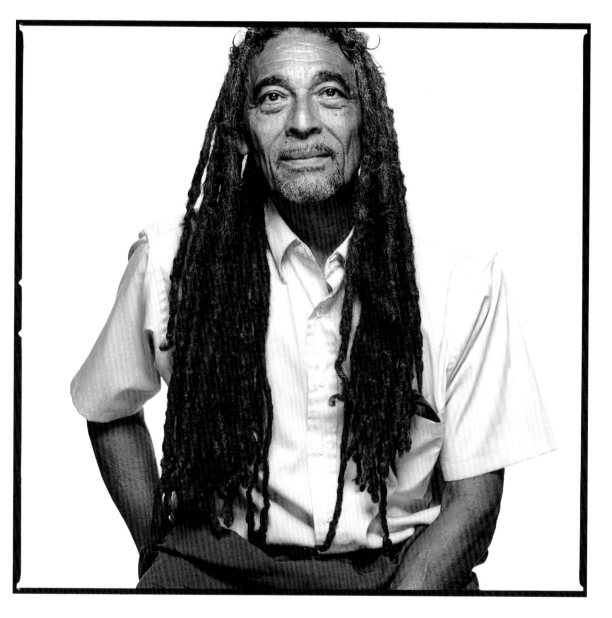

"I thought, Oh my God, we are going to die."

Ajamu Strivers (b. August 19, 1950), a self-described "service brat," lived in San Juan, Puerto Rico; France; and Arizona before his family settled in Sacramento, California, where he joined the Sacramento Branch of the party. He later worked for the state of California in roles including elections, telecommunications, warehouse management, and health and safety.

I WAS IN SACRAMENTO WHEN THE BLACK PANTHER PARTY CAME through the capital with the guns.* I was downtown, saying, Man, I'm going to check this out. I became very interested, then started going to Black Student Union (BSU) meetings at Sacramento City College. Then one day, I saw my captain, Charles Brunson (Esuto-sin Omowale Osunkoya), recruiting right by my house in Oak Park.

At that time, they had Panthers-in-training. You couldn't just join. They weeded out the wannabes or just flash people. We stuck with it and became Panthers-in-training. We had to read the Red Book,† and we had to memorize the Ten-Point Program. We were also doing the Breakfast for Schoolchildren Program, and in Sacramento, we would escort old people to the store and the bank because there were all the little thugs out there messing around and robbing them. My mom was walking around there too. After you joined, you also started selling newspapers.

The Sacramento Branch was different from other branches. We declared martial law in Oak Park right by the office and told all these little thugs, "If we catch you with a gun, we're going to shoot you." I knew all the gangsters, the thugs, the leaders, because that's what I used to do. I was a thug myself. We used to walk up to them and catch them alone when there were three of us. They knew we'd shoot them because they didn't have heart. When you're in a gang,

* On May 2, 1967, Bobby Seale led an armed contingent of Panthers to the capitol building in Sacramento to protest the Mulford Act, legislation that would outlaw carrying loaded firearms in public. It was drafted specifically in response to Panther armed patrols. The law ultimately passed, but the Panthers' charged appearance brought them to national prominence.

† Mao's (Little) Red Book contained pronouncements made by Mao Tse-tung on political, military, and social topics. The Panthers treated the text as a cornerstone of their political education.

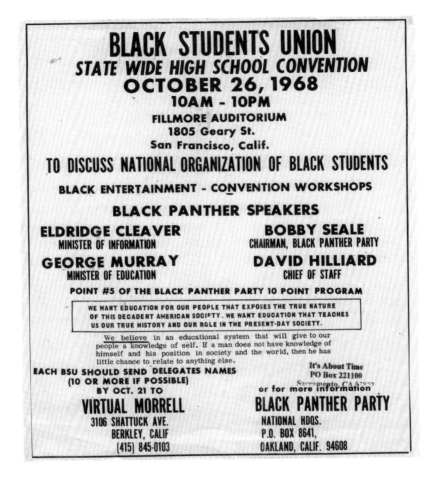

and you don't have heart, it'll come out. They knew me, and they knew I had heart because I had to battle with them. Being mixed race, I had to be rougher and tougher to be accepted. They knew I would do a 5150 (that I would go crazy on them). So we took the guns away from them, and pretty soon that died down.

Joining the party was the best thing I ever did. I either would've been dead or in prison, the way I was going. It straightened me out. When I came out of high school, I was semi-illiterate. I had low self-esteem because of my illiteracy.

The party used to hold political education (PE) classes, and I needed the discipline. You would jump up and read a paragraph of the Red Book, and they would help you with the words that you couldn't read—there were a lot of them. They'd say the word with

you. Then you would interpret the meaning of that paragraph. It gave me more self-confidence. Nobody was snickering or laughing, because it wasn't like that.

I was there for the Father's Day attack in 1969, right there in Oak Park. At that time, Los Angeles had sent up new attack squads, which the police had never had before. They were carrying guns and wearing riot gear to control the people.

Earlier that morning, I had gone around the neighborhood and seen that they blocked off Twelfth Avenue, and they had all these paddy wagons and police there. They had another one at Martin Luther King Boulevard and Broadway, right there at the Bank of America. Then they had another one at Broadway and Alhambra, all these paddy wagons. Then we went to McGeorge Law School, and that's where they had the attack squads.

As the day went on, we were the only office open, the Black Panther Party office, but we actually closed and mixed in with the community. The attack squads were wound up, and when one of my friends lit a firecracker, that's all it took. They started marching through the park with their shields and ax handles. That's what they used in those days. They blocked off Thirty-fourth Street in a V, and of course people started shouting, "Get off the street!" They herded them like cattle in a V to the paddy wagon, beating the people all the way down.

Behind the guys with the shields were the shotgun people, and they started shooting into the crowd. We went down there and opened up the office and let people go through into the alley to get away from the paddy wagons and away from the corral.

I remember being out there. We were trying to help slow down the attack squads' progression. I remember when I looked up, and I saw one officer with a shotgun. We made eye contact. I was in a corner, and I could see the shotgun go pow, in slow motion. I could just see the puff. I ducked my head back from part of a brick, and it missed my head by inches. They knew I was a Panther, and they knew I was slowing their progress.

After we went back through the office, all the people were gone. Then all these parents from everywhere came and were trying to pick

up their kids. The attack squads told the parents they couldn't get into the area and began breaking out their front headlights with their bats, saying, "You can't have your headlights on" and all this crazy stuff.

Another Black Panther member, Linx, and I were the last two in the office, which we had barricaded with sandbags. Next thing I know, man, the police shot tear gas into the office and came in and shot up the whole office. It was surreal. I could see the bullets coming through, hitting the chairs, and they were flipping in the air. I thought, Oh my God, we are going to die. For tear gas, we were taught to put cigarette filters up in our nose. We did that, but the gas still burned our faces. We crawled out the back door.

After the Father's Day raid, the Sacramento Branch closed down because we didn't have an office. At that same time, Huey had started purging people out of the party. They were accused of not serving the people, of being renegades. He was consolidating all the Panthers from the East Coast and West Coast to Oakland. Right after we got shot up, we didn't have any money, and they called up my captain and a few other people to go down to Oakland, but I stayed. The last time I was in the party was probably around 1971. They might have tried to get a house going, but it wasn't successful, so the party was over in Sacramento.

Everybody was concentrated in Oakland. I think that hurt the party nationally, and it just faded. The education level in the party was a little higher than that of the population. Some of the party members wanted a revolution. I said, "You've got to have community support because they'll just round you up and kill you after a while if you don't." To me it was a little arrogant telling people what to do instead of educating the masses more. I think that had we concentrated a little more on educating the people, I think the party would have done a lot better, but the revolution has no program, and you learn.

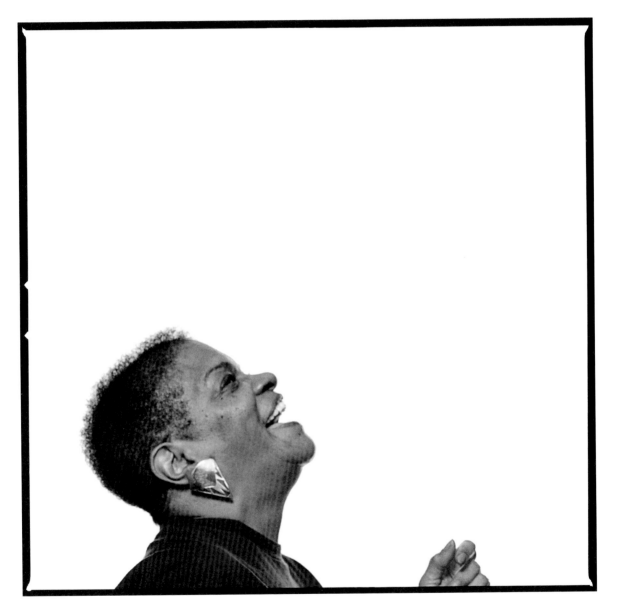

"When you're nineteen, you think nothing's going to happen
to you. It was exhilarating, and there was this attitude that
if you wanted to die, die for something you believe in."

Marion Brown (b. February 15, 1952) was born in New Orleans, where she joined the party. She worked a variety of jobs afterward in New Orleans and in the San Francisco Bay Area, including telephone operator, police dispatcher, and insurance processor.

I was always the rebel of my family. Malik (Rahim) said that if the people who became Panthers had not become Panthers, we would have become gang members because we were the white sheep in our families, which is what we called them in the black community.

I had a scholarship to an all-girls Catholic high school, and I set a record for demerits. They used to say a prayer every morning over the intercom. Some of my friends and I were in the ladies' room shooting craps, so I had to kneel all day for that. I got in trouble for wearing an afro. Those nuns were sadistic!

I remember a civil rights organization came to my school to recruit kids to sit at lunch counters. They wanted kids to be front and center because that would be more sympathetic. They showed us how to ball ourselves up so that when they hit you, they would do less damage. I walked my ass out of there. Nobody was going to hit me. That was it for me and the civil rights movement. That was one of the many reasons that the Panthers appealed to me, because it was about self-defense. It was about standing up for yourself and not backing down.

I started going to the Panther headquarters as a community worker but stopped for a while for college. But then the police had the raid on Piety Street on September 15, and then they tried to raid the place again in November. By that time, the Panthers had moved the office into the project, and when the police tried to evict them, the entire community turned out and stood between the police and the Panthers' office.

When I saw that on television, I ran off campus and hopped on a bus because I just had to be there. I had never seen anything like that before. People were partying in front of the line of armed police. It was surreal. They had riot gear on, and they were demanding that the people get out of the way. The people refused to move.

At one point, I got all the way up to the office steps and sat down. It was awesome. I will never forget that day. Everybody was out there, and it was like, "No, you're not going to do this. Not today." It was a feeling of standing up for what you believe in, even though you didn't know what the outcome was going to be. I guess the mayor did not want a bloodbath at that time. Later, when the police did raid the office, they came by in the middle of the night dressed as priests and mailmen.

I started going to the trial of the first group from the September 15 raid, and when they were acquitted, I became a full-time community worker. I was there practically every day. You had to prove yourself as a community worker before they let you join. By the end of 1971, I decided that school was not for me. I dropped out and became a full-time Panther.

When you're nineteen, you think nothing's going to happen to you. It was exhilarating, and there was this attitude that if you wanted to die, die for something you believe in.

Althea (Francois) and I would go downtown on Saturday to sell papers. The police would swoop in and take the guys away and leave us alone, or they would pick up the guys and then beat them up, and then we'd have to try and figure out where they were. They were always more aggressive with the men than they were with the women. I think there was something strategic behind it. I guess they figured we were weaker, so we could be intimidated more easily, but I found out years later that my mom used to get calls from men who either didn't identify themselves or said they were FBI. They asked her things like, "Do you know where your daughter is right now?" Or "We heard your daughter got killed." She didn't say a word to me for years about that. Then I found out that they did the same thing to Althea's mother.

Even after I left the party and came back to New Orleans in 1973, the FBI kept tabs on me. I started working at the phone company, and this is the God's honest truth. The FBI used to come by my job and ask me how I was. It was always the good cop thing. It was always, "How are you? Do you like your job? We were concerned about you."

I said, "Screw you. What the hell do you want?" They were interested in a guy named Clarence. The irony about it is that I couldn't stand Clarence. He had some serious issues, but this was a matter of principle. I couldn't let them know where Clarence was, so I told them, "Stay the hell out of my apartment. Don't come back here with that bullshit."

Ironically, in the 1980s, I worked as a dispatcher for the harbor police in New Orleans. A guy told me that when he ran my background with the FBI, it came up above his pay grade. He couldn't even look at it. He said that what he did find out, though, was that the FBI had intended to try to turn me and Althea because they figured that we were more educated than the other members in New Orleans, that we would be easier to flip. I was insulted.

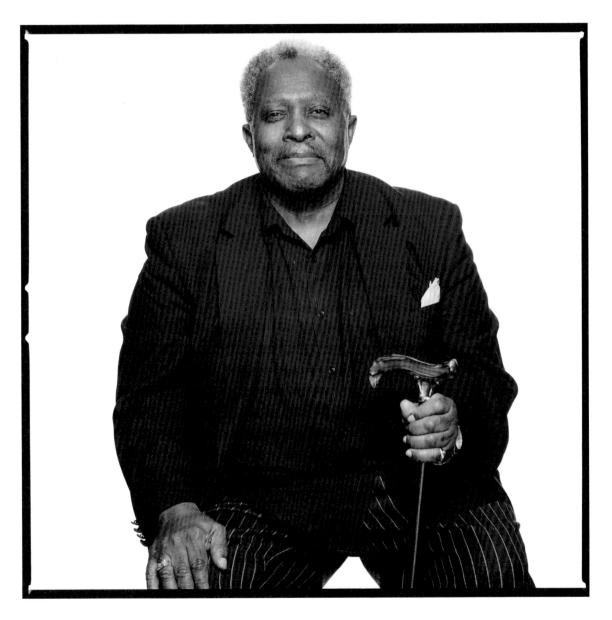

"I was never a talker. I was somebody who got involved."

Clarence Peterson (b. August 11, 1948) grew up in Philadelphia. Also known as "Stretch," he helped start the Philadelphia Chapter of the party, where he served as lieutenant of finance. He later worked for the city of Philadelphia in various roles including antigang organizer, finance account clerk, and tax review board clerk. He now writes crime mysteries and also works on the *Panther Post*, a newsletter produced by the National Alumni Association of the Black Panther Party.

WELL, THERE WERE TRYING TIMES DURING THOSE DAYS. WHAT DO you do? Do you continue to work and act like nothing's happening? Do you get high and act like nothing's happening? Or do you get involved? Well, you could just walk around like some guys did and just talk about it. I was never a talker. I was always somebody who got involved. I didn't hear about the party till 1968 with what they did in Sacramento. That totally got me. I thought, Oh my God. I'm with you all.

I became lieutenant of finance, probably because I had taken up bookkeeping in school. You had to account for everything. You had to give reports to Central Headquarters, to East Coast Headquarters. You couldn't let anything slide because then everybody would start looking at you.

All I think about are the good times. Sometimes we talk about crazy stuff, but most of the time we talk about fun stuff.

Sultan (Ahmad) and I were in the office one day on Twenty-ninth Street, and a couple of our neighbors came in and said, "You all have got to stop this out here." We said "What? What's going on?" They said, "They've already started a gang war, and the kids are on the street, and somebody might get hurt."

"Oh my God!" I said. So I went and picked up a gun, and Sultan picked up a gun, and we went outside to see what was going on. I saw this one gang called "Thirtieth and Norris Street" coming across the bridge, and I saw these other cats, my young boys, from my old gang, "Twenty-Eighth and Montgomery Street," coming down the street.

There were about thirty of them, and I stopped my young boys and I said, "No, there ain't going to be no war today."

"No, Stretch, you don't understand."

Sultan took the Norris Street bunch and said, "Ain't going to be no gang war today."

"What do you mean? Who are you?"

Sultan said, "We're the Black Panther Party."

"We ain't got nothin' to do with you all, but you know this and that and this . . . you don't understand."

There were all these young boys saying we didn't understand. We understood it all the way around.

Sultan grabbed the leader from Norris Street and a couple of his boys, and I grabbed the leader and a couple of my young boys, and we took them to the office and down into the basement. I said, "You see this?" We showed them some big guns. "If you all don't cut it out, we're going to come and wipe all of you out."

One of them said, "Why do you all want to do that?"

I was trying to keep a straight face. I said, "If all you knuckleheads don't end this, you are going to get one of these kids killed, and then we're going to really hurt everybody up."

When you want to stop a gang war, you find out who the leader is or who has the biggest mouth. Sometimes the leader is not starting the war; sometimes the leader is just letting a big mouth start something. Sometimes you might have to take them around the back of a truck or a corner and bounce them off a wall to make them understand that they don't want any more trouble with you. You don't do it in front of all their corner boys because that's an embarrassment, and now you've made a total enemy. We played crime intervention sometimes.

The most heartwarming story and the one that always sticks with me was after the raid in 1970. The cops tore up our office downstairs in one of our houses at Twenty-Ninth and Columbia (now Cecil B. Moore Avenue). They tore it up so bad, they took all the furniture out; they even took the pipes out of the house. This was after they had already raided the place. Then they blocked off the whole street so that none of us could get back into the house. Sultan and I were down at the corner of the blockade, and we saw

our neighbors go into the house and clean it up. When we did finally get back in, they were cooking meals for us. They brought furniture in. They found people who knew how to do handiwork and put the pipes back into place. That made me cry so bad. That was a day I will never forget.

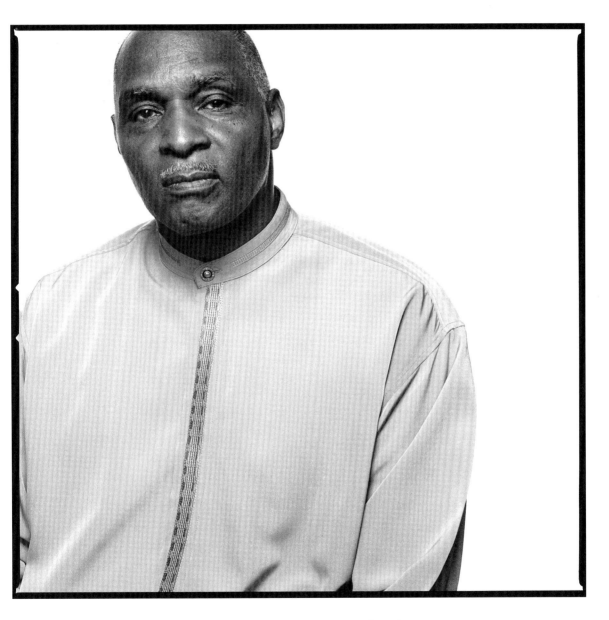

"The party was like a prairie fire that just whipped around the whole country."

Stephen Edwards (b. December 27, 1949) grew up in Houston, Texas, where he joined Peoples Party II (PPII), an organization established by Carl Hampton modeled on the Black Panther Party. PPII became the Black Panther Party Houston Chapter after Hampton was killed by the Houston police. Edwards received his master's in fine arts from the University of California at Los Angeles (UCLA) film school and is a photographer and filmmaker.

THE PARTY WAS LIKE A PRAIRIE FIRE THAT JUST WHIPPED AROUND the whole country because of this youthful enthusiasm to be a part of this movement. I was one of those people.

My title was deputy minister of information. I wrote weekly reports to the Oakland Headquarters and all the articles for the *Black Panther* newspaper coming in from the Houston Chapter. I was one of the primary people responsible for the dissemination of the *Black Panther* newspaper. I had to write all the press releases. I had to deliver the press statements. I had to go and make speeches. All of this was very overwhelming to a young man who was a C/D student in a segregated, underprivileged high school in Houston, Texas.

This was one of the reasons I was reluctant to be a member of the party—because Carl Hampton wanted me to be a leader right away. I didn't want to do that. I didn't feel I was intelligent enough, knowledgeable enough, strong enough, courageous enough. I would go with him, and he would turn out large numbers of people at rallies and have them mesmerized by what he was saying. I figured, I can't do this.

I remember the first time he sent me out to deliver a statement at Pacifica Radio. He wrote up the press statement himself. It announced that we were going to be creating our office on Dowling Street, and that we were in coalition with other people. Just a whole two-page statement that I had to do. No matter how much I practiced, I was so nervous, I stumbled through every sentence. I said to myself, I'm horrible. People are going to laugh at me for this. I finished reading it, and the whole room erupted in applause.

I was shocked and relieved and very happy that people really appreciated what I was saying, more so even than I did. That's how I got involved with the Black Panther Party.

**Arm Yourself or Harm Yourself:
People's Party II
and the Black Panther Party
in Houston, Texas**

Charles E. Jones
Cover by Boko

They were very afraid of what we were doing, and this is what COINTELPRO was all about. I was constantly harassed, arrested and interrogated by the FBI. We were shot at. There were a couple of instances where we had these drive-by shootings, where we'd be in our office at night, and they would just drive by and shoot up the place. It was designed to terrorize us out of existence, to keep people from joining up with us.

We had an incident where one of our members was arrested while fixing a flat tire. The police tried to frame him by saying they found a marijuana plant on him. At the time, you could go to prison for fifteen to twenty years.

I remember telling these reporters, "Think about it. We're harassed, monitored, and watched 24/7. Why in the world would one of our members go out and have marijuana on him while driving around and fixing a flat tire?" For the first time, they got it. They wrote the story as we said it happened.

The trial lasted about two weeks. We even got into a fistfight in the lobby of the courtroom. I was in the witness stand when somebody shouted out, "The police are beating up the Panthers downstairs." Then the whole courtroom cleared. People ran downstairs. I thought, Oh my God! They're really going to get us this time and convict this brother.

Our attorneys made a very eloquent presentation to the jury. They were two black men, and the jury was all white. I think they had two women on it. When the jury members came back, they said, "Not guilty." You cannot imagine the jubilation in that court. The judge had to constantly pound his gavel for quiet. It was just such a tremendous relief that they finally got it.

I think one of the things that they really listened to was a rule written by Bobby Seale that no party member could be in possession of marijuana while doing party work. This rule was read out in the courtroom by one of our attorneys. I could see that the jury was really paying attention to this. Why would he have marijuana when the rules said he shouldn't? He was a leading member of the organization.

The police also claimed they put him in the patrol car, took him down to the station, and then searched him down at the station, when they found the marijuana. When I was on the witness stand, I testified that I saw the police officers search him. No marijuana. They tried to cross-examine me, and I constantly said the same thing: "I don't care what you say. I don't care how many times you put this question to me. I witnessed the police officers search him before he was put in the patrol car." On top of that, our attorneys

read the policy of the police department: "Always search suspects before putting them in a patrol car."

The prosecutor was this young, arrogant, white guy, and he was packing a gun in the courtroom. I think they just thought that they could throw anything out there, and the jury would convict him. The jury basically said, "How can you expect us to believe these kinds of stories you guys are telling us? You've got to do better than this."

From that point on, we started to have a much easier time of organizing. More money came in; more people wanted to be a part of the organization. We had actually won. We beat them. One of the cops who participated in the frame up quit his job. Even the cops started treating us a little bit better. That was right during the time that Huey Newton announced that we were going to stop emphasizing the guns so much. I remember talking to this police officer, and he said he was so happy that we did that because he thought he was going to get killed.

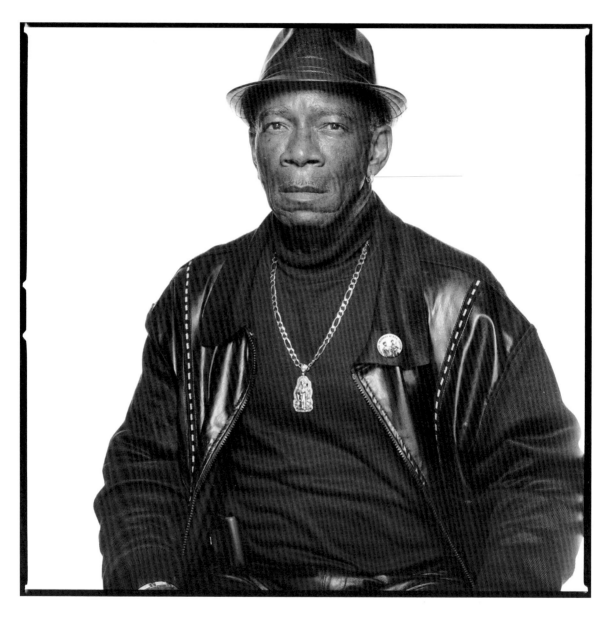

"I was fifteen years old when I joined the Black Panther Party. I wanted to make a difference. I wanted it bad."

Brian Hunter (b. May 4, 1955) joined the New Orleans Chapter of the party. He studied draft engineering in college and now works with people in recovery. He is still active in his New Orleans neighborhood, serving on a local board trying to build a community center.

I WAS FIFTEEN YEARS OLD WHEN I JOINED THE BLACK PANTHER PARTY. I wanted to make a difference. I wanted it bad. I even lived in a Panther house. I've always had a passion to try and help others, and there was a lot of police brutality going on in the city at that time.

Aggressive confrontations with the police were common. When I was seventeen, I suffered a broken rib and other injuries from the police. They were handling me very aggressively during a search. One thing led to another, and one of the officers struck me, which led to a fight. I was then taken to one of the precincts, where I was handcuffed and beaten with a flashlight.

I was happy that the Panthers had come to New Orleans. They were much needed. They gave the neighborhood and community a strong sense of pride. The Panthers were doing things that connected with the people on deep levels by providing services that were usually considered very human and giving you encouragement that you were somebody and did matter. Just to see the smiles on those kids' faces at the free Breakfast for Schoolchildren Program— it was very rewarding.

The party helped me develop into a man of morals and principles. I owe the Black Panthers a lot for the character that I developed. It was an experience that I would not trade for anything in the world. The camaraderie we shared was just unbelievable, and I was able to touch a lot of people's lives.

I remained in high school while I was with the Panthers, where I was very active also. My experiences and knowledge of the movement at that time led me to becoming a student body representative. In fact, one of the organizations I was a part of, Youth Organized and United of New Orleans (YOUNO), exposed two undercover agents that were infiltrating the Black Panthers at that time. They

held what they called "the people's court" on them, and the two agents were turned over to the people of Desire.* One of them got away, but the other was beaten pretty badly. That happened September 14, 1970, at night, and the shootout occurred the very next morning.

* Desire is a neighborhood in New Orleans.

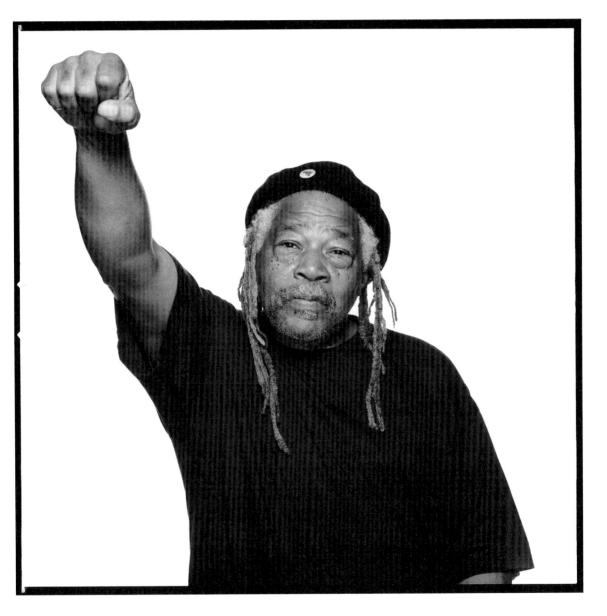

"I'll be damned if I was going to let one of these
racists treat me any kind of way."

Malik Rahim (b. December 17, 1947) grew up in New Orleans, Louisiana, and served in the US Navy in Vietnam. After Hurricane Katrina, he established and led Common Ground, a massive volunteer relief effort he set up in his mother's house. His work with Common Ground received widespread attention and led to his being named one of *GQ* magazine's Men of the Year in 2005.

AFTER THE (MARTIN LUTHER) KING (JR.) ASSASSINATION—THAT'S when I realized that we had to learn how to defend ourselves. That turn the other cheek wasn't working. I'll be damned if I was going to let one of these racists treat me any kind of way. I came from a community of "Maroons," where we have always stood up. Maroons were slaves that ran away and decided that they would rather live in the bayou than be a slave. We fought the (Ku Klux) Klan tooth and nail. The only area in Louisiana where the Klan didn't come in with any of their bullshit was here in Algiers. We were always classified as the most dangerous part of the city because of our Maroon heritage.

With that background, I decided that the Black Panther Party was the way for me. When I found out that they were organizing a chapter here, I called my wife of the time, and we joined, together with our two kids. Not only was I one of the first members of the party in Louisiana, but my wife and I were the first couple to join the party here.

I went to Vietnam. I served this country. Through my sacrifice I deserve equal rights with anyone. You can't tell me that one race has more rights than me, and we both fought in the same battle. Our people went through that already with the War of 1812, in the Battle of New Orleans. Blacks were promised their freedom if they fought for their white masters, only to be denied afterward. So we have seen betrayal. I didn't want to leave that as a legacy to my children. Now I've got twenty-three grandkids and six great-grandchildren, and if I can do nothing else, I want them to know that their grandfather stood up for justice.

You have to remember that I joined during the most dangerous time to be a member of the Black Panther Party. In 1970 Fred Hampton had just been killed, and you had quite a few other shootouts and murders going on involving Panther members. I was always

fearful for my kids, but I would have rather seen something happen to them than to have them grow up in an environment without any respect or without any integrity and just become another victim of this country.

In the party, I was officer of the day (OD). It was my position to make sure that whatever action was dictated by leadership was carried out. It gave me a chance to see the party from a very privileged position in Louisiana. Our political education classes and the services that we would render—our breakfast program, our senior escort program, our pest control program, our health-care program, our crime prevention program, our cleanup program—made the people of Desire support us and turned housing projects once classified as the most dangerous community in New Orleans into the safest. After the first shootout with the police, every time they tried to raid the office, the community would come out and stop them. It got to the point that the police had to dress up as priests in order to get close enough.

I never thought that the teachings I learned in the party would manifest themselves after a disaster. There wouldn't have been a Common Ground if there had not been the Angola Three support committee. And there wouldn't have been an Angola Three support committee if there had not been a Black Panther Party. I started four wellness clinics. No one could have told me about starting health clinics, but that's one of the things I learned in the party. Distribution centers were another thing that we learned. Our bio-remediation program was nothing more than an extension of our pest-control program.

In Common Ground, I had more than 19,000 volunteers in two and a half years who served more than half a million people. Of those, 18,000 were white, and they volunteered under the leadership of a black. That's something that has never happened in the history of the South, especially in Louisiana. I felt honored because I saw the essence of what made America great: those willing to stand up for peace and justice. We served nineteen parishes in Louisiana, two counties in Mississippi, and two counties in Alabama in the aftermath of Katrina. We did this in spite of the government, not with governmental support.

The reason Common Ground doesn't get respect is because here in the state of Louisiana they call it "Black Pantherism." They classify us as a racist organization based on violence. Our health clinic wasn't known as the Common Ground Health Clinic at first but as a Panther clinic until it was stripped away. You look at the fact of Brandon Darby.* You look at the fact that of all the volunteers who came down here, ours were the only ones who were actually beaten by the police. We had one nineteen-year-old kid who was arrested for the heinous crime of double parking at our distribution center. They didn't want to see us providing that type of service. We faced it all. We gave all our volunteers disposable cameras to carry with them so anytime they saw an injustice they could take a picture of it.

They are afraid of people understanding that the Black Panther Party was never a racist organization or a violent organization. We believed in self-defense, but you would never see Panther members trying to destroy anything. If you did, you found out later that it was done by provocateurs.

In *GQ* magazine for the year 2005, I was named a Man of the Year. They called me a Katrina organizer. Where did those organizing skills come from? The Black Panther Party. If they would have found out I was in the Panthers, I wouldn't have been in the magazine. But the greatest thing that ever happened to me in my life was becoming a member of the Black Panther Party.

* Darby was a highly visible and active cofounder of Common Ground who later became an FBI informant and right-wing activist and spokesperson.

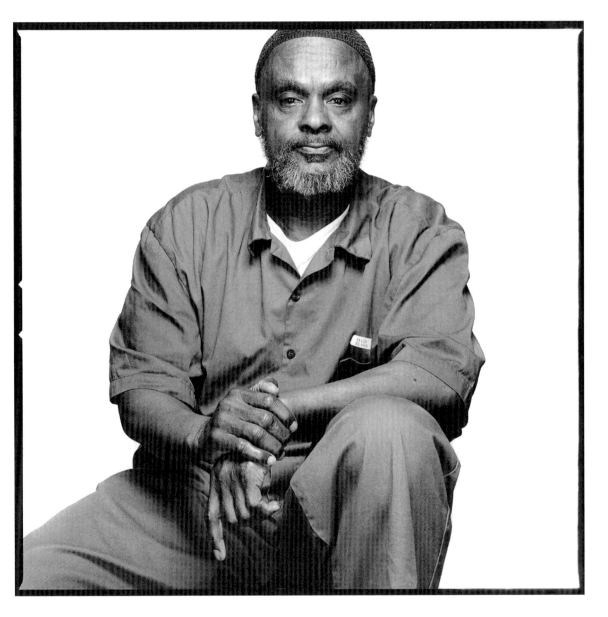

"Without a doubt, I am a political prisoner."

Abdullah Majid (formerly Anthony Laborde, b. June 25, 1949, d. April 3, 2016), born in Flushing, New York, was a founding member of the Queens Chapter of the party and a full-time party member from 1968 to 1971. At the time of his death, he was incarcerated in Five Points Correctional Facility, a maximum-security prison in upstate New York, for his role in the shooting death of one New York City police officer and the wounding of another.

ONE OF THE FIRST THINGS WE DID WAS STUDY HOUSING LAW. We then began to organize tenants to withhold their rents—rent strikes, if you will—until the landlords rendered the services that they were supposed to render according to the housing law. When people began to resist paying them, the landlords relied on the police to be their enforcers.

There were two incidents I can still remember freshly in my mind where off-duty cops came with the landlords and threatened to put tenants out right then, not even going through the due process of serving them with a notice of eviction and taking them to court. The police would come by and try and strong-arm tenants. On at least two occasions, we had to address the situation ourselves.

In one incident, a sister was organizing a rent strike. The landlord put his hands on her physically. She came back to the office. I took a couple brothers upstairs to see what was going on. About four or five of us went up there. The landlord was still there trying to shake people down. We had a verbal exchange. The cops told him they thought it would be prudent to leave, so he left. There were a few other incidents like that. In fact, I was arrested one time for intervening in an illegal eviction process.

The Black Panther Party had the Ten-Point Platform and Program. We wanted an end to the exploitation of our community, full employment for our community, education, housing, impartial trials for black people, and an end to the mass incarceration of black people. Our program was balanced. Actually, we were trying to work within the framework of the law.

With the Counterintelligence Program (COINTELPRO), J. Edgar Hoover himself did everything to undermine and break the law and violate the Constitution through infiltrating the party with

agents provocateurs, literally creating crime in many instances, which in turn brought the reaction from the law enforcement community to disrupt the party. We were exercising what were supposedly our constitutional rights, the First Amendment right to free speech, the Fourteenth Amendment right to equal protection of the law. They were the ones that were doing the lawbreaking. Yet none of them were ever held accountable for any of their acts. I'm talking about the FBI and the Justice Department.

You have brothers who are still in prison, rotting in prison as we speak right now, for crimes that the government knows they didn't commit. Geronimo ji-Jaga and Dhoruba bin Wahad are two cases people are aware of. Geronimo did twenty-seven years for two murders that they knew he didn't commit. Dhoruba bin Wahad did almost twenty years for acts that they know he didn't commit. These were just two of them where brothers were fortunate enough to get exculpatory evidence made available. We have many of them that we know of that weren't as fortunate. They still languish in prison today as we speak.

In fact, much of the trial for the case that I'm currently incarcerated for had to do more with my political background than it did on the actual charges. I was tried three times, first of all for murder and attempted murder of a police officer. This was in Queens, New York. During each of the trials, the district attorney made a point of emphasizing that these guys were revolutionaries, members of the Black Panther Party, the Black Liberation Army. They indicated that we were allegedly involved in the Brinks armored truck expropriation that took place in Nanuet, New York, and the liberation of Assata Shakur from a New Jersey prison. These things were done to prejudice the jury, to make it appear that we were some hell-bent, crazy, mad men bent on destroying America. Without a doubt, I am a political prisoner.

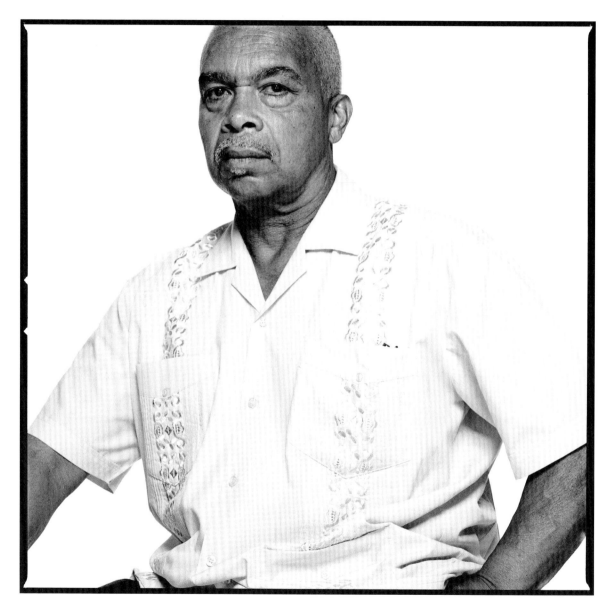

*"The original intent of the party, self-defense of our
community, was there and remained there."*

Cisco Torres (b. November 28, 1948) was born in Puerto Rico and raised in eastern New York City. He left as a teenager to join Job Corps in Louisville, Kentucky, and then VISTA Volunteers in Chicago, Illinois. He then enlisted in the US Air Force and served as airborne infantry in Vietnam. Torres was one of the so-called San Francisco Eight, charged in 2007 in the 1971 killing of a police officer. The final charge against him was dismissed in 2011.

In Vietnam I had an exemplary record, but as soon as I got sent stateside, I started organizing soldiers at my base because they wanted veterans to take what they called "riot training." I said I didn't want it, that I wasn't turning my weapon against American citizens. After taking our grievances to the general on base at the time—actually we just barged into his house—we were interrogated, including by the FBI, and put in the stockade. Through my organizing activities I had come into contact with the Panther Party in Denver, and they arranged for an old activist lawyer to defend me. The situation escalated to a court martial, but my lawyer made a good strategic move. He subpoenaed the general, who had told me that nothing would result from my coming to see him. We eventually agreed that I would take a bad conduct discharge that I could later upgrade to honorable conditions. My captain had to escort me off the base. He handed me my medals, including a bronze star, and said, "Jesus, I would love to have your record." I told him he could have my medals, and when he refused, I threw them in the garbage can and left.

I was supposed to join my brother in the Young Lords, but the people in the party said, "Hey, brother, the struggle is everywhere. You might as well stay here. You're already known here." It was the time of internationalism, so I stayed and joined the Black Panther Party.

I got into it just when the "split" was coming down, and members were being cast out. I got along with the different people, and party people would try to explain to me what was going on, but I was simply in the party doing work, selling newspapers and carrying out the breakfast program.

It was during this time that I got a whiff of the infiltration. We had people come through who stayed in the office, and somebody

looked at one of their wallets and saw a badge. The police would call pretending to be someone else and mentioning the name of a member. They would say, "Hey, Cisco! I'm in jail with your comrade, and he says to get the guns out of the office, man. They're getting ready to raid the office." They'd say, "So-and-so is over here telling on you. You'd better get out of there now." I'd tell the other people in the office, and we'd go sit on the stoop, and then the police would ride around, pointing their guns at us and waiting for somebody to panic to provoke a shootout. That was the Counterintelligence Program (COINTELPRO) at work.

I was never approached to infiltrate because they already had my military record, including reports from a psychologist and CIA investigation and knew I didn't want anything to do with them. The United States had nothing to offer me, you know? I think they just said, "He's gone" because for them I wasn't approachable. Although later on, when I did get arrested for something, they tried to approach me. I just told them, "Get the hell out of here. Talk to my lawyer." If there's one thing I learned in the military, it's that all you give your opponent is your name, rank, and serial number. When it comes to giving information on your comrades, you don't talk to them.

I would say I was in the party for a year when things started spiraling out of control. The Denver Chapter office had already shut down because of the "split." That's when I went underground. For me that meant moving from place to place, working when you could. Wherever we went, we still carried the party lines. You still wanted to keep breakfast programs going, still do community work, but that became more difficult. By then we had been targeted. People were getting hurt, people were dying, people were being arrested. There was also a sense of panic and anxiety too. Imagine all of this coming at you at a young age. When I look back and think, "You know, we were dealing with the US government, FBI, CIA, criminal investigations, you know?" That's a lot. We had the might of the state thrown at us.

That was at the time when we stole, trying to fund our programs. One thing that the FBI did say when we were caught "expropriating funds" from banks—because I went to prison for a bank

robbery—they said that none of us ever got rich or drove a Cadillac, which was true. We still were trying to help comrades get out on bail and still trying to support the community and help people pay rent in the community. When we got dispersed, we didn't have that organization. When the office closed down, when the leadership got arrested, then you had members out there trying to survive, sometimes directionless. We formed certain pockets, certain cells, but we still tried to maintain the work.

The reason I'm talking to you now is so that you can listen to the different takes on the party's history. When it started out, it wasn't reactionary. There might have been certain reactionary elements in it, but for the most part the people were dedicated to serving the community, serving their people. The original intent of the party, self-defense of our community, was there and remained there.

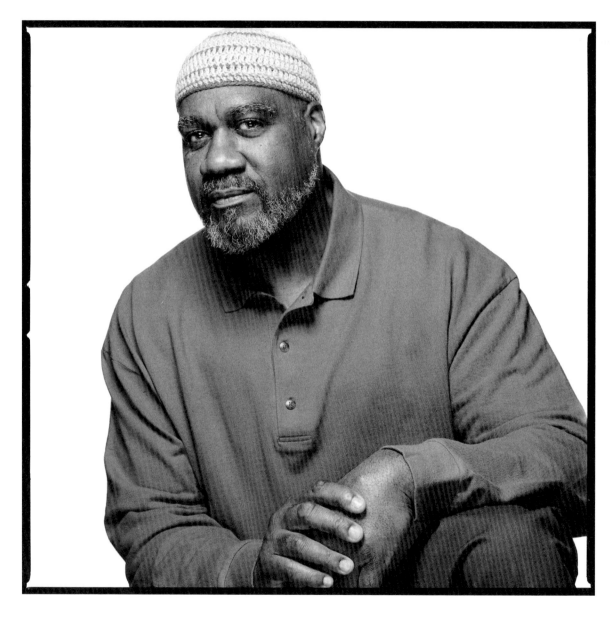

*"The FBI was engaged in a very ruthless
campaign to destroy the party."*

Jalil Muntaqim (formerly Anthony Bottom, b. October 18, 1951) grew up in the San Francisco Bay Area. He was a youth organizer with the National Association for the Advancement of Colored People (NAACP) before joining the Black Panther Party. Along with two other Panthers, he was convicted of the 1971 killing of two New York City police officers. He received a sentence of twenty-five years to life. He is currently incarcerated in Attica Correctional Facility, a maximum-security prison in upstate New York. While in prison, he earned bachelor's degrees in psychology and sociology and launched a campaign to petition the United Nations to recognize the existence of political prisoners in the United States.

I'VE BEEN CONVICTED OF KILLING TWO POLICE OFFICERS BACK IN 1971. Unfortunately, we did not receive a fair trial. If you look at the record of our case you will find that a lot of exculpatory materials and information were withheld from the defense at the time of the trial. Unfortunately, the parole board wants you to be remorseful and to admit guilt, so if you want to get the opportunity to get out of here, that's what you have to do. It's damned if you do, damned if you don't.

Our intent was never self-serving or self-aggrandizing. Our goals were always to support the development of the community. We created the free breakfast program, the free health clinic program. We established the first program to have buses come to prisons for visitation rights. We established the basis for sickle-cell anemia research. All of that came from the Black Panther Party. We also created one of the first "cop watches," patrolling our communities to ensure that people had their civil rights adhered to and were not brutalized by the police. That was part of what made us dangerous to the social order of the day, by virtue of our willingness to fight back and ensure the safety of the black community.

In fact, one of my most vivid memories in the party was when we went to Soledad Prison for Black Solidarity Day. There was a group of us, two carloads, and a bunch of guys and women. There was difficulty getting me in because I was so young, but we managed to persuade the authorities that if the young guys didn't get in, then nobody was going in, and that would upset the prisoners, so they allowed us all in. When I walked into that institution, I had a premonition that I would be in prison, one time, one day, for a

long period of time. The clanging of the metal door slamming. The noise in the hallways from the prisoners. It shook me. When I left, I told myself I'd never go to another prison to visit anybody again. I believe I was seventeen.

I do believe I was targeted for my involvement with the party. There ain't no fuss about that. We have documentation indicating we were targeted. The FBI was engaged in a very ruthless campaign to destroy the party that included everything from assassination to infiltration. When we look at the breadth of the FBI's campaign against the party, we say that anyone convicted on the basis of being involved in the Black Panther Party is naturally a political prisoner. Our work was political, and our imprisonment was based upon our political work.

We were encouraged by our youthful enthusiasm, our bravado about what we believed to be the right way to challenge the system, and we ultimately had to pay the price for it. Some of us knew we were going to be sent to prison. Some of us knew we were going to be killed. But we believed that we were going to be successful in building a revolution.

There is a maxim by Mao Tse-tung that "politics is war without bloodshed, while war is politics with bloodshed." Well, our goal was to counter the violence, to end it, not perpetuate it. Along with the physical aspect of violence, when you look at economic injustice, that's violent. When people cannot eat, when they don't have places to sleep, those are forms of violence, and you're denying people their human rights. Our goal was to stop the violence of human rights violations. And if it was necessary to engage in counterviolence in order to do so, then that's the nature of the war itself. But understand that we were not the ones who started the war.

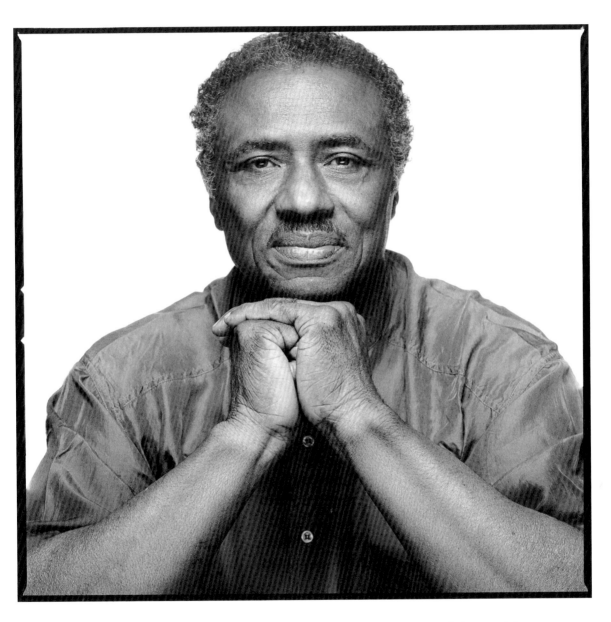

"It's like we were out there for American society and the world
to see, standing on our own, and we were unapologetic."

Herman A. Bell (b. January 14, 1948) grew up in Brooklyn, New York, before moving to Oakland to play college football on a scholarship. He is currently incarcerated in Great Meadow Correctional Facility, a maximum-security prison in upstate New York, where he has served more than forty-two years of a twenty-five-years-to-life sentence for killing two New York City police officers. While in prison, he earned bachelor of science degrees in psychology and sociology and a master's degree in sociology and has been active in various prison programs. While incarcerated, he also helped found the Victory Gardens Project in rural Maine, which taught gardening and farming skills in the context of political awareness.

WE MAKE A DISTINCTION BETWEEN POLITICAL PRISONERS AND SOCIAL prisoners, and obviously I am not a social prisoner. I am in prison as a result of being a social activist from the black community in the fight for social justice in our society.

As for my case itself, I was convicted along with two codefendants of having assassinated two New York City police officers in 1971. My conviction was upheld in my two appeals, and the Supreme Court denied us entry. Parole is my one hope of getting out of here. But it's also complicated as far as what you have to say before the parole board to have any hope of being released. They want you to admit guilt. That's more or less the situation. Of late, I've read of a few cases over the past year or so where that doesn't completely apply anymore. There are a few guys who have maintained their innocence throughout, and they were subsequently released, but they were social prisoners, not political prisoners. The parole board just applies a higher standard to us.

I've gone to six parole hearings, and at some point that same question arises about why I didn't go on to play football. There was so much going on at that time. I was also in the process of trying to find out who I was as a person. In my younger years, I must admit that I was mentally asleep. But then riots in the inner city began to take place, the Freedom Rides, the sit-ins at the restaurants. They fired my imagination. They inspired me and made me feel like I had to make a contribution too. With some measure of social consciousness then, I arrived on campus at Laney College in California in the midst of the antiwar movement. I was like, What is imperialism?

What is colonialism? In addition to that, there were people such as Malcolm X, my mentor, who woke me out of my mental stupor. To me, he epitomized a fine model of a black man.

I felt, as Dr. (Martin Luther) King (Jr.) said, that we went to the government with a check and were told at the window that there were insufficient funds. I felt like we certainly had a raw deal here in our society, so how could I not become involved in this struggle for social justice? In a sense, I set aside my personal ambition and decided to do what I could to help improve the quality of life of our people. In a way, that explains why I didn't choose the white picket fence and the two-car garage and all the other things that might or might not have come to me had I gone in that other direction.

One of my important functions was security within the community itself. There were, from time to time, domestic disturbances and so forth. A husband was beating up his wife, and sometimes a wife was beating up her husband. People knew who we were in the community. They would come find us and bring us to an apartment or house to intercede. We would pull them apart for a while to cool off and find out what the deal was, and we would find some kind of resolution one way or the other. That was really quite exhilarating and satisfying in the sense that we were there on the spot on the basis of our authority as party members and respectable members of our community, and people would hear what we had to say and respect that.

Folks would donate cars to the party, refrigerators; they'd bring clothes around; community merchants brought food. They identified with the party, and that was a gratifying feeling too. Then there was the newspaper. We took great pride in that newspaper and in Emory Douglas's cartoons. He really demonized the police. He would do them so bad that sometimes, when the paper came out, we wouldn't read the articles at first, which had some really sharp political analysis. We'd go right to the cartoon section to see what Emory had cooked up. He'd lampoon these guys so bad that some of us would feel bad about how he was treating the police. It was hilarious, a just bit of payback. It's like we were out there for American society and the world to see, standing on our own, and we were unapologetic.

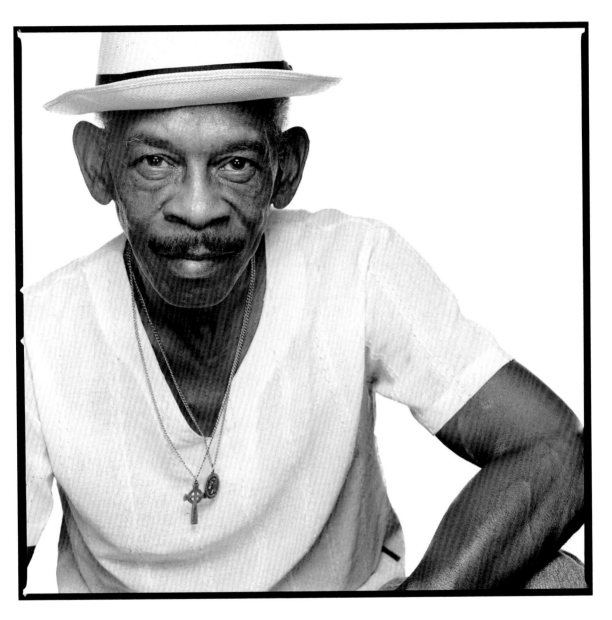

"We were children, and they moved on us
like we were North Vietnam."

Thomas McCreary (b. January 3, 1945) was raised in Brooklyn, New York. Before joining the Black Panther Party, he served in the US Army in Vietnam and worked in the merchant marine. He later worked for the Legal Aid Society in New York City and as a counselor with the Salvation Army.

WHEN I SPEAK ON COLLEGE CAMPUSES, ONE OF THE THINGS I ALWAYS ask the youth is, "When you hear the name 'the Black Panther Party,' what's the first thing that comes to your mind?" A lot of them say, "Black berets, leather jackets, and guns." I always dispel the myth about the guns because everybody wants to put the guns in there. I tell them, "Listen, the majority of the Black Panther Party members were not in shootouts with police. There were only a few of us fools out there playing with guns."

A lot of the guys who went underground in the Black Liberation Army were Vietnam veterans. We were the ones dealing with a lot of the arms. The police killings (of African Americans) in New York were horrendous back in the 1960s—just like Ferguson. It was always acquittal or justifiable homicide, so people decided that we had to do something. We couldn't go on like that because we were being murdered in the streets.

I went under and stayed under for about two-and-a-half years before I was captured in St. Louis on February 15, 1972, after St. Valentine's Day. There were five police officers involved in the shootout, and there were four of us. One of us was killed and one escaped, and he was never captured. Two of us were captured, myself and Henry "Sha Sha" Brown. In total, I ended up with sixty years, and he got seventy-five.

Being underground means you're not dealing with your familiar haunts any more. I was in safe houses from Atlanta to Cleveland. Detroit, Milwaukee, Kansas City. You're constantly on the move when you're wanted. Some of us were on the FBI Ten Most Wanted list, so we had to move. We survived. We did a lot of expropriations of banks. We were tired at night. We were tired shitless. The only thing we had going for us then was youth. We had energy—a lot of

fucking energy, and we were angry as hell, man. We were totally pissed off. We were just going on sheer vibes.

After the Counterintelligence Program (COINTELPRO) was exposed, I became convinced, like I am to this day, that the only thing that we are guilty of is not leaning on this government hard enough. When they started killing kids in Harlem and Bedford-Stuyvesant and around the United States, my position was, if there are going to be wailing black mothers in the black community, we're going to have some white mothers wailing in the white community. We wanted them to know what suffering was really all about. Every time a cop got killed or wounded, they would always come out crying crocodile tears. They'd parade the family up there with the children. They never showed any of our children and the fathers who were killed. They didn't show that. They didn't even talk about that. When Panthers were killed in the city, they acted like they came from Mars, that they didn't have families or that their families didn't suffer.

When COINTELPRO came out, I was a rank-and-file member of the Black Panther Party. I was insignificant in terms of leadership. But we got files from every-fucking-body—the Central Intelligence Agency, US Army Intelligence, US Navy Intelligence, National Security Council, FBI, local police. They had almost 3,200 pages on some of us Panther members going back to my Student Nonviolent Coordinating Committee (SNCC) days. These people were spying on us, and we were kids. The average age of a Panther was between seventeen and twenty-three years old. We were children, and they moved on us like we were North Vietnam.

I ended up in the penitentiary around 1973 and got out in 1977 because I got a reversal after COINTELPRO was exposed. Three FBI agents came to visit me in prison in Jefferson City, Missouri. When I walked in this room, three suits were sitting there. I knew what it was. I said, "Oh, hell, no."

They told me, "No, no, no. Come back. Listen, sir, we just want to talk to you." They gave me a hypothetical situation. They said, "We can get you back to New York. We know your mother has

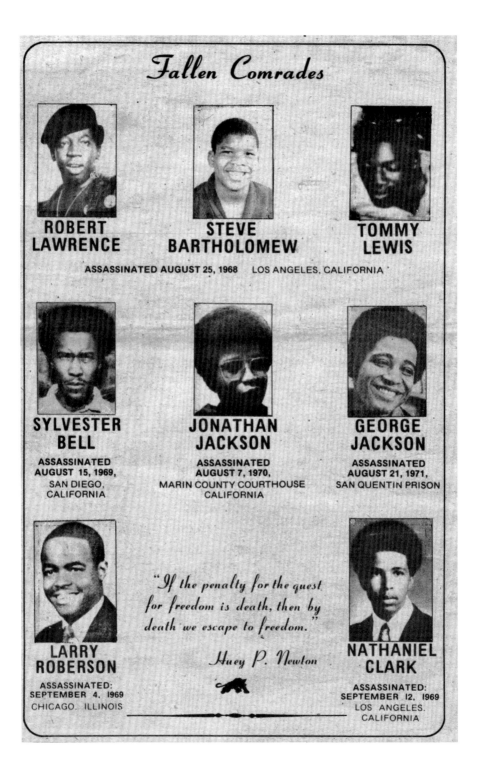

Fallen Comrades

ROBERT LAWRENCE

STEVE BARTHOLOMEW

TOMMY LEWIS

ASSASSINATED AUGUST 25, 1968 LOS ANGELES, CALIFORNIA

SYLVESTER BELL

ASSASSINATED
AUGUST 15, 1969,
SAN DIEGO,
CALIFORNIA

JONATHAN JACKSON

ASSASSINATED
AUGUST 7, 1970,
MARIN COUNTY COURTHOUSE
CALIFORNIA

GEORGE JACKSON

ASSASSINATED
AUGUST 21, 1971,
SAN QUENTIN PRISON

LARRY ROBERSON

ASSASSINATED:
SEPTEMBER 4, 1969
CHICAGO. ILLINOIS

"If the penalty for the quest for freedom is death, then by death we escape to freedom."

Huey P. Newton

NATHANIEL CLARK

ASSASSINATED:
SEPTEMBER 12, 1969
LOS ANGELES.
CALIFORNIA

a brownstone in Brooklyn. We see you've got these college credits here. You bring us a bachelor's degree, and we'll get you paroled to New York."

I was thinking they wanted me to snitch, so I asked, "What do you want me to do?"

He said, "Well, let's just say later there comes a time when you may hear of people talking about, or you yourself may talk about suing and lawsuits against the government. Maybe you wouldn't partake in that, because one hand washes the other." They wanted me to agree to not sue them.

My lawyer told me she didn't do that kind of deal, but I had never done time before, so I asked her, "Who's doing the time? Me or you?"

I did it. I made the deal. It was the worst mistake I ever made in my life. I got back to New York, completed my bachelor's at Adelphi University in Garden City, and they reneged on the agreement. I ended up doing ten calendar years on parole in New York City. Ten years. A lot of guys come out on a life sentence and don't do ten years on parole.

Two weeks after agreeing to that shit, it came out in newspapers all across the United States—J. Edgar Hoover had been exposed for spying on the American people. COINTELPRO was exposed for spying on people from Malcolm X in the 1950s all the way up to Martin Luther King Jr., SNCC, the Nation of Islam. Every major black organization. The Black Panther Party was the hardest hit.

Dhoruba (bin Wahad) got a reversal after nineteen years. Geronimo Pratt stayed locked up for almost twenty-seven, and then they freed him. Those reversals tell you that the judicial system was corrupt. Nobody's held accountable for that. Nothing is sacred, especially life. Just like when we were underground—when we went underground, they didn't count on us to make it. Those of us that survived, we weren't supposed to make it. We're not supposed to be here, man. We were supposed to have died.

CONCLUSION

IF THE #BLACKLIVESMATTER MOVEMENT HAD STARTED FIFTY YEARS ago, it might have begun in April 1968 with the killings of Reverend Martin Luther King Jr. and Panther Bobby Hutton. While the world mourned the loss of America's "apostle of peace" in King, Panther founder Bobby Seale placed Hutton's murder in a much more stark context. In a speech he gave at the Kaleidoscope Theatre in Los Angeles ten days after Hutton's death, Seale noted that in the three weeks "before Bobby Hutton died, some five other young brothers" had been killed in encounters with Oakland police.

The Panthers, of course, had picked up their guns in defense of black lives long before the shooting of Hutton but ultimately found that course unproductive—electing to shift their focus toward other types of interventions to illustrate the dignity and worth of black lives. Nearly twelve years later in November of 1981, Seale, reflecting on the history of the party, told a packed auditorium at Quinnipiac College in Hamden, Connecticut, "Those who want to live in the 1960s are misunderstanding the situation today. Nothing stays exactly the same." He continued, "In the 1960s, events captured the imagination of the people." He concluded prophetically, "Today we don't need guns; we need computers."[1]

Although it might seem odd at first blush to conclude a book dedicated to the work of the rank and file of the party with the words and prognostications of one of its founders, Seale's words reveal a deep truth. In the same way the Panthers responded to the needs of their era by picking up their guns, young activists today have responded to the events of their own historical moment using the most powerful tool of organizing and resistance at their disposal: social media. In the space of two years they have built a vibrant campaign that has dramatized the issue on both the national and global stages.

The resurgence of interest in the Black Panther Party on its fiftieth anniversary is thus a reflection not only of new movies, plays, and documentaries that have sought to recover its history but the influence of contemporary issues that have allowed its message of self-defense, self-help, and self-determination to resonate across time.

In the words of former Panthers we find connections to the Department of Justice's blistering investigation into police misconduct in Ferguson, Missouri, which revealed the nagging persistence of Jim Crow justice in America. In the portraits and words of the former Panthers we find not only the battle scars but also the collective knowledge and wisdom that comes from enduring and surviving such struggles.

And yet, there was no glorious end for the BPP, no major legislative victory to point to or signature event like the March on Washington seared into the American consciousness. The decline of the party was swift and unceremonious. Already fraying under the strain of COINTELPRO, the changing political landscape, and internal strife and discord, the party effectively ceased to be a national organization when Huey Newton called for closing down all chapters and consolidating all Panther personnel to Oakland for the purpose of creating a revolutionary beachhead. From 1973 to 1977, under the leadership of Elaine Brown, the Panthers regrouped locally and became a force in Oakland politics while strengthening their social programs, as exemplified by the renowned Oakland Community School, which ran until 1982. By the time the last of the Panthers drifted away, however, little of their Ten-Point Platform and Program had been realized.

With some distance from the day-to-day work of the organization, some Panthers were able to appreciate the profundity of what they had accomplished and the price they paid. Many Panthers describe experiencing a form of posttraumatic stress syndrome as a result of their time in the party. Indeed, some of the Panthers in this book say they self-medicated with drugs and alcohol in the aftermath of the party, and others severed ties completely with their former comrades, only reconnecting decades later as various alumni groups and reunion committees slowly formed. Currently, about

fifteen former Panthers remain incarcerated as political prisoners, and the struggle for their release is a constant refrain and focus of activity among former Panthers. While this text was being finalized, two of them died in prison, Wopashitwe Mondo Eyen we Langa (formerly David Rice) and Abdullah Majid, who is included in this book. Another political prisoner, Albert Woodfox, the last member of the Angola Three, was released.

Even in light of these negative effects, the Panthers do not see their work as a failure. Nor should we, for if the present resurgence of interest in the party is any indication, their message still resonates. The airing of the PBS documentary *The Black Panthers: Vanguard of the Revolution* in February of 2016 electrified social media. Director Stanley Nelson's sweeping look at Panther history, warts and all, introduced the words and deeds of the BPP to a new generation in search of strategies and symbols to combat oppression in their own moment. Although it is easy to be seduced by the striking images of armed, uniformed Panthers staring down police, the deeper lessons of that history are to be found in the recollections of those who lived through that struggle and remain committed to a pending revolution in which the goals of equality and justice as first articulated by the party in 1966 can finally be realized.

EDITOR'S NOTE
SOJOURN WITH THE PANTHERS

"Why the fuck do you want to take pictures of the Black Panthers?"

I was sitting across the table from Billy X Jennings in a sunny cafe near his house in Sacramento, California, in the spring of 2011. At the sound of his raised, barbed voice, a few patrons looked up from their brunches, but Billy X never took his eyes off of me. It was a feeling of close scrutiny I would become familiar with over the next four years as I worked on this project.

Formerly a personal aide to Huey P. Newton and the main campaign office manager for Bobby Seale when he ran for Oakland mayor, Billy X is the closest thing the Panthers have to an official archivist. His home overflows with Panther history—pictures, letters, postcards, posters, and perhaps the largest single collection of the *Black Panther* newspaper, the party's main propaganda, fund-raising, and recruitment tool. At the time we met, he was organizing a forty-fifth annual Panther reunion, held in Berkeley in October 2011, the birth month of the party, and I was asking him to let me stage a portrait studio there.

Why the fuck did I want to take portraits of the Black Panthers?

There wasn't and still isn't a straightforward answer. I knew I wanted to work on a project of historical importance, and despite my sheltered upbringing in East Bay suburbia, I somehow picked up that the Panthers first formed in nearby Oakland. (I was living next door in Berkeley at the time.) I also knew that the Panthers were controversial, but the more I read, the more I sensed that the stories about them were incomplete and not their own. I wanted to hear them for myself. It was much more than the surface thrill of touching the otherwise hidden. As someone who has always felt "other" myself, I am drawn to outsiders and the admittedly fleeting feeling of borrowed acceptance that accompanies hearing the stories that

they share only with each other. In some ways, those are the only stories that matter.

There were other reasons too. While photographing "Islamic Converts in Prison" inside San Quentin Prison as part of my journalism graduate school thesis, I spoke with two inmates who told me they had been Panthers. Though they mentioned the party in passing, their words stuck with me, and a question began forming in my mind, shaped by my own family history: "What happens to revolutionaries in America?"

Both of my great-grandfathers on my father's side were leading generals in the revolutionary army that overthrew China's last emperor in the so-called Revolution of 1911, leading to the collapse of the imperial system and the formation of the Republic of China. In fact, October 2011 marked the one-hundred-year anniversary of that revolution, which the Chinese government commemorated with a week of official celebrations and a lavish feting of the descendants of these revolutionaries, my father included. So I knew how history treated revolutionaries when they won. The Panthers, however, lost.

I tried explaining these things to Billy X, but he looked unimpressed. When we were driving back to his house from the cafe, in response to a question I no longer recall, I blurted out, "You can trust me." Billy X snorted, not unkindly, and said he'd heard that before. I laughed too, realizing how hollow my words must have sounded. As I would be reminded continually while working on this project, the Panthers are guarded and vigilant and with good reason: their history has been defined by government-sanctioned infiltration, sabotage, attacks, imprisonment, and assassinations; pillorying by the media; and their own self-destructive, even murderous, infighting and personal clashes, which echo to this day. I was asking Billy X for entrée into this world.

We continued meeting throughout the summer at a Berkeley coffee shop and in a fast-food restaurant parking lot in Oakland. At the coffee shop, Billy X said that things were getting worse in America and that protest and revolution were on the way. I dismissed his words as a thwarted revolutionary's wish fulfillment, but

later that year in September, protesters took over Zuccotti Park in New York City's financial district. What began as Occupy Wall Street became simply Occupy as protests over massive income inequality and wealth disparity spread quickly around the country and the world, embedding the specter in the public mind of the wealthiest 1 percent dominating the other 99 percent. A few years later, protests and turmoil would break out over a seemingly never-ending series of highly questionable and possibly criminal killings by police of unarmed African American men: Michael Brown in Ferguson, Missouri; Eric Garner in Staten Island, New York; Freddie Gray in Baltimore, Maryland; Walter Scott in North Charleston, South Carolina; and Samuel DuBose in Cincinnati, Ohio. I say "seemingly never-ending" knowing that for the Black Panthers there is no "seemingly" about it. The party was created fifty years ago to combat, with arms if necessary, police brutality in African American communities. Indeed, its original name was the Black Panther Party for Self-Defense, and the violence and debasement they were defending against had existed since before America was even founded.

A few weeks before the forty-fifth anniversary reunion, with no word from Billy X, I resigned myself to the photo shoot not happening. But then it did. He called me a week before, telling me I was in.

WHAT MAKES THESE PORTRAITS AND INTERVIEWS EFFECTIVE IS AN emotional engagement based on trust that could only be built up over time as a slowly growing number of key people from the party vouched for me. As any Panther (or former Panther, depending on who you ask) will tell you, they were always willing to collaborate with others based on mutual interest regardless of skin color. Our shared interests in showing the portraits and telling the stories of individual members of the party overlapped, especially those of the rank-and-file members who until now have gone unseen and unheard. When it comes to media attention, they are the outsiders of the outsiders. But these members were precisely the ones who

conducted the on-the-ground organizing that made the party so effective, and who, through their stories, offer some of the most practical organizing lessons that can still be applied today.

The portraits—shot over a period of four years in Berkeley, San Francisco, New York City, New Orleans, Winston-Salem, and three maximum-security prisons in upstate New York—drove the project initially, but the accompanying interviews complement the images in ways that far exceeded my expectations. My coeditor, Yohuru Williams, said the interviews "complicate" the Panther story in a good way. I agree. By giving so many individual Panthers the extended space to tell their own stories, I had always hoped that a more detailed and nuanced image of the party would emerge, moving us beyond the oversimplified extremes of either denunciation or hagiography that have largely defined the Panther legacy. To Phyllis Jackson, one of the Panthers included herein, I described my approach as "pointillist storytelling." I believe wholeheartedly that it was a success.

I conducted all of the interviews myself either in person or by phone using the same basic set of questions. I edited them for clarity and length, and they have been fact-checked to the extent possible when confirming events that happened almost fifty years ago. These accounts accurately represent our conversations in terms of tone, tenor, and content, which was my promise to my subjects, along with my promise not to cherry-pick the juiciest bits.

Are there any explosive revelations? Not really. Anyone seeking those has any number of films and books to choose from, some of them written by Panthers themselves. Did my subjects tell me everything? Certainly not, and quite a few told me as much. However, there are stories here—told with both pride and humility as well as candor—that have never been heard widely before and that offer intimate knowledge not only of how the party worked and what made it run successfully on a day-to-day level but also why it ultimately failed. Especially with the fiftieth anniversary of the party approaching, many Panthers were willing to share these stories to expand and correct the historical record, which they see as skewed against them. Some simply wanted recognition for their

efforts. Several were quite ill, but they agreed to speak with me at length nonetheless. One of these individuals, Ronald "Elder" Freeman, who appears on the cover, died from cancer two months after we spoke.

I woke up this morning to a photograph in my e-mail inbox sent to me by my father. In it, my father's father stands next to his father, one of the revolutionary generals. Several things about this family portrait strike me: the general's open, amused expression, his relaxed turn toward his more formally posed adolescent son, his fingers resting lightly on his shoulder. These humanizing details seem incongruous with formal portraiture at the time and with the moniker "revolutionary" itself, by which I have come to know him. Such a picture has the power to take us beyond what we thought we knew about someone and into a realm of reexamination. I would never presume to say that the portraits in this book captured the essence of these individuals—human beings are simply too mercurial and complex to be distilled into 1/125th of a second. But I do believe the portraits contain humanizing details and important truths about each person that I hope will drive readers to review their stories closely and engage in the critical reexamination the Black Panther Party merits.

<div style="text-align: right">

Bryan Shih
Sag Harbor, New York
November 2015

</div>

APPENDIX

PANTHER TEN-POINT PLATFORM AND PROGRAM

What We Want Now! What We Believe!

"To those poor souls who don't know Black history, the beliefs and desires of the Black Panther Party for Self-Defense may seem unreasonable. To Black people, the ten points covered are absolutely essential to survival. We have listened to the riot producing words "these things take time" for 400 years. The Black Panther Party knows what Black people want and need. Black unity and self-defense will make these demands a reality."*

What We Want Now!

1. We want freedom. We want power to determine the destiny of our Black Community.

2. We want full employment for our people.

3. We want an end to the robbery by the white men of our Black Community (later changed to "We want an end to the robbery by the capitalists of our black and oppressed communities").

4. We want decent housing, fit for shelter of human beings.

5. We want education for our people that exposes the true nature of this decadent American society. We want education that teaches us our true history and our role in the present day society.

6. We want all Black men to be exempt from military service.

7. We want an immediate end to POLICE BRUTALITY and MURDER of Black people.

8. We want freedom for all Black men held in federal, state, county, and city prisons and jails.

* Excerpt from Joshua Bloom and Waldo Martin, *Black Against Empire.* iBooks. https://itun.es/us/iAepT.l.

9. We want all Black people when brought to trial to be tried in court by a jury of their peer group or people from their Black Communities, as defined by the Constitution of the United States.

10. We want land, bread, housing, education, clothing, justice, and peace.

What We Believe

1. We believe that Black People will not be free until we are able to determine our own destiny.

2. We believe that the federal government is responsible and obligated to give every man employment or a guaranteed income. We believe that if the White American businessmen will not give full employment, the means of production should be taken from the businessmen and placed in the community so that the people of the community can organize and employ all of its people and give a high standard of living.

3. We believe that this racist government has robbed us, and now we are demanding the overdue debt of forty acres and two mules. Forty acres and two mules was promised 100 years ago as redistribution for slave labor and mass murder of Black people. We will accept the payment in currency, which will be distributed to our many communities: the Germans are now aiding the Jews in Israel for genocide of the Jewish people. The Germans murdered 6,000,000 Jews. The American racist has taken part in the slaughter of over 50,000,000 Black people; therefore, we feel that this is a modest demand that we make.

4. We believe that if the White landlords will not give decent housing to our Black community, then the housing and the land should be made into cooperatives so that our community, with government aid, can build and make decent housing for its people.

5. We believe in an educational system that will give our people a knowledge of self. If a man does not have knowledge of himself and his position in society and the world, then he has little chance to relate to anything else.

6. We believe that Black people should not be forced to fight in the military service to defend a racist government that does not protect us. We will not fight and kill other people of color in the world who, like Black people, are being victimized by the White racist government of America. We will protect ourselves from the force and violence of the racist police and the racist military by whatever means necessary.

7. We believe we can end police brutality in our Black community by organizing Black self-defense groups that are dedicated to defending our Black community from racist police oppression and brutality. The second Amendment of the Constitution of the United States gives us the right to bear arms. We therefore believe that all Black people should arm themselves for self-defense.

8. We believe that all Black people should be released from the many jails and prisons because they have not received a fair and impartial trial.

9. We believe that the courts should follow the United States Constitution so that Black people will receive fair trials. The Fourteenth Amendment of the U.S. Constitution gives a man a right to be tried by his peers. A peer is a person from a similar economic, social, religious, geographical, environmental, historical, and racial background. To do this the court will be forced to select a jury from the Black community from which the Black defendant came. We have been, and are being, tried by all-White juries that have no understanding of "the average reasoning man" of the Black community.

10. When in the course of human events it becomes necessary for one people to dissolve the political bonds which have connected them with another, and to assume among the powers of the earth the separate and equal station to which the laws of nature and nature's god entitle them, a decent respect to the opinions of mankind requires that they should declare the causes which impel them to separation. We hold these truths to be self-evident, and that all men are created equal that among these are life, liberty, and the pursuit of happiness. That to secure these

rights, governments are instituted among men, deriving their just powers from the consent of the governed—that whenever any form of government becomes destructive of these ends, it is the right of the people to alter or abolish it, and to institute new government, laying its foundation on such principles and organizing its power in a such a form as to them shall seem most likely to effect their safety and happiness. Prudence, indeed, will dictate that governments long established should not be changed for light and transient causes; and accordingly all experience hath shewn that mankind are more disposed to suffer, while evils are sufferable, than to right themselves by abolishing the forms to which they are accused. But when a long train of abuses and usurpations, pursuing invariably the same object, evinces a design to reduce them under absolute despotism, it is their right, and their duty, to throw off such government, and to provide new guards of their future security.

COINTELPRO DOCUMENTS

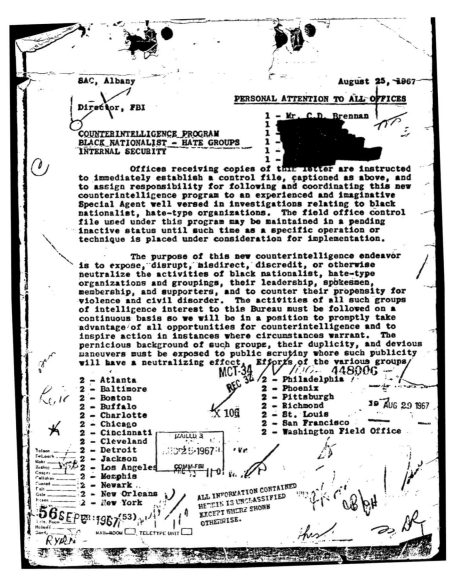

Memo from the office of FBI director J. Edgar Hoover to the special agent in charge (SAC) in Albany, New York, authorizing a new, covert counterintelligence program against "black nationalist, hate-type organizations" that could "under no circumstances" be traced back to the bureau. The Black Panther Party was not mentioned specifically in this early memo, but it would soon become the central target of COINTELPRO operations. (COINTELPRO Black Extremist Part 1 of 23, pp. 3–5, August 25, 1967.)

All documents retrieved from FBI Freedom of Information Act Library (The Vault), https://vault.fbi.gov/cointel-pro/cointel-pro-black-extremists.

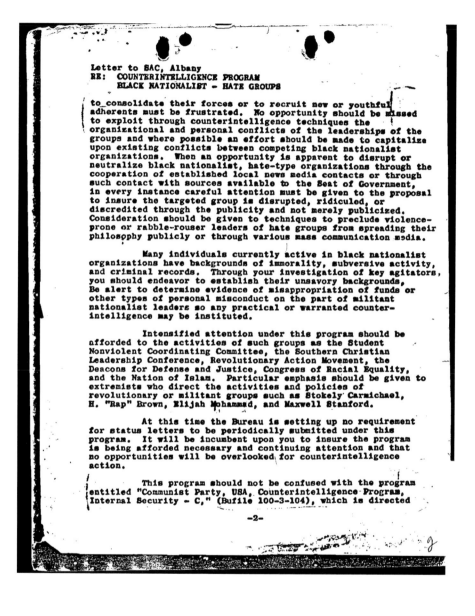

Letter to SAC, Albany
RE: COUNTERINTELLIGENCE PROGRAM
 BLACK NATIONALIST - HATE GROUPS

to consolidate their forces or to recruit new or youthful
adherents must be frustrated. No opportunity should be missed
to exploit through counterintelligence techniques the
organizational and personal conflicts of the leaderships of the
groups and where possible an effort should be made to capitalize
upon existing conflicts between competing black nationalist
organizations. When an opportunity is apparent to disrupt or
neutralize black nationalist, hate-type organizations through the
cooperation of established local news media contacts or through
such contact with sources available to the Seat of Government,
in every instance careful attention must be given to the proposal
to insure the targeted group is disrupted, ridiculed, or
discredited through the publicity and not merely publicized.
Consideration should be given to techniques to preclude violence-
prone or rabble-rouser leaders of hate groups from spreading their
philosophy publicly or through various mass communication media.

 Many individuals currently active in black nationalist
organizations have backgrounds of immorality, subversive activity,
and criminal records. Through your investigation of key agitators,
you should endeavor to establish their unsavory backgrounds,
Be alert to determine evidence of misappropriation of funds or
other types of personal misconduct on the part of militant
nationalist leaders so any practical or warranted counter-
intelligence may be instituted.

 Intensified attention under this program should be
afforded to the activities of such groups as the Student
Nonviolent Coordinating Committee, the Southern Christian
Leadership Conference, Revolutionary Action Movement, the
Deacons for Defense and Justice, Congress of Racial Equality,
and the Nation of Islam. Particular emphasis should be given to
extremists who direct the activities and policies of
revolutionary or militant groups such as Stokely Carmichael,
H. "Rap" Brown, Elijah Mohammad, and Maxwell Stanford.

 At this time the Bureau is setting up no requirement
for status letters to be periodically submitted under this
program. It will be incumbent upon you to insure the program
is being afforded necessary and continuing attention and that
no opportunities will be overlooked for counterintelligence
action.

 This program should not be confused with the program
entitled "Communist Party, USA, Counterintelligence Program,
Internal Security - C," (Bufile 100-3-104), which is directed

-2-

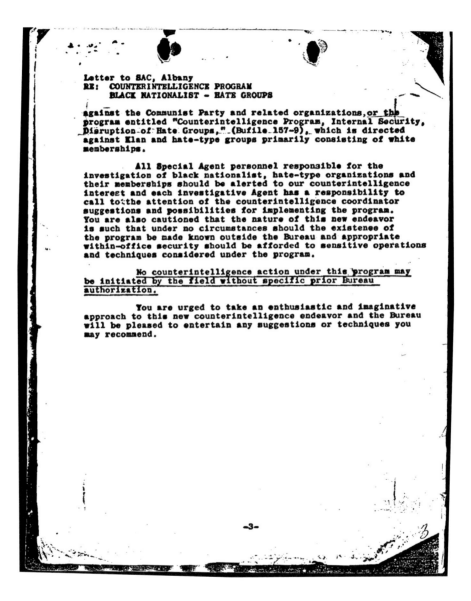

Letter to SAC, Albany
RE: COUNTERINTELLIGENCE PROGRAM
 BLACK NATIONALIST - HATE GROUPS

against the Communist Party and related organizations, or the
program entitled "Counterintelligence Program, Internal Security,
Disruption of Hate Groups," (Bufile 157-9), which is directed
against Klan and hate-type groups primarily consisting of white
memberships.

 All Special Agent personnel responsible for the
investigation of black nationalist, hate-type organizations and
their memberships should be alerted to our counterintelligence
interest and each investigative Agent has a responsibility to
call to the attention of the counterintelligence coordinator
suggestions and possibilities for implementing the program.
You are also cautioned that the nature of this new endeavor
is such that under no circumstances should the existence of
the program be made known outside the Bureau and appropriate
within-office security should be afforded to sensitive operations
and techniques considered under the program.

 No counterintelligence action under this program may
be initiated by the field without specific prior Bureau
authorization.

 You are urged to take an enthusiastic and imaginative
approach to this new counterintelligence endeavor and the Bureau
will be pleased to entertain any suggestions or techniques you
may recommend.

-3-

Airtel to SAC, Albany
RE: COUNTERINTELLIGENCE PROGRAM
BLACK NATIONALIST-HATE GROUPS

nationalist activity, and interested in counterintelligence,
to coordinate this program. This Agent will be responsible
for the periodic progress letters being requested, but each
Agent working this type of case should participate in the
formulation of counterintelligence operations.

GOALS

 For maximum effectiveness of the Counterintelligence
Program, and to prevent wasted effort, long-range goals are
being set.

 1. Prevent the coalition of militant black
nationalist groups. In unity there is strength; a truism
that is no less valid for all its triteness. An effective
coalition of black nationalist groups might be the first
step toward a real "Mau Mau" in America, the beginning of
a true black revolution.

 2. Prevent the rise of a "messiah" who could
unify, and electrify, the militant black nationalist movement.
Malcolm X might have been such a "messiah;" he is the martyr
of the movement today. Martin Luther King, Stokely Carmichael
and Elijah Muhammed all aspire to this position. Elijah
Muhammed is less of a threat because of his age. King could
be a very real contender for this position should he abandon
his supposed "obedience" to "white, liberal doctrines"
(nonviolence) and embrace black nationalism. Carmichael
has the necessary charisma to be a real threat in this way.

 3. Prevent violence on the part of black
nationalist groups. This is of primary importance, and is,
of course, a goal of our investigative activity; it should
also be a goal of the Counterintelligence Program. Through
counterintelligence it should be possible to pinpoint potential
troublemakers and neutralize them before they exercise their
potential for violence.

 4. Prevent militant black nationalist groups and
leaders from gaining respectability, by discrediting them
to three separate segments of the community. The goal of
discrediting black nationalists must be handled tactically
in three ways. You must discredit these groups and
individuals to, first, the responsible Negro community.
Second, they must be discredited to the white community,

- 3 -

Memo from J. Edgar Hoover to the special agent in charge (SAC) in Albany, New York, distributed to FBI field offices throughout the United States, outlining the broad goals and targets of COINTELPRO. (COINTELPRO Black Extremist Part 1 of 23, pp. 69–70, March 4, 1968.)

Airtel to SAC, Albany
RE: COUNTERINTELLIGENCE PROGRAM
BLACK NATIONALIST-HATE GROUPS

both the responsible community and to "liberals" who have
vestiges of sympathy for militant black nationalist simply
because they are Negroes. Third, these groups must be
discredited in the eyes of Negro radicals, the followers
of the movement. This last area requires entirely different
tactics from the first two. Publicity about violent tendencies
and radical statements merely enhances black nationalists
to the last group; it adds "respectability" in a different
way.

 5. A final goal should be to prevent the long-
range growth of militant black nationalist organizations,
especially among youth. Specific tactics to prevent these
groups from converting young people must be developed.

 Besides these five goals counterintelligence is
a valuable part of our regular investigative program as it
often produces positive information.

TARGETS

 Primary targets of the Counterintelligence Program,
Black Nationalist-Hate Groups, should be the most violent
and radical groups and their leaders. We should emphasize
those leaders and organizations that are nationwide in scope
and are most capable of disrupting this country. These
targets should include the radical and violence-prone
leaders, members, and followers of the:

 Student Nonviolent Coordinating Committee (SNCC)
 Southern Christian Leadership Conference (SCLC)
 Revolutionary Action Movement (RAM)
 Nation of Islam (NOI)

 Offices handling these cases and those of Stokely
Carmichael of SNCC, H. Rap Brown of SNCC, Martin Luther King
of SCLC, Maxwell Stanford of RAM, and Elijah Muhammed of
NOI, should be alert for counterintelligence suggestions.

INSTRUCTIONS

 Within 30 days of the date of this letter each office
should:

 1. Advise the Bureau of the identity of the Special
Agent assigned to coordinate this program.

 — 4 —

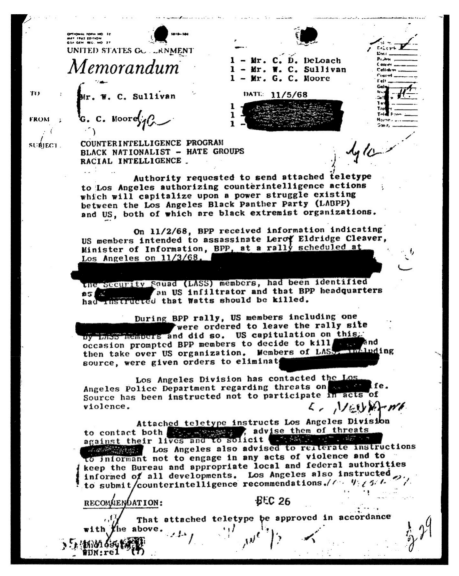

Memo from George C. Moore (FBI Racial Intelligence Section chief), to William Cornelius Sullivan (one of J. Edgar Hoover's top assistants) approving a misinformation campaign to foment violence between the Panthers and a rival organization called US. On January 17, 1969, two Panthers, Bunchy Carter and John Huggins, were killed on the UCLA campus in a shootout with US members. See also "COINTELPRO: The FBI's Covert Action Programs Against American Citizens," Supplementary Detailed Staff Reports on Intelligence Activities and the Rights of Americans, Book III, Final Report of the Select Committee to Study Governmental Operations with Respect to Intelligence Activities, United States Senate, April 23, 1976, http://terrasol.home.igc.org/HooverPlan.htm. (BE Section 04, p. 230, November 5, 1968.)

Memo from J. Edgar Hoover encouraging the FBI field office in San Diego to find, if necessary, extralegal means to justify raiding the local Panther office on informants' word that there were near-nightly "sex orgies" occurring there. (BE Section 14, p. 24, November 18, 1969.)

CREDITS

Archival artwork that appears on pages 13, 30, 40, 44, 47, 70, 81, 90, 95, 114, 135, 140, 145, 158, 195, 197, 209, 232, and 236 is from It's About Time: Black Panther Party Legacy and Alumni, http://itsabouttimebpp.com.

"Rules of the Black Panther Party" on page 63 appears courtesy of University of California.

NOTES

CHAPTER 2, "THE BLACK PANTHER PARTY AND THE RISE OF RADICAL ETHNIC NATIONALISM"

1. Laura Pulido, *Black, Brown, Yellow, and Left: Radical Activism in Los Angeles* (Berkeley: University of California Press, 2006), 158.

2. Ibid., 167.

3. Amy Sonnie and James Tracy, *Hillbilly Nationalists, Urban Race Rebels, and Black Power: Community Organizing in Radical Times* (Brooklyn, NY: Melville House, 2011), 156.

4. Ibid., 164.

CHAPTER 2, "THE GLOBAL PANTHERS"

1. "Dalit Panthers Manifesto," in *Untouchable! Voices of the Dalit Liberation Movement*, ed. Barbara Joshi (London: Zed Books, 1986), 145; Lata Maurugkar, *Dalit Panther Movement in Maharashtra: A Sociological Approach* (London: Sangam Books, 1991); Jayashree Gokhale, *From Concessions to Confrontation: The Politics of an Indian Untouchable Community* (Bombay: Popular Prakashan, 1993), 264; N. M. Aston, ed., *Dalit Literature and African American Literature* (Delhi: Prestige Books, 2001); Vijay Prashad, "Afro-Dalits of the Earth, Unite!" *African Studies Review* 43 (2000): 189–201; Anupama Rao, *The Caste Question: Dalits and the Politics of Modern India* (Berkeley: University of California Press, 2009).

2. Oz Frankel, "The Black Panthers of Israel and the Politics of the Radical Analogy," and Robbie Shilliam, "The Polynesian Panthers and the Black Power Gang: Surviving Racism and Colonialism in Aotearoa New Zealand," in *Black Power Beyond Borders*, ed. Nico Slate (New York: Palgrave Macmillan, 2012), 81–126.

3. Martin Klimke, *The Other Alliance: Student Protest in West Germany and the United States in the Global Sixties* (Princeton, NJ: Princeton University Press, 2010): 118–119; Maria Höhn, "The Black Panther Party Solidarity Committee and the Trial of the Ramstein 2," in *Changing the World, Changing Oneself: Political Protest and Collective Identities in West Germany and the U.S. in the 1960s and 1970s*, ed. Belinda Davis, Wilfried Mausbach, Martin Klimke, and Carla MacDougall (New York: Berghahn Books, 2010): 214–240.

4. Jennifer B. Smith, *An International History of the Black Panther Party* (New York: Routledge, 1999), 78–79.

5. Michael L. Clemons and Charles E. Jones, "Global Solidarity: The Black Panther Party in the International Arena," in *Liberation, Imagination, and the*

Black Panther Party: A New Look at the Panthers and Their Legacy, ed. Kathleen Cleaver and George Katsiaficas (New York: Routledge, 2001), 20–39.

CHAPTER 3, "REVOLUTION, STRUGGLE, AND RESILIENCE"

1. Elaine Brown would become the highest-ranking woman in the history of the Black Panther Party when she took over leadership from Huey P. Newton in 1972. Elaine Brown, *A Taste of Power: A Black Woman's Story* (New York: Anchor Books, 1993).

2. Kathleen Cleaver, "Speech Delivered at Memorial Service for Bobby Hutton," in *Say It Loud! Great Speeches on Civil Rights and African American Identity*, ed. Catherine Ellis and Stephen Drury Smith (New York: New Press, 2010), 72.

3. Cleaver, "Speech Delivered at Memorial Service for Bobby Hutton," 73.

4. For instance, Kathleen Cleaver and George Katsiaficas, eds., *Liberation, Imagination, and the Black Panther Party: A New Look at the Panthers and Their Legacy* (New York: Routledge, 2001); Robyn C. Spencer, "Engendering the Black Freedom Struggle: Revolutionary Black Womanhood and the Black Panther Party in the Bay Area, California," *Journal of Women's History* 20, no. 1 (2008); Tracye A. Matthews, "'No One Ever Asks What a Man's Role in the Revolution Is': Gender Politics and Leadership in the Black Panther Party, 1966–1971," https://libcom.org/files/No%20one%20ever%20asks%20 what%20a%20man's%20role%20in%20the%20revolution%20is.pdf; Angela D. LeBlanc-Ernest, "'The Most Qualified Person to Handle the Job': Black Panther Party Women, 1966–1982," in *Black Panther Party (Reconsidered)*, ed. Charles E. Jones (Baltimore, MD: Black Classic Press, 1998). See also Alondra Nelson, *Body and Soul: The Black Panther Party and the Fight Against Medical Discrimination* (Minneapolis: University of Minnesota Press, 2011); Ashley Farmer, "What You've Got Is a Revolution: Black Women's Movements for Black Power," PhD diss., Harvard, 2013. Although numerous scholars are working diligently to uncover and center the voices of black women in the history of 1960s liberation struggles, including the Black Panther Party, a full-length narrative history of Panther women does not yet exist.

5. Rhonda Y. Williams, *Concrete Demands: The Search for Black Power in the 20th Century* (New York: Routledge, 2015). Kathleen Cleaver defined "Black Power" as "an organized black community united around basic political desires and needs as outlined in the program of the Black Panther Party." She argued that unity based on a common agenda "is the only power that the state cannot destroy when the community is prepared to defend itself against the police. This is the creation of black power, the first step toward obtaining control over the entire black community." Kathleen Cleaver, "Racism, Fascism, and Political Murder," *Black Panther* 1968, It's About Time Website, http://www .itsabouttimebpp.com/Women_BPP/pdf/Kathleen_1.pdf.

6. Spencer, "Engendering the Black Freedom Struggle," 94–95.

7. Madalynn C. Rucker and JoNina M. Abron, "'Comrade Sisters': Two Women of the Black Panther Party," in *Unrelated Kin: Race and Gender in*

Women's Personal Narratives, ed. Gwendolyn Etter-Lewis and Michele Foster (New York: Routledge, 1996), 147.

8. Kiilu Nyasha, "Kiilu Talks About Life Experiences," Women of the Black Panther Party, It's About Time website, http://www.itsabouttimebpp .com/Women_BPP/salute_women_index.html.

9. Nelson, *Body and Soul*, 58.

10. Cleaver, "Racism, Fascism, and Political Murder."

11. Connie Matthews, "Interview with Scandinavian Rep. of Black Panther Party: Connie Matthews," *Black Panther*, October 18, 1969, It's About Time website, http://www.itsabouttimebpp.com/Women_BPP/pdf/Sisters_in _the_Party_3.pdf.

12. Candi Robinson, "Shellie Bursey and Brenda Presley Face Fascist U.S. Courts," *Black Panther*, October 17, 1970, It's About Time website, http:// www.itsabouttimebpp.com/Women_BPP/pdf/Shellie_and_Brenda.pdf.

13. Ibid.

14. "Repression: The Torture of Panther Women," *Black Panther*, November 22, 1969, It's About Time website, http://www.itsabouttimebpp.com /Women_BPP/pdf/Panther_Women.pdf.

15. Brown, *A Taste of Power*, 362.

16. Spencer, "Engendering the Black Freedom Struggle," 90–113. Also see Angela D. LeBlanc-Ernest and Ericka Huggins, "Revolutionary Women, Revolutionary Education: The Black Panther Party's Oakland Community School," in *Want to Start a Revolution? Radical Women in the Black Freedom Struggle*, ed. Dayo Gore, Jeanne Theoharis, and Komozi Woodard (New York: New York University Press, 2009), 161–184.

17. Ericka Huggins, phone interview with Bryan Shih, June 25, 2015.

18. Ibid.

19. Ibid.

20. "On Hearing Soul Serenade," June 7, 1969, Folder: Servant: Insights and Poems, Box 14, Huey P. Newton Papers. Courtesy of Robyn C. Spencer.

21. Huggins, phone interview, June 25, 2015.

22. Rucker and Abron, "'Comrade Sisters,'" 156.

23. See SHIELDS for Families website, https://www.shieldsforfamilies.org.

24. The name of her program is ONTRACK Program Resources. See, "Madalynn C. Rucker, Honoree of the 7th Year Anniversary Celebration of the Exceptional Women of Color (EWOC)," https://ontrackconsulting .org/madalynn-c-rucker-honoree-of-the-7th-year-anniversary-celebration -of-the-exceptional-women-of-color-ewoc/.

25. See Greenhope Services for Women website, http://www.greenhope .org/index.shtml.

Chapter 4, "The Black Panther Rank and File"

1. For example, Hugh Pearson, *The Shadow of the Panther: Huey Newton and the Price of Black Power in America* (Reading, MA: Addison-Wesley, 1994);

David Hilliard with Keith and Kent Zimmerman, *Huey: Spirit of the Panther* (New York: Thunder Mouth Press, 2006). Pearson, at least, offered a typology of Panther membership consisting of three elements, though typically offering no source for it: the lawful, those "who had no qualms about breaking the law if it could be rationalized as a revolutionary activity," and the criminal (192).

2. Introduction to *Spinner: People and Culture of Massachusetts*, vol. 3, ed. Donna Huse (New Bedford, MA: Reynolds-DeWalt, 1984), 1, quoted in Jama Lazerow, "The Black Panthers at the Water's Edge: Oakland, Boston, and the New Bedford 'Riots' of 1970," in *Liberated Territory: Untold Perspectives on the Black Panther Party*, ed. Yohuru Williams and Jama Lazerow (Durham, NC: Duke University Press, 2008), 119n7.

3. Jama Lazerow, "'A Rebel All His Life': The Unexpected Story of Frank 'Parky' Grace," in *In Search of the Black Panther Party: New Perspectives on a Revolutionary Movement*, ed. Yohuru Williams and Jama Lazerow (Durham, NC: Duke University Press, 2006).

4. Lazerow, "Black Panthers at the Water's Edge."

CONCLUSION

1. "People in the News," (Frederick, Maryland) *Post*, November 11, 1981, C-2.

INDEX

BRYAN SHIH IS A PHOTOJOURNALIST BASED IN New York. A former contributor to the *Financial Times* and National Public Radio in Japan, he is a graduate of the University of California at Berkeley Graduate School of Journalism and a former Fulbright scholar. His work on the Panthers led to his selection for the *New York Times* inaugural portfolio review in 2013 and garnered him one of the highest rankings among entries in the LensCulture 2015 Portrait Awards competition.

YOHURU WILLIAMS IS DEAN OF THE COLLEGE of Arts and Sciences at Fairfield University. Previously history department chair and director of black studies at Fairfield, he also served as chief historian for the Jackie Robinson Foundation and Museum in New York. He received his PhD from Howard University and is author of *Black Politics/White Power: Civil Rights, Black Power, and the Black Panthers in New Haven* and coeditor of *A Constant Struggle: African-American History, 1865–Present, In Search of the Black Panther Party: New Perspectives on a Revolutionary Movement*, and *Liberated Territory: Untold Local Perspectives on the Black Panther Party*. He has appeared on Al Jazeera America, Fox Business, C-SPAN, and NPR.

The Nation Institute

Founded in 2000, **Nation Books** has become a leading voice in American independent publishing. The imprint's mission is to tell stories that inform and empower just as they inspire or entertain readers. We publish award-winning and bestselling journalists, thought leaders, whistle-blowers, and truthtellers, and we are also committed to seeking out a new generation of emerging writers, particularly voices from under-represented communities and writers from diverse backgrounds. As a publisher with a focused list, we work closely with all our authors to ensure that their books have broad and lasting impact. With each of our books we aim to constructively affect and amplify cultural and political discourse and to engender positive social change.

Nation Books is a project of The Nation Institute, a nonprofit media center established to extend the reach of democratic ideals and strengthen the independent press. The Nation Institute is home to a dynamic range of programs: the award-winning Investigative Fund, which supports groundbreaking investigative journalism; the widely read and syndicated website TomDispatch; journalism fellowships that support and cultivate over twenty-five emerging and high-profile reporters each year; and the Victor S. Navasky Internship Program.

For more information on Nation Books and The Nation Institute, please visit:

www.nationbooks.org
www.nationinstitute.org
www.facebook.com/nationbooks.ny
Twitter: @nationbooks